The Adobe Photoshop CS4 Layers Book

The Adobe Photoshop CS4 Layers Book

Harnessing Photoshop's most powerful tool

Richard Lynch

Focal Press is an imprint of Elsevier 30 Corporate Drive, Suite 400, Burlington, MA 01803, USA Linacre House, Jordan Hill, Oxford OX2 8DP, UK

© 2009, Richard Lynch. Published by Elsevier Ltd. All rights reserved.

The right of Richard Lynch to be identified as the author of this work has been asserted in accordance with the Copyright, Designs and Patents Act 1988.

No part of this publication may be reproduced, stored in a retrieval system, or transmitted in any form or by any means, electronic, mechanical, photocopying, recording, or otherwise, without the prior written permission of the publisher.

Permissions may be sought directly from Elsevier's Science & Technology Rights Department in Oxford, UK: phone: (+44) 1865 843830, fax: (+44) 1865 853333, E-mail: permissions@elsevier.com. You may also complete your request online via the Elsevier homepage (http://elsevier.com), by selecting "Support & Contact" then "Copyright and Permission" and then "Obtaining Permissions."

Notice

No responsibility is assumed by the publisher for any injury and/or damage to persons or property as a matter of products liability, negligence or otherwise, or from any use or operation of any methods, products, instructions or ideas contained in the material herein. Because of rapid advances in the medical sciences, in particular, independent verification of diagnoses and drug dosages should be made.

Library of Congress Cataloging-in-Publication Data

Lynch, Richard (Richard A.)

The Adobe Photoshop CS4 Layers Book : Harnessing Photoshop's Most Powerful Tool/Richard Lynch.

p. cm.

Includes bibliographical references and index.

ISBN 978-0-240-52155-8 (pbk.: alk. paper) 1. Adobe Photoshop. 2. Photography—Digital techniques.

3. Image processing—Digital techniques. I. Title.

TR267.5.A3L949 2009

006.686-dc22

2008051098

British Library Cataloguing-in-Publication Data

A catalogue record for this book is available from the British Library.

ISBN: 978-0-240-52155-8

For information on all Focal Press publications visit our website at www.books.elsevier.com

09 10 11 5 4 3 2 1

Printed in Canada.

Working together to grow libraries in developing countries

www.elsevier.com | www.bookaid.org | www.sabre.org

ELSEVIER

BOOK AID

Sabre Foundation

CONTENTS

Acknowledgments	x
Introduction	xii
Chapter 1: The Basics of Layers: Layer Functions and Creation	1
What Is a Layer?	2
Layer Palettes and Menus	7
Types of Layers	13
Layer Viewing Preferences	15
Getting Started Creating Layers	16
Exercise	20
Summary	28
Chapter 2: Layer Management: Concepts of a	
Layer-Based Work Flow	29
The Outline for Image Editing	
Setup	31
Capture	
Evaluation	
Editing and Correction	
Purposing and Output	
The Logic of Layers	
When to Create a New Layer	
Naming Layers	
Grouping Layers	
Merging Layers	
Moving and Activating Layers	
Clipping Layers	52
Linked Layers	56
Smart Objects	60
Summary	63
Chapter 3: Object and Image Area Isolation in Layers	65
Isolating Correction in Adjustment Layers	
Detailing the Levels Slider Changes	
Applying Levels for Color Correction	
Isolating Image Objects	

	Adding Layers for a Change	81
	Simple Layer Repair Example	
	The Art of Color Balance	86
	Summary	87
Chapte	r 4: Masking: Enhanced Area Isolation	91
	Expanding on Process	92
	Clean Up	
	Reducing Image Noise	
	Enhancing Natural Color and Tone	
	Add Soft Focus	
	Color Enhancements	110
	Sharpen and Enhance Contrast	111
	Additional Manual Sharpening	115
	Summary	
Chanto	r E. Anniving Layer Effects	121
Chapte	r 5: Applying Layer Effects The Basics of Effects and Styles	
	Saving Styles	
	Managing Styles	
	Manual Effects	
	Automated Manual Effects Tools	
	Combining Manual Effects and Styles	
	Summary	
	Juninary	140
Chapte	r 6: Exploring Layer Modes	143
	Layer Mode Behavior	144
	Normal	145
	Dissolve	146
	Darken	146
	Multiply	147
	Color Burn	147
	Linear Burn	148
	Darker Color	
	Lighten	148
	Ligiticiti	
	Screen	
		149
	Screen	149 149
	Screen Color Dodge	149 149 150
	Screen Color Dodge Linear Dodge	149 150 150
	Screen Color Dodge Linear Dodge Lighter Color Overlay Soft Light	149 150 150 150
	Screen	149 150 150 150
	Screen	
	Screen	
	Screen	

	Difference	153
	Exclusion	153
	Hue	154
	Saturation	154
	Color	154
	Luminosity	155
	Separating Color and Tone	156
	Sharpening Calculation	162
	Summary	166
Chapter	7: Advanced Blending with Blend If	169
	Blend If: An Overview	169
	Knockouts	177
	Blend If in Compositing	179
	Blend If as a Mask	190
	Creating a Color-Based Mask	191
	Summary	199
Chapter	8: Breaking Out Components	201
-iiapici	A Historic Interlude	
	Creating Color from Black and White	
	An Alternative: Creating Filtered Color	
	Separating a Color Image into RGB Components	
	Using Separations	
	Summary	
Chanter	9: Taking an Image through the Process	229
Chapter	The Image	
	General Image Editing Steps: A Review	
	Applying the Image Editing Checklist	
	Summary	
Chanter	10: Making a Layered Collage or Composite Image	257
Chapter	What is a Collage?	
	Guidelines for Collage	
	An Example Collage	
	Creating a Panorama	
	Working with HDR Images	
	Making an HDR Image	
	Create an HDR Image in Photoshop	
	Automated HDR Conversions	
	Manual HDR Conversions	
	Summary	
	341111417	2/3
Photosh	op's Essential Tools List	
	Exploring New Tools	276

	External Applications	277
	Commands	278
	Functions	278
	Freehand Tools	281
	Filters	281
ndex		. 285

ACKNOWLEDGMENTS

ocal Press is to be commended for their excellent work and dedication to authors. A sincere thanks to my publisher. Though the crew has changed, the excellent staffing continues, and the book-writing projects that I was all but ready to abandon because of previous publishers continue with Focal Press. Thanks especially to Danielle Monroe, who measures time with patience. Thanks as well to Kara Race-Moore for her excellent detailed work. Thanks to Ben Denne for making sure we stayed on course, and to all the others who previously helped me on my way at FP, including Paul Temme, Emma Baxter, and Asma Palmeiro.

Thanks to the management at betterphoto.com, who established my online courses, especially Jim Miotke and Kerry Drager. And thanks to the hundreds of students who keep my eye on the ball as to what people learning the program really need (and not just what is conceptually cool).

More thanks to those few trusted friends in the business: Greg Georges (gregorygeorges.com) and Al Ward (actionfx.com), Todd Jensen (thefineartoriginals.com, toadprint.com), Fred Showker (60-seconds.com), Barbara Brundage, and Luke Delalio (lukedelalio.com).

Unbridled thanks to the home base for their patience, ability to plan around, competence in objectively ignoring, and occasional input and inspiration: Lisa, who is as delicious as her meals; Julia, whose spirit manifests in spectacular ways that I hope to grow to understand; Isabel, who always has a kind word for my most awful images; and Sam, whose bellows in the night break glass.

Special thanks ... Mitch Waite, Stephanie Wall, Beth Millett, Bonnie Bills, Pete Gaughan, and Dan Brodnitz (see, it's not all bad). And, of course, Robert Blake for the "F".

Thanks to nameless others, named here, who affect things in ways they cannot know: Alan R. Weeks, Kevin Harvey, Larry Woiwode, Tony Zenos, Joe Reimels, Hagen-Dumenci, Dr. Fun, Murphy (1988–2007), AT, VDL, VOL, TV, SB, P-G, TC, DL, JK, and various Lynches, Nardecchias, and Hongs.

INTRODUCTION

If you've picked up this book, you are familiar enough with Photoshop to know layers are important, and smart enough to know they can help you improve your images. I've been using layers for about 15 years, but I can still remember how I worked before I was introduced to them and found out what they could do for me.

Sometime in early 1993, just before I was introduced to Layers, I was working for a how-to photography book publisher as an editor/designer. We had Photoshop 2.5. I used Photoshop to make adjustments to scanned images and make them ready for print. Photoshop was fairly new at the time; it didn't yet have all of the features that would, not much later, make it the industry standard in image editing. One of the features yet to be adopted was layers.

The project I was working on included topographic maps for a book on waterfalls. The book had been self-published by an author who added the maps to the book to give the reader an idea of the landscape around each of the falls. The author had public domain maps scanned and placed in the book at the original size. At that size, the maps accounted for the bulk of the original book. We made the decision to reduce the size of the maps to a single page in the reprint to save space and make the whole landscape visible at a glance while saving some money in production costs. Regrettably, the author had the original maps, but not the image files from the scans. We had to rescan the maps for the new book. In line with saving costs, we decided to scan the images in-house.

It seemed scanning the maps should have been easy. The maps were way too big for the flatbed scanner we had, but I figured I could scan the maps in parts and put them together in Photoshop. I fit as much of a map as I could onto the scanner and scanned it in even columns and rows, leaving a little overlap, saving the scans to separate files. I'd planned to assemble them all later in Photoshop like a puzzle (see Figure I.1).

I made all the scans, then made a new image large enough to hold all the scans, and then started placing them in the image one at a time via copy and paste. Placing the first image was easy, and everything at that point was working as planned. The next image wasn't nearly as easy. The lines for the topographic maps didn't line up very well. I tried moving the image in all directions and doing some rotation, but I couldn't get all the lines to match up at one time, no matter what I did or how I fussed. When I got the lines near the bottom to align, the ones at the top would be off, and if I nudged right or left, it would fix one thing and goof up something else.

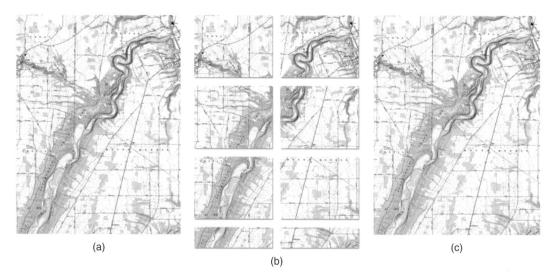

FIG I.1 (a) The topographical map was far too big to fit on the flatbed scanner. (b) The plan was to scan the map in pieces and fit them all together. (c) When reassembled the new map would look like the original whole . . . at least that was the plan.

As it turned out, lining up the pieces of the map was a nightmare. I did the best I could aligning that second piece, and finally decided it would never align perfectly—it seemed I was a victim of scanner distortion in addition to lacking perfect alignment between scans. When I deselected the pasted piece, it merged with the original, misaligned gradation lines and all (see Figure I.2). All I could do was Undo and try it again or move on to the next piece. None of the subsequent pieces aligned perfectly, and I was left with many disconnected gradation lines.

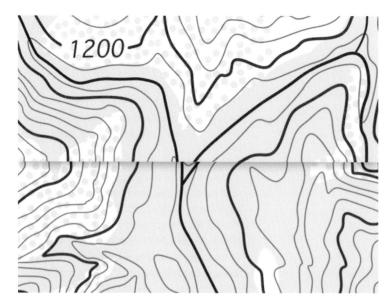

FIG I.2 The gradation lines mismatched every time a piece was put in place.

I continued putting the pieces together and after I was all done I went back and painstakingly corrected every line by manually patching (a technique we'll look at later in this book). It took many hours of additional time to make, finesse, and blend all of the repairs to make the gradation lines look right. When I finished the first map, I went to work on the next map. It took weeks to complete them all.

Several months after the map project, Adobe released Photoshop 3. I read about the new version, which featured Layers as the key new addition. Layers were a way to let you store parts of your image independently in the same image, letting you stack your changes without committing them. Instead of the situation you had before, in which selected parts of the image would automatically merge into a single image plane when deselected, you had the option of keeping the area separate. Layers offered the opportunity to reposition the objects you had on separate layers at any time.

I thought back to the maps and how even that simplistic view of layers would have saved me hours of time. I could have pasted the separate scans to their own layers so I could move each independently even after I had all of the scans in one image (see Figure I.3).

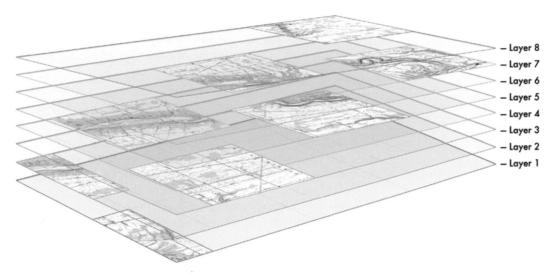

FIG 1.3 Layers would allow image areas to remain separated as if each were placed on its own pane of glass in the image.

There were many other advantages to layers that I would discover in the coming months that went far beyond the simple way I first thought of them. I would have power over opacity and could lower it for any given layer (say, to 50 percent) to see through to the content of the layers underneath and see better how the layers might align. I would be able to erase areas of the map that I was adding to blend the overlap optimally and with more forgiveness and lessen or eliminate the need for patching. I could have made patches

for the gradation lines in new layers and greatly simplified blending in those adjustments. In all, the advantages of layers would have cut the work I had to do on the map by days, not just hours.

Over the years and through the next six-plus versions of Photoshop, I would discover many other uses for layers, including:

- Using layers to allow completely nondestructive image editing. Editing images would never lead to loss of the original source.
- Using layers as the center of the image correction work flow. Layers could store every step in the editing process for later examination, changes, or learning about techniques.
- Using layers as an organizational tool for all corrections. Layers can be grouped and structured to organize selective and global corrections.
- Using layers to store multiple versions of an image all in one file. Various
 versions of an image can be stored in separate groups so there is no
 hunting for files or unnecessary file duplication.
- Using layers to leverage advantages of other color modes without converting from RGB (red, green, blue). Working on separate image components does not require a mode change when you use layers to isolate color and tone.
- Using layers to create custom CMYK and duotone separations for print, allowing ultimate flexibility and control of print results on printing presses.
- Using layers to mix channels and perform calculations. With infinitely more flexibility than standard tools like Channel Mixer or Calculations, layers are the ultimate in creating masks and black-and-white conversion.
- Using layers for repeatable custom effects. Along with custom color and tone adjustments, custom sharpening, soft focus, and other special effects are all possible.
- Using layers to enhance control of the application of any tool in Photoshop. Filters, painting tools, and all adjustments can be masked, moved, and applied in different modes and opacities.
- Using layers for compositing images, creating panoramas, and extending visual depth with high dynamic range (HDR) effects.

Layers has seen some enhancement, though it was remarkably well matured in that initial release. Layer functionality then and now includes some extraordinary powers that, even now, I have still barely seen mentioned in tutorials and books and even then never explored to potential. In this book we take a look at them all, and focus on those that you will find most useful every day.

Layers—what I consider the most powerful tool in all of Photoshop, a feature in Photoshop used so extensively that it will effect the correction of *every* image—had never been the subject of a book until the first edition of this book appeared in 2007. This is very surprising considering that more esoteric features such as Channels and Actions have books written about them.

Every Photoshop book worth the paper it's written on mentions layers, and some have dedicated chapters to them, but no other book focuses on using Layers as the core of your methodology for obtaining the best images, every time, with the least amount of work. This book paved that new direction and continues to lead the way.

The Goal of This Book

The goal of *The Adobe Photoshop CS4 Layers Book* is to give the reader a complete approach to editing images using Layers as a springboard to better corrections and a complete work flow. This book will show that layers are the catalyst to organizing corrections, solidifying work flow (the holistic process of editing images) and acting as the central component to controlling every image change. Readers will learn professional correction techniques that are viable in any image, and they will become familiar with the power of layers as an organizational, correction, and revision tool. The ultimate goal is to portray layers as the heart and soul of image correction and build a foundation of good practices to help approach correction and enhancement of any image. The book focuses on the correction of photographic images rather than using layers for general graphics; the name of the program is, after all, *Photoshop*. Although the focus is on image correction, the exploration of layer functions and features is comprehensive.

Users need to understand how using layers can have an immediate, profound, and long-term effect on the overall quality of their images. This book shows not only the nuts and bolts of what layers do, but also how they envelop the entire process of image correction and control.

Achieving the Goals

The process of discovering layers starts with the essence of learning what layers are and exploring the Layers interface and commands in detail, then works back through the application of layers in real-life image editing situations using images found on the CD. The approach looks at the fundamentals of images and image editing and shows how layers enable users to make any adjustment to an image in a nondestructive fashion using essential tools and concepts. Nondestructive techniques means enabling users to make image changes that in no way compromise original image information; layers build on top of the original source to alter it, rather than changing it directly, which could lead to losing or permanently altering valuable details.

The techniques provided in this book help you take your corrections to a professional level without hocus-pocus or steps that are impossible to comprehend and apply to your own images. You'll see what happens behind the scenes in step-by-step procedures, and when appropriate, you'll be given the tools—customized actions created just for this book—to move through those steps quickly to set up image editing scenarios.

This book will divulge:

- a process of approaching image corrections (a work flow) centered on layered development with proven methods and a proven, core tool set;
- high-powered editing techniques and scenarios that leverage the power of layers to enhance your ability to make any image adjustment;
- realistic image editing situations with real images by using realistic expectations to get real results;
- timeless techniques that span many versions of Photoshop based on good core fundamentals and essential understanding that can be used with any image.

The book will not:

- show you fleeting techniques that emphasize the newest tools just because they are new;
- examine a plethora of rarely used tools in excruciating detail just because they are there;
- · show you how to create effects that you may use once in a lifetime—if ever.

Who Should Read This Book

This book is for anyone who is serious about enhancing his or her Photoshop skills and getting better results from all of his or her digital images. It applies to those who use either a digital camera or a scanner with a Mac or PC.

Readers of this book should probably not be absolute beginners with Photoshop. They should at least have dabbled in using layers, perhaps knowing they could make more of them.

It is assumed that readers are familiar with the basic Photoshop tools (or that they are competent to research these in Photoshop Help) and that they have fairly good general computer skills (there is nothing here about program installation, troubleshooting, or the like). This book is written for:

- users who want to understand how to use layers optimally for nondestructive adjustment and organizing image corrections;
- serious hobbyists who want to get more from their investment in Photoshop by leveraging the power of its most potent tool;
- those with some Photoshop experience who are looking for an organized approach to editing any image and getting consistently better image results.

How This Book Is Organized

As you go through the book, you will discover a mixture of practical theory, examples of the types of changes you'll make in images daily, and projects to work on to help you understand the process as well as why it works. Projects are devised so that you see what goes on behind the scenes to help

understand what you have done, not so that you just complete an exercise or press a button and ogle the result. When you understand concepts and techniques, you can apply that understanding to other images predictably—either by using tools provided to drive the processes or by manually applying learned techniques.

The book helps establish a routine so that you set clear goals for editing your images and establish a method of approaching your images consistently. The examples provided ensure that you can see the changes when they have achieved the desired result. This understanding will enable you to apply the techniques you learn to other images so that your images can be improved consistently.

In Photoshop, many tools and functions can be accessed by more than one method. When following along with the book's step-by-step instructions, use the suggested steps for accessing the tools. Using other methods may cause sequences to behave unpredictably. For example, opening Levels with the keyboard shortcut (Command+L/Ctrl+L) will open the Levels dialog box but will *not* produce an Adjustment layer, and this can affect the outcome of a procedure that depends on the Adjustment layers being created.

You will learn multiple color-separation methods to take apart image color and tone, as well as different ways to isolate color components, image objects, and areas. When you can isolate colors and image areas, you can correct those areas separately from the rest of the image and exchange, move, and replace elements to make better images. You can also effect better blending between areas and make more realistic changes. Actions included on the CD are introduced in the exercises and will reveal functional scenarios that can be used with any image and simplify the process of applying what you learn.

The chapters build from one to the next, each using some ideas from the previous chapter(s), building to chapters that follow the image process from beginning to end by using a single image. Chapters incorporate mini exercises that invite the reader to "Try It Now," using a hands-on approach to learning. All images used in these exercises are on the CD so the user can work along, and in many cases completed samples, including the layers used and developed in the steps, are also provided so that you can check your work.

No book of any length can completely explore every facet of every concept, but it should give you a good idea of the possibilities. To that end, each chapter ends with a segment that considers the implications of using the

techniques and concepts you've learned in that chapter. The purpose and content of each chapter are listed below:

Chapter 1: The Basics of Layers: Layer Functions and Creation

Understanding how to work with layers starts with understanding some basics about what layers are, what their capabilities are, what functions are in the Layers palette, and how to locate all that you need to apply basic layer power. Readers will explore the Layers palette, see how all the basic functionality fits into the Layers palette and menus, learn how to create layers, access and apply basic layer functions, and adjust the layer viewing preferences. We'll run through a hands-on no-knowledge-necessary example of using layers and see some simple effects that can be achieved in the world of layers.

Chapter 2: Layer Management: Concepts of a Layer-Based Work Flow

Before readers really become enamored with layers, the flexibility that they offer, and the organization they provide, they need to know their practical application—and then how to use them most effectively. There are reasons to create layers based in the scope of layer capabilities and the changes you want to make; in a similar vein, there are reasons not to create layers, reasons to delete or combine layers, and means of managing layer content such as merging, linking, and grouping. Effectively managing layers and layer content will help keep image corrections on track, will allow users the flexibility to step back in corrections, and will also keep image file sizes from bulking up unnecessarily. This chapter includes a brief discussion of layer types, such as Type and Adjustment layers, linking, alignment, activating, deletes, and duplication. Readers will test out all the layer creation and combining features and will be introduced to the steps of a digital work flow.

Chapter 3: Object and Image Area Isolation in Layers

The core strength of layers comes from their ability to help you isolate change. This chapter begins to look at how to isolate image areas effectively. Sure, you can isolate areas with selection, but selection has disadvantages in that changes are permanent and selected areas are only temporarily isolated, rather than with layers, with which changes remain permanently isolated and can be adjusted. Layers enhance your freedom to correct the image because once areas are isolated, you can make adjustments and then fine-tune the adjustments in ways that are impossible with simple selective change. We'll look at using layers to isolate image areas and objects using copy and paste and applying a simple layered effect using layer styles and manual effects. We'll also look at blending layers using Opacity, compositing images, and controlling composition.

Chapter 4: Masking: Enhanced Area Isolation

Even more advanced means of isolating image areas in layers exist in the form of masking. Masking is making adjustments to the visible image without actually changing or removing image areas; areas are hidden, or masked, in the image based on a masking component, which acts separately from the

pixels. We'll look at masking as it applies to layer transparency, layer clipping, Adjustment layers, and proper layer masks. We'll use layer masking to paint in effects, affect image sharpness selectively, and change image color selectively.

Chapter 5: Applying Layer Effects

With the ability to isolate image areas comes the advantage of applying layer-based effects. We will look at the effect possibilities, practical uses, and applications. We'll consider the difference between Fill and Opacity, and peek around the corner to Chapter 6 and revisit part of Chapter 1, looking at creating layer effects using standard layers. Using concepts from Chapters 3 and 4 to isolate and mask image areas, we consider the advantage of creating effects manually rather than using packaged effects.

Chapter 6: Exploring Layer Modes

People who get involved in using layer modes often just apply them willy-nilly, like filters, and experiment till they see something that they like. There is a better approach to layer modes: actually knowing what they do and when they can be helpful. Not all layer modes are really useful for everyday correction, but some are and they are very powerful tools. We'll look at ways that users can use layer modes every day for image enhancements and improvements. Calculations help make simple separation of images into color and luminosity components, which in turn allow a peek at what modes do and allow useful change. Manual effects like dodge and burn, image comparison, contrast enhancement, and more are all enabled by layers and modes.

Chapter 7: Advanced Blending with Blend If

Photoshop has several advanced blending modes that allow users to blend layers based on components/channels, qualities in the current layer, and qualities in layers below the current layer. This capacity is mostly encompassed by Blend If and component targeting. These powerful tools are often great to use as adjuncts to more familiar layer tools, but we will explore examples of more than one type, in practical examples that use Blend If for image change. We'll also load up some tools that make using Blend If an easy part of everyday corrections.

Chapter 8: Breaking Out Components

As per the previous chapters we will look at ways to leverage the power of layers to separate out image areas into RGB channels. These powerful methods of separating images into components can lead to a plethora of advantages in creating layer-based masks based on specific image qualities and can open the door to a world of creativity in manipulating tone, color, shape, and composition. Custom tools are provided for users to create involved image scenarios that allow layer-based channel mixing of different sorts and target tone and color change in a more powerful way than other channel mixing options or controls offered as standard Photoshop tools.

Chapter 9: Taking an Image through the Process

Now that we have explored the parts of layers and what they can do, we will look at applying layers as a complete process to an image from beginning to end. This chapter offers the opportunity to review every preceding chapter as part of an actual application in image correction, as we explore concepts and changes in a single sample image. The sample offers the opportunity to create focus on the work flow and process and instill the idea of outlining what to do with an image before approaching corrections and shows how to keep everything organized during the process.

Chapter 10: Making a Layered Collage or Composite Image

As an exercise in creativity and an opportunity to break out all the tools that readers encountered in the course of this book, the final chapter is devoted to exploration of compositing and collage work. The emphasis is on considering the idea of collage, and then looking at how to expand your canvas and image depth, working with panoramas and HDR images implemented using the power of layers. Source images are provided from the examples in the book for looking at panorama stitching, composites, and collage and rendering an HDR image. Readers will be encouraged to exercise their layer muscles by using techniques from previous chapters to make a creative collage from a variety of source images and are invited to share those with other readers on the photoshopcs.com web site.

The CD

One of the most important parts of this book is the CD. First, the CD contains all the images from the book so that readers can work through the corrections exactly as they are portrayed. Second, the CD contains a set of custom actions that will help readers set up scenarios in their images and repeat long sets of steps that are in the book but would otherwise be tedious to apply. To use the actions and simplify procedures you'll have to do nothing more than load and run an action. These actions/tools are meant for readers of this book only and should not be shared freely with other Photoshop users. The actions must be installed into Photoshop via the Actions palette to be accessible (instructions are included below and in the appropriate chapter). The CD, images, and actions will operate on Windows and Macintosh computers.

To install the actions, first locate the Actions folder on the CD. Actions in this folder can be dragged directly to the Actions palette in Photoshop, or they can be loaded through the Load Actions function on the Actions palette menu (see Figure I.4).

After you've installed the actions, you'll be able to access them in the Actions palette. Open the Actions palette by choosing Actions from the Window menu. The usage of the actions is discussed in this book, and all are described in the Readme file for the actions on the CD. Please make use of the web site for the book and use the online forum to discuss any problems you may be having with the CD. Find links for the forums on the web site: http://www.photoshopcs.com.

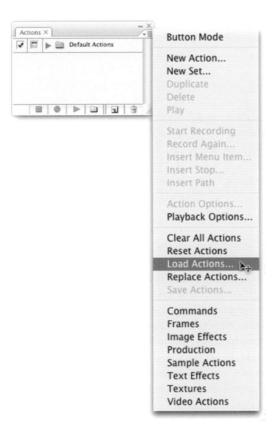

FIG I.4 Open the Actions palette from the Photoshop Windows menu, then choose Load Actions from the palette menu.

The images used as practice files in the book are provided on the accompanying CD so that readers can work along with the exercises. They are mostly provided as .psd files (Photoshop documents) or .tif files, but may be in other formats as appropriate to a particular exercise. These images are copyrighted and for educational purposes only; please use them only in the context of the exercises. Work with the images by opening them with Photoshop directly off the CD, and save them as you need them to your hard drive. The images are all compatible with Macintosh and Windows computers.

Mac and PC Compatibility

The actions and images on the CD are completely compatible with Mac and PC platforms, and they work in the same way within Photoshop across platforms. The greatest difference a user will note in the book is that shortcuts differ between Mac and PC. For example, to open the Levels palette on a PC, the user would press the Ctrl+L keys; on a Mac the user would press

the Command + L keys (Command is sometimes known as the Apple key). Keyboard equivalents on Mac and PC are:

Macintosh	Windows	Example
Shift	Shift	Shift+X
Option	Alt	Option+X/Alt+X
Command	Ctrl	Command+X/Ctrl+X
Control+click	Right-click	Control+click/Right-click

All keystrokes are included in their entirety in the book, first Mac, then PC, separated by a slash (/).

The Leveraging Photoshop Layers Blog

The Leveraging Photoshop Layers blog (web log) is like a newsletter that helps keep you up to date on frequently asked questions, tips, and troubleshooting, as well as topics of interest (recent postings before the publication of this book centered on topics of color management). I post the blog so that anyone can read it. Subscribers get notified of all updates and new articles. Subscription is free, and the content is always available online. The frequency of posts and updates will be at least every two months, but may be much more frequent depending on activity on the web site. There are several ways to subscribe. You can sign up on the web site for the method that best fits your needs (http://www.photoshopcs.com) or you can subscribe with feed subscription services (e.g., http://www.feedblitz.com), RSS, or Atom reader.

Changes to Layers in Photoshop CS4

Several changes to CS4 have affected the use of layers, though core functionality remains mostly the same. Features that affect layers include:

- Adjustments palette shows settings for adjustments instead of floating dialogs;
- Masks palette for creating editable, feathered, density-controlled masks.

The Adjustments palette does not directly affect the performance of layers, but it does change the work flow some. You'll find you want to keep the Adjustments palette in a prominent place, like you might keep the Info or Layers palette, so that it will always be in view—or else you won't have a way to view your Adjustment layer settings!

The Masks palette offers some excellent control for masks that goes beyond the call of standard masking. You can blur for blending without affecting the content of your masks, and this can be readily substituted for any blurring mentioned in the exercises in the text.

Contacting the Author

I have been in the practice for years of supporting my books through the Internet via my web sites and forums and through email, which is not a common practice of authors—though it should be. I visit my sites and various forums online regularly. I am glad to answer reader questions and consider it an opportunity to add to explanations in the book and note areas that could use enhancement in future editions.

On the site, I keep a blog to keep readers abreast of questions that I get asked and answered, and I post errata (or a list of any errors and typos found after publication). I have also added a forum since the last version of the book and welcome discussion there. All this is meant to help you through any troubles you might have with the book and techniques. I provide these resources so that you can get legitimate answers direct from the source, rather than having to fish around in other forums or on other web sites where there is likely no one who knows the materials better than I do. However, you'll need to seek me out, as it is much more difficult for me to find you. If you have questions, it is likely that other people will have those same questions, too. Please feel free to ask as the need arises. Use the forums at photoshopcs.com.

To catch up on any information having to do with this book, please visit the official web site: http://www.photoshopcs.com. You will find links there to all the resources (forum, blog, troubleshooting, errata, etc.). Although you should visit the web site first as a primary resource, readers can also contact me via email using the following addresses: rl@ps6.com or thebookdoc@aol.com. Depending on volume, I respond personally to email as often as possible, and I look forward to your input.

The Basics of Layers: Layer Functions and Creation

For some reason, no one ever wants to be a beginner. It is as if some shame is attached to not inherently knowing the basics, even if you have never done something before. Many students in the Photoshop courses that I teach online assume they aren't beginners, and they jump into courses that are over their heads, for fear of the stigma of being a beginner. But everyone at one time or another is a beginner, and even savvy users sometimes learn from going over the basics.

Working with Layers starts with understanding some basics about layers, what they do, and how to locate all the functions. In this chapter we explore the Layers palette, see how all the basic layer functions are situated in the Layers palette and menus, learn how to create layers, apply layer functions, and use viewing preferences. We'll run through a hands-on no-knowledge-necessary example of using layers and see some of what layers can do. This chapter will help make sure we are all starting off with the same basic understanding of and familiarity with layers. With that introduction under our belt, we can look forward to applying layers to images.

Please note that although this book will look at many tools and features, it will focus on the explanation and exploration of using layers. Photoshop Help can provide more depth or information about tools and their applications not provided by the text of this book. To find Photoshop Help, click Photoshop's Help menu and choose Photoshop Help, or press Command+/ or Ctrl+/ (Mac or PC).

What Is a Layer?

Images are usually considered to be two dimensional. That is, when images get printed on a piece of paper or displayed on a screen, they have a height and width only. Although there may be an appearance of depth, there is no actual depth. The images are flat, and they lack that third dimension.

Whenever you view images fresh from a digital camera, the image is flat and two dimensional on your screen. This is true, even though the color image is actually stored as separate red, green, and blue (RGB) grayscale components in the file (see Figure 1.1). The components of your RGB image

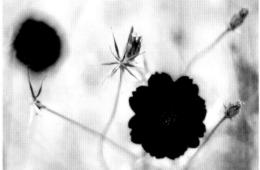

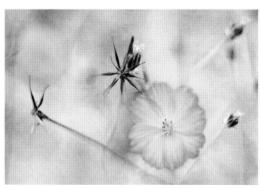

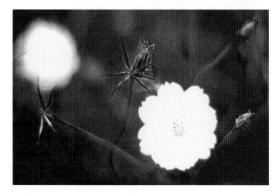

FIG 1.1 Though your color RGB images have separate red, green, and blue components, they appear as a single 2D composite color image on screen and in print.

are combined by the computer when the image is displayed, and the result is a two-dimensional color image rendered on your computer screen in full color. That is, several components (in this case the red, green, and blue light components) are combined to produce the color result.

In a similar way, multiple layers can combine and still result in a twodimensional image. Layers act as additions to your image that overlay one another as you add them to the layer stack (see Figure 1.2). These additions

are full color as opposed to the grayscale RGB components. When an image with layers is displayed in Photoshop (or Elements and other programs that can recognize images stored with layers) the result is still a two-dimensional image made from a composite of the layers (see Figure 1.3). Each individual layer stores complete RGB color that combines in two dimensions, as if you were looking down through the layers from the top of the layer stack.

Adobe called the virtual stacking of images "layers" because they act like a layered stack of transparent images. New image content is added to the original image and creates adjustments contained in distinct layers, building on changes over the original image content. Layer additions make change happen without changing the content below the new layer, and that is known as "nondestructive" editing: pixels from the original layers are virtually, rather than actually, altered. This ability to make additions to the image in layers keeps changes and alterations more fluid and movable, allowing you to finesse and sculpt the image result without "destroying" original image information.

Let's take a quick look at what this means in Photoshop by making a change to an image and experimenting a little with the advantages offered by layers first hand.

During Try It Now exercises, refrain from exploring palettes and images and taking detours from the steps as you are working through the exercise. I know it is easy to get distracted by shiny things. Clicking here or there during the steps may easily cause the step-by-step procedures to fail if you don't know what you are doing or how to return to the exact state of the image before your distraction/exploration. Explore after you've achieved success with the steps the first time. If it doesn't work the first time, give it a second try!

☐ Try It Now

- You could use any flattened image for this exercise, but open Sample_
 1.psd on the CD included with the book (see Figure 1.3).
- Choose the Paint Brush tool from the Tool palette, or press B on your keyboard to select the Paint Brush tool.
- Set your Brush options to a 100 percent hard brush, 20 pixels in diameter. Be sure the Flow and Opacity are 100 percent and the Mode for the brush is Normal (see Figure 1.4).
- 4. Create a new layer in the image. To do this choose Layer>New>Layer from the Layers menu at the top of the Photoshop program screen. The New Layer dialog will appear. Change the Name from Layer 1 to MyName, and click OK, leaving the rest of the defaults as is. A new layer will appear in the Layers palette, named MyName. (If the Layers

- palette is not showing on your screen, choose Layers from the Window menu. You will see a thumbnail, or smaller view, of Sample_1.psd in the Layers palette.)
- 5. Use the brush to write your name quickly in script right across the image by clicking and dragging the brush right on the image (see Figure 1.5). Your attempt at writing your name will come out on the MyName layer in the Layers palette.
- 6. Choose the Move tool by pressing V on your keyboard. Check the Options bar and be sure the Auto-Select box is not checked.
- 7. Click and drag on the image in a circle.

FIG 1.3 Sample_1.psd.

FIG 1.4 Open the Brush options shown here by clicking the brush in the Options palette at the top of the Photoshop program screen.

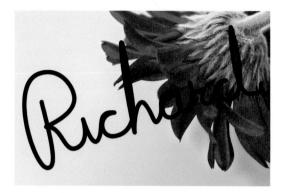

FIG 1.5 Your script may not be so neat depending on how comfortable you are with your input device, but neatness is not important for this example.

What should happen is that your name should move around the image without affecting the original background. You can move the signature wherever you want. Though we won't go this far right now, you could distort, rotate, and resize the signature without directly affecting the image below, as it remains in its own layer. If you shut off the view for the MyName layer (click the eye icon to the left of the layer in the Layers palette), you see the original image with no change. This is the core of nondestructive editing: image changes remain isolated from the original layer. But now let's be a little more destructive and see what happens without layers to compare the difference.

- 8. Press Command+E/Ctrl+E (Mac/Windows). This will merge the MyName layer with the Background.
- 9. Choose the Move tool by pressing V on your keyboard. The settings should be the same as in step 6.
- 10. Click and drag on the image in a circle.

You'll find you can't move the signature. This is a layer property of the Background—it is locked and will not move. You have to double-click the layer in the Layers palette (right on the thumbnail), and that will convert the Background to a layer (accept the defaults in the New Layer dialog that appears by clicking OK). Once you do that and try to drag the signature again, you'll drag the whole image. If you try to shut off the view you shut off the whole image. All parts of the image, at this point, have combined. In essence, that is Layers in a nutshell: you have separation between the correction and the result, and you can separate them at any time. This ends up being a huge advantage in editing your images. Layering allows you to work on distinct image areas while retaining new image information separately in new layers and original information in the Background below. This ability to retain original image information while building in changes separately is known as nondestructive editing; you retain the original image information undisturbed as you make changes by adding image layers. Each change is incorporated as if it were made on a transparent sheet over your image that can be removed

or reordered. The layers are stored separately in the working image file and when saved to layer-friendly formats (TIFF, PSD, PDF). During editing, layer content can be viewed and managed using the Layers palette (see Figure 1.6).

FIG 1.6 To open the Layers palette, choose Layers from the Window menu or press F7 to toggle the Layer palette view.

Create layers as needed, for infinite adjustments to your images, and store them with the image. When needed, copy layers within the current image and to other images. At any time, they can be adjusted and revisited for further changes. Each layer is a distinct visual object that can fill the entire image plane, though the visibility of individual layers and layer content is affected by layer properties such as Mode, Opacity, Masking, Clipping, and Visibility. These give the user flexibility in incorporating layer content.

Whereas the basic functionality of layers simply allows you to keep image content and changes separate, the separation allows you the advantage of customizing how image areas combine. Control gives you advantages that allow you to achieve results that would otherwise be impossible or extremely difficult in an image without layer capabilities. Each of these capabilities will be explored through the examples and exercises in this book.

Layer Palettes and Menus

One of the keys to making use of layers is using layer functions. The bulk of the layer functions are found between the Layers palette, the Layers palette menu, the Layer menu, and Layer Style dialog. NOTE: Menus are listings of functions and features by name that can be selected with a click. These menus may be on the main program menu bar, but they may also be attached to palettes or other menus as submenus. Palettes (and dialogs) differ from menus in that they are floating windows that may have buttons or other graphical interface options that go beyond just a listing of features by name.

The Layers palette (see Figure 1.7) is really a command center for controlling layer views and how layers combine. Open the Layers palette by choosing Layers from the Windows menu.

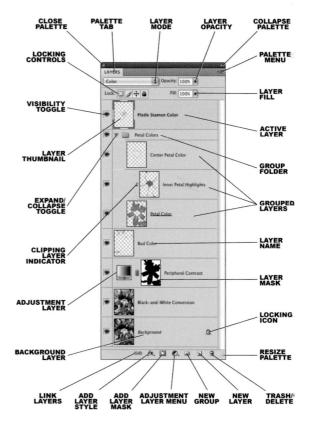

FIG 1.7 This diagram outlines the major features found on the Layers palette. Keep in mind where this is for referencing features.

Simple buttons on the palette allow you to access many powerful features at a click. For example, you can toggle the visibility for individual layers on or off, add effects, create new layers, duplicate layers, and delete them. Other button features allow you to lock layer transparency, color and transparency, position, or the entire content of the layer (transparency, color, and position). For a listing of Layers palette features see Table 1.1.

 TABLE 1.1
 Layers palette features.

lcon	Button	Function
44	Minimize Palette	Toggles the palette to expanded/ collapsed views. Behavior varies depending on whether the palette is docked or floating.
	Close Palette	Available on floating palettes only. Closes the palette.
Normal 🛟	Blending Mode	Blending Mode allows selection of modes to control how layers interact
✓ Normal Dissolve		with layers below.
Darken		
Multiply		
Color Burn		
Linear Burn		
Darker Color		
Lighten		
Screen		
Color Dodge		
Linear Dodge (Add)		
Lighter Color		
Overlay		
Soft Light		
Hard Light		
Vivid Light Linear Light		
Pin Light		
Hard Mix		
Difference		
Exclusion		
Hue		
Saturation		
Color		
Luminosity		
Opacity: 100%	Layer Opacity	Opacity controls the transparency of the entire current layer from 0 to 100%
iili: 100% 🕨	Layer Fill	Similar to Opacity. Fill affects only the content of the layer; layer styles are not affected.

(Continued)

TABLE 1.1 (Continued)

lcon	Button	Function
New Layer 企業N Duplicate Layer Delete Layer Delete Hidden Layers	Layers Palette menu	Accesses the context-sensitive Layers palette menu. Items available on the menu vary depending on the currently active layer(s).
New Group New Group from Layers		
Lock All Layers in Group		
Convert to Smart Object Edit Contents		
Layer Properties Blending Options Edit Adjustment		
Create Clipping Mask 飞器G		
Link Layers Select Linked Layers		
Merge Down		
Animation Options Panel Options		
Close Close Tab Group		
3	Lock Transparent Pixels	Locks layer pixel transparency. Restric change to color/tone only.
B	Lock Image Pixels	Locks layer pixel transparency and color/tone.
+	Lock Layer Position	Locks layer position. Transparency and color/tone can still be changed or adjusted.
a	Lock All	Locks transparency, color/tone, and position of layer content.
9	Layer Visibility Toggle	Shows/hides the content of the associated layer.
3	Link Layers	Allows layer linking. Linking allows movement or transformation of the content of more than one layer at a time. Will also maintain alignment

TABLE 1.1 (Continued)

lcon	Button	Function
fx_ Blending Options	Add Layer Style	Allows users to add a layer style to the active layer by selection from the Layer Style menu.
Drop Shadow Inner Shadow Outer Glow Inner Glow Bevel and Emboss Satin Color Overlay		
Gradient Overlay		
Pattern Overlay		
Stroke		
	Add a Mask	Adds a layer mask to the active layer if there is not one. If there is already a layer mask, adds a vector mask. If there are both or the layer is a Background layer, this is disabled.
0.	New Adjustment Laye	image based on selection from the
Solid Color		menu that appears.
Gradient		
Pattern		
Brightness/Contrast		
Levels		
Curves		
Exposure		
Vibrance		
Hue/Saturation		
Color Balance		
Black & White		
Photo Filter		
Channel Mixer		
Invert		
Posterize		
Threshold		
Gradient Map Selective Color		

(Continued)

TABLE 1.1 (Continued)

lcon	Button	Function
	Create a New Group	Adds a new empty layer group above the active layer if clicked. If layers are dragged to the button, a new group is created with those layers in it.
٦	Create a New Layer	Adds a new blank layer above the currently active layer when clicked. If layers are dragged to the button the layers are duplicated.
9	Delete Layer	Deletes active/selected layer(s) when clicked. Layers dragged to the button are deleted.
.di	Resize Palette	Click and drag on this to change the size of the Layers palette.

Photoshop's Layers palette menu and the program's Layer menu share much of the same functionality, with a few exceptions depending on the current editing task. Both menus are context sensitive, meaning that available functions appear depending on what features can logically be applied. Options are grayed out when not available. Although functions on the menus represent many of the same things, accessing those functions in different ways may affect how layers are created and handled in the image.

It is not necessary to memorize all the functions and menus; there will be layer functions you rarely use and those you will perhaps never use. Those you use frequently will become automatic and are likely already attached to shortcuts that you will learn out of habit. The graphic reference to the functions (Figure 1.7) will prove to be a handy guide if you are not very familiar with layers. What is more important than memorization is to know what type of functions are available and generally where they can be found and what type of access the program provides to those functions. That way even if you don't know the exact tool or function, you at least know where it can be located. Rolling over tools and icons on the palettes in Photoshop will reveal tool tips that name the item/function, and using these actively in the program as you edit will help you become familiar with all the functions in context.

There will be occasional mention of version-specific features in exercises (including features in newer Photoshop versions); however, in most cases if you are using an older version of the program or even Photoshop Elements, it will not have an impact on your work with images or completion of the exercises in this book or use of the book's techniques.

Types of Layers

There are several distinct types of layers that can be created in your images. All layers are visible in the Layers palette, though some (Adjustment layers, Type layers, and layer groups) are represented by icons. The types of layers are listed in Table 1.2.

TABLE 1.2 Types of layers.

Layer Type	Description	Comments
Background layer	Specialized content layer that is the dedicated background for the image. The bottommost layer of an image; the result of a flattened image. These layers are always locked, have no mode, and are always 100% opaque. Can be converted to a regular layer by double-clicking.	Background layers have little to do with the photographic notion of "background" in that the content is not necessarily just image background information and shouldn't be assumed to isolate this image area. Most images start with just a Background layer.
Type layer Specialized content layer that contains editable type. Type layers are automatically added by application of the Type tool by clicking on the image or clicking and dragging (to form a type box). Type layers can be masked, used with applied blending modes, and varied in opacity/fill.		The editable type in a Type layer is what sets it apart. Once a Type layer is rasterized (turned into a bitmap) it becomes like any other content layer—it just happens to be in the shape of type, type that isn't editable, but has other advantages.
Fill layer	Layers that apply color fills, gradients, or patterns. These are created using the Layer>New Fill Layer submenu. Fill layers can be masked, used with applied blending modes, and varied in opacity/fill. Because they contain content, they can be converted to a Background layer.	Fill layers are closely related to Adjustment layers and Type layers. They have content (color, gradient, pattern), which makes them distinct from Adjustment layers, yet the content can be edited only through a dialog, which makes them much like Adjustment layers.
Adjustment layer	A layer that applies a specific function to underlying layers in the layer stack. These are specific functions created using the Layer>New Adjustment Layer submenu or by clicking on a Create button for a specific Adjustment layer type in the Adjustments palette. Adjustment layers can be masked, applied using layer modes, and varied in opacity/fill. They cannot be converted to a Background layer.	Adjustment layers have no content of their own. They represent calculations and are very useful for applying nondestructive adjustments in the form of levels corrections, color balance, hue/saturation, etc., all of which can be adjusted or undone at any time during editing. All Adjustment layers can be masked as well to provide control over how the adjustment is employed in a given image.

(Continued)

TABLE 1.2 (Continued)

Layer Type	Description	Comments
Layer Groups	A folder in the layers structure that can be used to group layers (or other groups) and is an organizational tool. Grouping allows all layers in the group to be treated like a unit so that they can easily be moved, viewed/hidden, or masked as one. Groups can be created and yet contain no layers that will affect change.	Originally introduced as Layer Sets with Photoshop 7, the name was changed to Groups with Photoshop CS. A Group can denote an organizational vehicle (grouping a set of changes) or be a means of controlling a set of layers as one unit. This is the only layer in the Layers palette that may have no content whatever.
Clipping layers, Clipping group, Clipping mask	Clipping layers are made up from at least two layers that have been grouped using the Create Clipping Mask feature. The bottommost layer in a clipping group acts as a Background layer for the entire clipping group. The solidity of the Clipping layer controls what is revealed in the layers that are clipped (added to the clipping group). These work like cookie cutters for which the bottom layer is the mold.	One of the least well-defined common layer functions. I find it the most useful quick-targeting feature in Photoshop Layers functionality. Allows users to mask instantly any layer with the solidity of another. Once you start thinking in layers, this is an oft-used tool.
Smart Objects Smart Objects group layers together and save the object (one or more layers) in another image (PSB file type) that is referenced by the current image. This can reduce image file size, but may be more useful for updating several files at once.		An interesting use of Smart Object is to have consistent graphic elements in several images, such as doing portraits for a Little League team where the look of each card is the same. You can create the graphic card component, then save it and import it to multiple images.
Video layer	Allows incorporation of video clips into images. Works much like a Smart Object referencing an external video file.	Added in Photoshop CS3. Not terribly useful for image editing.

The distinction between Background and normal layers is an important one. Background layers serve a distinct purpose as the base for your images while simultaneously losing a lot of the functionality of free-floating layers. Certain tools will behave differently when applied to Backgrounds and other tools cannot be applied at all. For example, the Eraser tool will erase to the Background swatch color rather than transparency as it would in other layers. You cannot apply a layer mask to the Background layer.

The above reference is just a quick look at the vast capability of layers. Handson experience with layers in realistic situations will familiarize you better with how to look at and control layer content and the advantages they provide

for editing images. That is the purpose of the rest of the book. Before getting into creating your first layers, let's take a quick look at controlling what you see on the Layers palette by reviewing layer viewing preferences, and then we'll practice making a few layers.

Layer Viewing Preferences

Layer viewing preferences determine how you see thumbnails in the Layers palette. Set these preferences on the Layers palette menu. To get to the Layers palette menu, open the Layers palette; it helps to have an image open as well so you can see the differences resulting from changing the settings.

☐ Try It Now

- 1. Open any image in Photoshop.
- If your Layers palette is not already in view, choose Layers from the Window menu.
- Click on the Layers palette menu button at the upper right of the Layers palette.
- 4. Choose Panel Options from the menu that appears. The Layers Panel Options dialog will appear (see Figure 1.8).
- Choose your preference for the size of the thumbnail that you prefer to view.

FIG 1.8 Layers Panel Options.

Either the second or third option from the top is recommended for thumbnail viewing. This will allow you to get an idea of layer content without taking up too much of your screen. No view will prove to be completely adequate when trying to distinguish layers. Although the largest thumbnail gives the best view of the layer content, it may prove to be too large for many of the exercises in this book, as the layers will cascade off the screen. The None option will take up the least amount of screen landscape, but will make you rely entirely on layer naming, which negates the value of visual cues.

You can change this option at any time; it applies to the palette, and not to actual layer content.

Getting Started Creating Layers

There are many ways to create new layers in Photoshop, and the methods serve different purposes. **Table 1.3** describes various methods and the most common techniques to execute them.

TABLE 1.3 Methods to create new layers in Photoshop

Function	How To
Duplicate layer	 Drag any layer (including the Background layer) to the Create a New Layer button. This creates a duplicate layer and adds the word "copy" to the right of the new layer name. Choose the Duplicate Layer command from the Layers Palette menu or Layer menu. Creates a duplicate and adds the word "copy" to the new layer name. From the top menus choose Layer>New>Layer Via Copy or press Command+J/Ctrl+J (Mac/PC) with no selection active. Creates a duplicate and adds the word "copy" to the new layer name. With two images open, click on a layer in the Layers palette and drag to the currently inactive image. Hold the Shift key on the keyboard while dragging to center the image in the image you are dragging it to. Creates a new layer in the second document with the same name as the layer in the originating document.
Blank layer	 Click the Create a New Layer button. Creates a new layer with the default name Layer # (where the numbers are sequential, starting with 1). Choose the Layer>New>Layer command from the Program menu or New Layer from the Layers Palette menu. Creates a new layer with the default name Layer # (where the numbers are sequential, starting with 1).

TABLE 1.3 (Continued)

Function	How To
Layer via copy	 Create a selection and then copy (Command+C/Ctrl+C) and paste (Command+V/Ctrl+V). Creates a duplicate of the selected area in a new layer with the default name Layer # (where the numbers are sequential, starting with 1). Choose Layer>New>Layer Via Copy or press Command+J/Ctrl+J with a selection active. Duplicates selected area to a new layer with the default name Layer # (where the numbers are sequential, starting with 1). Press Command+Option+Shift+E/Ctrl+Alt+Shift+E. Merges visible layer content to a new layer with the default name Layer # (where the numbers are sequential, starting with 1). The new layer appears above the currently active layer (if a layer is active) or at the top of the layer stack.
Layer from Background	 Double-click the Background layer in the Layers palette. Converts the Background layer to a nonbackground layer. The new layer will be created from the Background with a default name of Layer 0. Choose Layer>New>Layer from Background. Converts the Background layer to a nonbackground layer. The new layer will be created from the Background with a default name of Layer 0.
New Background layer	 Choose Layer>New>Background From Layer. This changes the active layer to the Background layer. The command is available only if a Background layer does not already exist in the image.
Adjustment layer	 Choose one of the New Adjustment Layer submenu options from the Layer menu (including Levels, Hue/Saturation, Invert, etc.). A New Layer dialog will open, allowing you to change Name, Clipping, Color, Mode, and Opacity. Once you accept the New Layer option by clicking OK, the Adjustment layer options will appear in the Adjustments dialog. Choose any of the Adjustment layer options from the Create New Adjustment or Fill Layer menu off the Layers palette. The Adjustment layer options will appear in the Adjustments dialog. Click any of the Adjustment layer buttons on the Adjustments palette. The Adjustment layer options will appear in the Adjustments dialog.
Fill layer	 Choose any of the New Fill Layer submenu options from the Layer menu (Solid Color, Gradient, Pattern). A New Layer dialog will open, allowing you to change Name, Clipping, Color, Mode, and Opacity. Once you accept the New Layer option by clicking OK, a function dialog will appear as appropriate. Choose any of the Fill layer options from the Create New Adjustment or Fill Layer menu off the Layers palette. The Adjustment layer options will appear in the Adjustments dialog. Choose the Shape tool, then be sure the Shape Layers option is selected on the Option bar (use mouse tool tip to find the button for the option). Click and drag on the image.

(Continued)

TABLE 1.3 (Continued)

Function	How To
Type layer	 Choose the Type tool and click on the image. This creates a new Type layer. Use the keyboard to enter text once the cursor appears. The Type tool can be used in combination with vectors to make type on a path and with shapes to make text in a shape.
	 Choose the Type tool and click and drag on the image. This creates a new Type layer and creates a text box that will contain the text that is entered. Use the keyboard to enter text once the cursor appears.

Try It Now

- 1. Open a new image that is 500 \times 500 pixels in RGB with a transparent background.
- 2. Use the options in Table 1.3 to create all of the layer types.

If you take a moment and sit down in front of the computer and run down the bullet list, you can test out creating all these new layers. Of course there are reasons to create layers, but right now gain some familiarity with the basic creation methods. This will help you locate them later when you need them, and play is a great way to become familiar and comfortable with creating layers. It won't be long till we are immersed in serious layer work!

If you do go through the exercise of creating the layers, you'll notice that different layer types are created with different icons in the Layers palette. Table 1.4 shows the icons and what they mean.

At this point we have dissected enough of the Layers palette and the things that you will see there to have a reasonable orientation as to what to expect.

TABLE 1.4 Identification of various layer icons.

lcon	Layer Type
	Black and white
* Ø:	Brightness/contrast
3	Channel mixer
50	Color balance

TABLE 1.4 (Continued)

lcon	Layer Type
	Curves
*	Exposure
	Gradient
	Gradient map
	Hue/saturation
	Invert
	Levels
	Pattern
	Photo filter
	Posterize
	Selective color
	Solid color
	Threshold
Т	Туре
V	Vibrance

Exercise

Running through the bullet list and creating random layers in a stack may be interesting, but not nearly as interesting as working through a practical example. In this exercise, we will take an image, add a copyright, burn in the frame, and add a drop shadow using some simple layer creation and techniques. The exercise is a fairly easy, more or less practical run-through of some layer creation techniques that will take about 15 minutes and requires little or no understanding of layers. This is meant to be a glimpse into layer functionality; although there is some explanation of what is going on during the exercise, better understanding of the features we are looking at will come as we explore the possibilities of layers throughout the rest of the book.

There is almost always more than one way to execute a set of steps to accomplish a result in Photoshop. Though you may usually use different methods, even for simple steps, it is suggested that you follow the steps as written the first time you run through any exercise in this book—especially when a specific means of accessing a function is suggested. Experimenting with other methods may yield somewhat different or confusing results. If an option or function step is not specifically mentioned, it is left up to you to choose.

Try It Now

- Open any image and flatten if necessary (Layer>Flatten Image). The image should have only a Background layer when viewed in the Layers palette. Use Sample_2.psd off the CD if you need an image to use.
- Flattening is not something you will do all the time when opening images—quite the opposite. We flatten the image here at the beginning of the exercise to simplify the image and to have a common place to start our steps.
- Double-click the Background layer. This will open the New Layer dialog (see Figure 1.9).

FIG 1.9 The New Layer dialog with default name

3. Change the layer name from Layer 0 to "1 Original Background" by typing in the Name field. Click OK to accept the changes (Figure 1.10).

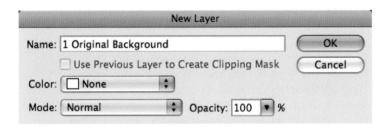

FIG 1.10 The New Layer dialog with changed name.

- Set the Background swatch color to white. To do this press D on the keyboard (sets default colors). This color selection will affect the results of the next steps.
- Create a new layer (click the Create a New Layer button on the Layers palette). This creates a new layer above the 1 Original Background layer named Layer 1.
- Make the new layer into the Background layer by choosing Background From Layer (Layer>New>Background From Layer). This will change the layer to a Background and fill with white. The name of the layer will change to Background.
- 7. Choose Canvas Size from the Image menu. When the dialog appears, choose the options shown in Figure 1.11: New Size: Width: 120 percent (choose from the menu in the dialog box), New Size: Height: 120 percent. Be sure the Relative box is not checked, leave the Anchor (white box in center) at the default, set the Canvas Extension Color to Background. Click OK to accept the changes. This will create a white border around your image.

FIG 1.11 The dimensions for the Current Size will be based on the image you have open and will likely be different from what you see here. The settings you will change are below the top panel.

Canvas Extension Color was new as of Photoshop CS3.

Background is the default for earlier versions, so there is nothing to change in CS2 and previous versions of Photoshop.

- 8. Choose the Type tool by pressing T on your keyboard.
- 9. With the Type tool selected, choose a font and font color for a copyright from the Options bar. If you don't know what to choose, pick Arial, Regular, 12 pt, and black. Change these options on the Options bar, located near the top of the Application Frame, or just under the program menus. See Figure 1.12.

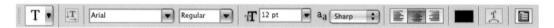

FIG 1.12 If you are having trouble locating the Options bar be sure Options is checked in the Window menu. If it is checked and you still can't locate the bar, uncheck, and then check it again, watching near the top of the screen as you do so. You should see it hidden and then replaced on screen.

- 10. Click on the 1 Original Background layer in the Layers palette to activate it and then click on the image with the Type tool. This will create a new Type layer in the Layers palette just above the 1 Original Background layer, and a blinking cursor will show on the image.
- 11. Type in "Copyright © 2009 [your name]", click the Commit Any Current Edits button on the Type Options bar, and move the copyright to a place in the image that seems suitable using the Move tool. To choose the Move tool, click the Move tool on the toolbar, or press V on your keyboard.

To get the copyright symbol, press Option + G on a Mac; on Windows, hold down the Alt key and press the following keys on the number pad in order: 0, 1, 6, 9. Then release the Alt key. If this does not work immediately or if you have a keyboard with no number pad, turn on the Num Lock feature from the keyboard (press the Num Lock or similar button). For more information about Num Lock on PCs, consult your computer's user manual. Laptop users may need to consult their owner's manual for operation of special keys.

12. Change the name of the Type layer you just created by adding a 2 to the beginning of the name. To do this, choose Layer Properties from the Layer menu or the Layers palette menu. Once you have completed the name change click OK to accept the changes. At this point your layers should look similar to Figure 1.13.

FIG 1.13 As you build on additions to the image, the layer stack grows, helping you keep each addition separate and in order.

- 13. Create a new layer at the top of the layer stack, and name the layer "3 Frame Burn".
- 14. Hold down the Command/Ctrl key (Mac/PC) and click directly on the thumbnail image in the Layers palette for the 1 Original Background layer. This will load the solid part of that layer as a selection. You should see the selection in the image as a marquee traveling around the original image.
- 15. Invert the selection (press Command+Shift+I/Ctrl+Shift+I).

Expression Research R

16. Fill the selection with black on the 3 Frame Burn layer. To do this, be sure the 3 Frame Burn layer is active, choose Fill from the Edit menu, and when the Fill dialog appears choose these options: Use: Black; Mode: Normal; Opacity: 100 percent. Do not check the Preserve Transparency checkbox. See the dialog in Figure 1.14 for the Fill dialog. Click OK to accept the changes. This will fill the frame area with black.

FIG 1.14 Use these settings for step 16 of the exercise.

- 17. Deselect by pressing Command+D/Ctrl+D. Deselecting ensures you will apply the next changes to the whole image.
- 18. Move the layer down in the stack by pressing Command+[/Ctrl+[. This will switch the order of the 2 and 3 layers.
- 19. Apply a Gaussian blur to the layer. Choose Gaussian Blur from the Blur submenu on the Filter menu (Filter>Blur>Gaussian Blur). Set the Radius to 30, and click OK to accept the changes.

The size of the blur radius will be more or less effective depending on the original size of your image. Use 30 for your radius for smaller images (1000 \times 1500 pixels, like the sample I provided), 50 for medium images (2000 \times 3000 pixels), and 70 for large images (3000 \times 4500 pixels).

- 20. Press Command+Option+G/Ctrl+Alt+G or choose Create Clipping Mask from the Layer menu. This will create a Clipping layer from the 3 Frame Burn and the 1 Original Background layers. Your layers should look like Figure 1.15 after completing this step.
- 21. Change the Opacity of the 3 Frame Burn layer to 40 percent, and change the Mode to Multiply using the Mode drop list and Opacity slider on the Layers palette. Lowering the Opacity will lessen the effect of the change.

FIG 1.15 Clipping mask layers are identified in the Layers palette by underlining the name of the base layer (in this case layer 1 Original Background) and indenting other layers in the mask (in this case 3 Frame Burn). Only one layer can be used as the base, but many layers can be included in the mask stack.

- 22. Click on the Background layer to activate it.
- 23. Create a new layer, and name it "4 Drop Shadow". Because you activated the background before creating the layer, it will appear in the layer stack just above the Background.
- 24. Hold down the Command/Ctrl key and click on the 1 Original Background layer thumbnail in the Layers palette to load it as a selection.
- 25. Fill the 4 Drop Shadow layer with 50 percent gray. Use the Fill function from the Edit menu, and change the Use drop list under Contents to 50 percent gray. This will fill in color under the 1 Original Background layer and no change should be apparent in the image.
- 26. Deselect, Command+D/Ctrl+D. This will release the selection.
- 27. Choose Gaussian Blur from the Filter menu (Filter>Blur>Gaussian Blur). When the Gaussian Blur dialog appears, use a radius of 20 pixels, and click OK to accept the changes. This will soften the edges of the 4 Drop Shadow layer. Again the amount you blur will depend on the size of the image if you are using an image other than the sample provided. At this point, the layers should look like Figure 1.16.

FIG 1.16 The complexity of the image is building, and so is the number of layers used to store the changes.

- 28. Choose the Move tool (press V), and move the 4 Drop Shadow by holding down the Shift key and pressing the right arrow on the keyboard twice and then the down arrow twice. Release the Shift key. This action will have moved the content of the current layer 20 pixels down and 20 pixels right.
- 29. Click on the 4 Drop Shadow layer in the Layers palette to be sure it is the active layer in the image and then make a Hue/Saturation Adjustment layer by choosing Hue/Saturation from the New Adjustment Layer submenu on the Layer menu (Layer > New Adjustment Layer > Hue/Saturation). When the New Layer dialog appears, click the Use Previous Layer to Create Clipping Mask checkbox and change the name of the layer to "5 Drop Shadow Color" before clicking OK. The Hue/Saturation dialog will appear in the Adjustments palette.

The Adjustments palette is brand new to Photoshop in CS4. The palette should make completing adjustments more efficient than in previous versions by continuously providing access to active dialogs rather than requiring clicks to accept changes.

30. Click the Colorize box and adjust the Hue, Saturation, and Lightness sliders to adjust the color of the drop shadow to something pleasing. Moving the Hue slider (right or left) will change hues as if they are on a color wheel. Moving the Saturation slider to the right will increase saturation; moving it to the left will decrease saturation. Moving the Lightness slider to the right will lighten the shadow; moving the slider left will darken the shadow. Click OK to accept the changes. Your layers should look like Figure 1.17.

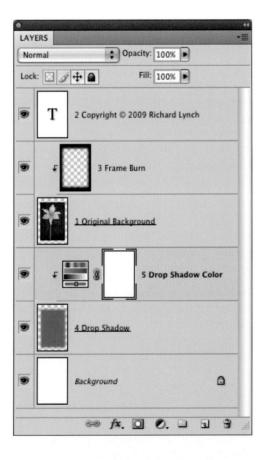

FIG 1.17 You should now have six layers from the top down (by name): 2 Copyright Text, 3 Frame Burn, 1 Original Background, 5 Drop Shadow Color, 4 Drop Shadow, and Background.

The Use Previous Layer to Create Clipping Mask checkbox has been named different things in almost every other version of Photoshop. It is the only checkbox on the New Layer dialog, and it always does the same thing: it creates a clipping group from the layer you are creating. See the Types of layers in Table 1.2 for more information.

If you really want to test out your understanding of layers thus far see if you can accomplish the following. Don't worry if you can't complete all the items in this list, some of this will be discussed in the upcoming chapter.

- Change the color position and face of the type in the Copyright layer.
 Hints: double-click the Type layer in the Layers palette to select all the type, use Hue/Saturation like you did in later steps for colorizing the drop shadow, or use the options on the Options bar.
- Make a group from the foreground layers you created (2 Copyright Text, 3
 Frame Burn, 1 Original Background).
- Activate the 5 Drop Shadow Color layer, and merge down to commit the color change and reduce the number of layers in the image.

Summary

We looked at a lot of things in this chapter, from the basics of what a layer is to how they are applied. You should have had the opportunity to explore the palettes and menus with which layers are created and manipulated and gained a more comprehensive visual conception of what layer functions look like as part of the palette. We've looked at the possibilities of adjusting how the Layers palette displays and have explored the initial possibilities of creating layers, as well as working through an example of how you might use layers to effect change in an image.

You are invited to ask questions of the author now or at any time in your exploration of this book and materials. The web site photoshopcs.com is dedicated to this book and meant to support readers. It includes additional techniques, a forum, a blog, contact information for Richard, and more.

The core purpose of this chapter is introductory. Now that you have seen some of what layers can do, let's move on to learning how they help you manage your work flow and form the basis of your image editing process.

Layer Management: Concepts of a Layer-Based Work Flow

The greatest benefit to using Layers is that you get tremendous flexibility in controlling image changes and the ability to revisit, adjust, and view changes at any time later in the correction process. You can also store the changes to see what you did and create techniques by examining your process. The biggest drawback to layers—other than learning to harness the tremendous number of options—is bulking image file size and organizing an ever-lengthening layer stack. This chapter looks at how to use layers as a means of managing your approach to correcting images and keeping those changes organized by incorporating layers as the core of your work flow.

Talking about managing layers before talking about using them is really a chicken and egg scenario: it could be argued that it is more important to know what to do with them than how to manage them. However, my thought is simply this: start with good fundamental practice in using layers, and it will be more natural to use them in a way that is most beneficial to your images.

Managing layers starts with knowing how to create them—which we looked at briefly in the previous chapter—and continues with knowing how and when to combine them to save file size and to group and arrange them to

keep them and your image corrections effective and organized. Making the effort to keep things organized may take a little more time at first, but, like all maintenance and organization, will help in the long haul to keep you on track and becomes more natural as you do it consistently. For example, when you make a meal, you might follow a recipe. This can save you from goofing up dinner entirely. Along the way you might make some adjustments to taste depending on your level of confidence, or depart from the recipe entirely once you are sure of what you are doing. The recipe acts like a fallback or outline of a basic plan.

When you follow an organized plan for using layers, they end up being not only a means of correction and an organizational tool for those corrections, but a means of driving corrections, organizing the correction work flow, acting as a history of image correction and ultimately as a device for learning about image corrections and what is successful. Effectively managing layers and layer content will help keep your corrections on track, will allow you the flexibility to step back and forward in corrections, and will keep your images from bulking up to ridiculous size unnecessarily. Just like a recipe, layers act as a plan for getting to where you want to go, while keeping you safe from damaging the original image content.

To look at Layers as part of a total process, we'll begin with an outline of an approach to image editing. Then we'll look at more theoretical applications of layers for organization and image correction and how layers factor into and direct the process of correction.

The Outline for Image Editing

For the sake of putting layers in the context of process, we'll look at a complete outline for processing images from beginning to end. Layers are crucial to every stage of correction. Our outline will look a bit beyond just the process of correction to be sure the process is considered from end to end: from monitor to print. Consider this outline as your plan for editing images and use it as a road map in making all your image corrections—especially if you do not have your own plan in place.

The steps to image editing include several distinct parts:

- Setup
- · Capture
- Evaluation
- Editing/correction
- Purposing/output

Setup encompasses all the necessary steps for preparing your equipment (computer and photographic) for capture, image editing, and output. Capture is exposing/gathering your digital source images as files to use in editing and output. Evaluation is looking at the images and considering what you will do with the image and the steps you will be taking in correction. Editing and

correction is manipulation of the source image captures according to your evaluations and in preparation for output. Purposing and output encompasses all manner of final use of images in display, in print to different media and processes (inkjet, offset, light process), or for a monitor (web pages, video). Although layers are involved directly only in the editing stage, the other stages all affect the choices you make in the correction and editing stage, so it is valuable to have a guick look at the entire process in more detail.

Setup

Setup is everything you need to do to prepare for image editing: being sure your capture device, system, and editing program are set up correctly and that you have considered the purpose or use of the image. This is important to ensure you will get the results you want.

- Be sure your computer system is ready for image editing with Photoshop.
 You will need to consider the requirements for running Photoshop, such
 as how much RAM your computer has, the speed of the processor, and
 generally the ability of your computer system to handle the demands of
 image editing. Check the requirements (find these on the packaging or
 on the Adobe web site). You will also want to have significant free disk
 space and establish a backup routine for images (and have the appropriate
 media on hand). Concerns for your computer setup may extend to having
 a firewall in place, virus protection, and image-editing input devices
 (mouse, trackball, graphic pen).
 - You are not limited to using a mouse when editing images, and other devices may be more to your liking. Image-editing input device possibilities include trackballs (http://aps8.com/trackball.html) and graphic pen/tablet combinations (http://aps8.com/wacom.html). I rarely use a mouse for serious image editing.
- Calibrate your monitor, and create a custom ICC profile. A custom profile is
 usually made during the calibration process done with calibration systems.
 The profile helps Photoshop compensate for color display. Calibration is an
 essential step in color management and matching what you see on screen
 to what will appear in print and on other monitors.
 - Calibration devices such as the ColorVision Spyder 2 Pro (http://aps8.com/spyder.html) can simplify calibration, make it more accurate, help manage ICC profiles, and make color management less of a chore.
- Set up Photoshop. This includes setting up color management preferences, preferences for scratch disks/memory usage, and testing output. Photoshop is a memory hog, and it is not unheard of to dedicate a hard drive to the

- sole purpose of being a Photoshop scratch disk. Giving Photoshop a lot of room to do what it does ensures your best chance of getting the results you intend consistently and that your system functions optimally.
- Have a system for archiving. Be prepared to archive the original image files safely when you download them from the camera and before you begin work on them. This may require consideration of archiving media and equipment. Archiving is crucial to a safe work flow in which you always work with a copy of an image to do all of your image editing and safely store copies in case of drive failures or other catastrophic loss. If any step in the editing goes awry, or you lose an image, you will want to be able to return to the original image to start over. Working on copies will also give you the opportunity to "repurpose" the original in the future or take advantage of new and emerging technologies that might help you get more from the original image capture. DVD drives, CD-ROM, RAID arrays, tape backup, external drives, and even online storage can all be considered in keeping your images safe.
- Consider the final purpose of your images. Resolution, size, color, file type, and
 purpose all affect the final result. This can affect your other choices in setup.
 You may work at different resolutions and in different color modes throughout
 the image-editing process for specific purposes, but knowing what you need
 from the outset of the project can help you work smarter, with less possibility
 of getting into situations in which you compromise image integrity.
- Be prepared to make the best use of your camera. Know your camera settings and controls. Nothing will do more to help you get the best shot than knowing how to work your camera. This will include becoming familiar with your camera's unique settings. If you use accessories, knowing how they function is important as well. One of the most important accessories for any piece of equipment you own is the owner's manual. Be sure to put yours to good use, and read it several times from cover to cover—or at least those sections written in your own language! Remember to bring all necessary equipment if you'll be shooting in the field: have ample memory on hand, to take all the shots you want, and ample power (several sets of new or newly charged batteries).
 - I have several 4 or 8 GB cards on hand whenever I shoot (see http://aps8.com/4gb.html or http://aps8.com/8gb.html). In addition I carry an 80 GB Wolverine portable hard drive that reads seven types of memory card and can be powered by battery (http://aps8.com/wolverine.html). Between these, I can store about 12,000 shots without downloading to my computer.
- Learn about scanner features and scanner software. Software and features
 on scanners can often vary drastically between makes and models. Just
 like being familiar with your camera and settings, knowing what your
 scanner model can do and your options for scanning will help you get the

most from the images that you scan. If using a scanner, again, make friends with your manual. Color calibration and profile building specifically for the scanner may also be appropriate steps to take at the point of setup.

Capture

With setup completed, you will want to take the utmost care in the actual capture of your images so that the result will be the most useful and of the highest quality. Starting with the best source image leads to the opportunity to achieve the best result.

- Take command of your camera to get the best shot. This includes working
 with settings such as aperture and shutter speed, as well as controlling
 other qualities of capture such as depth of field and framing. Proper
 settings extend to the use of other accessories, such as flash, and also
 mechanics like holding the camera perfectly still as you press the shutter
 or moving evenly as you track to follow motion or create special effects.
 Knowing the settings is only half the battle; practice in using the modes
 and settings and creating interest in your captures will improve your
 photographic technique and enhance the improvements possible with
 Photoshop. There is nothing that can substitute for good source images.
- Capture additional frames. Don't be afraid to snap the shutter with your camera pointed at any subject that you might later use for retouching, compositional changes, or enhancements. If you don't take a photo, you will not have the source to work with. For example, if shooting a group portrait you might take three to five shots of the group to be sure smiles are in place, eyes are open, poses are acceptable—you want to capture enough source images to make necessary enhancement and replacement easy. If shooting a high-contrast scene, you may want to make one exposure for the highlights and one for the shadows so you can merge the results later. Don't be too quick to delete potentially useful images just because they are not perfect in preview. You should have plenty of memory for more images (take a second look at your steps for preparation), and weed out the clunkers in Photoshop, in which you can give them a fair look.
- Control scanner settings to get the best scans. Settings for optimal scanning
 will often be achieved manually or via some manual intervention. In the
 case of scanning, resolution, color mode, white point, and more may be
 choices you will need to make to optimize results. Most scanners have auto
 modes, but the best scans are often made with scanners that allow manual
 adjustment during the process of scanning.
 - If you intend to scan nondigital images, be sure that you have the scanner you need to do the job. Using a flatbed scanner for printed images is fine, but I've yet to see quality scans of negatives or slides even from quality flatbeds using a transparency adapter. Dedicated slide and negative scanners have come way down in price, and a dedicated scanner may be your best option for digitizing slides and negatives.

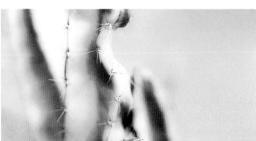

- 1. Enhance color
- 2. Extend image to the right
- 3. Enhance contrast between blue/yellow
- 4. Sharpen needles
- 5. Soften color blotchiness and highlights

FIG 2.1 Making notes on a rough print of your image may help your evaluation and can keep your desired goals in mind.

Evaluation

Actually looking at your images on screen and carefully evaluating them are what determines which steps you take in making corrections. You should take a moment to jot down some notes as to what you hope to accomplish with your changes (see Figure 2.1). The result of the evaluation should be a short, but detailed, list of things you want to improve or change. A set plan helps keep you on track and suggests the tools and techniques to employ to reach you goals for a given image. Planning can also keep you from distracting and fruitless experimentation.

- Consider tone and color. Analyzing tone and color should include
 determining qualities like the image type (high key, low key, high contrast).
 You will want to consider the dynamic range, how vivid the image is, the
 exposure, the saturation, and the color balance/color cast.
- Consider cropping and horizon level check. Cropping can be used to solve
 compositional problems as well as removing distractions or simply
 reshaping an image. A common problem in landscape photos is a tilted
 horizon, and this can often easily be fixed with a cropping adjustment, as
 can some problems with perspective.
- Consider small-scale composition enhancements and adjustments. These
 adjustments fix obvious damage, eliminate dust or debris, and possibly
 remove distracting objects in the image.
- Consider imaging heroics. What I consider "heroics" are special
 compositional enhancements and corrections that go well outside "small
 scale" and the normal path of your work flow. Changing composition
 considerably (e.g., moving or adding a complex object to an image,
 compositing several images into something much different, and possibly
 some instances of HDR (high dynamic range) compositing), complex
 custom masking, re-creating objects, etc., are all heroic efforts to make an
 image work. These changes are usually very complex and require many

- steps in adjustment, a lot of skill, and many layers. Experimentation is considered heroics.
- Consider image enhancements. Once an image is refined through more
 obvious corrections, you may want to add general enhancements like
 softness, sharpening, saturation, and other general qualitative adjustments
 to enhance the image. This can include adding graphic elements, such as
 border styling, framing, type, etc. These enhancements may not be part of
 the original image.

Editing and Correction

When correcting and editing images, you will take specific steps to achieve the goals set during your evaluation. This is where you will actually employ layers as a core tool in organizing and executing the steps necessary to complete your corrections.

- Make general color and tonal adjustments. This means executing tonal and
 color adjustments that will not use selection or masking. You will rely on
 levels for most of this general correction. Other tools to consider are hue/
 saturation and color balance.
- Make general damage corrections, such as eliminating dust from scans, fixing cracks and holes in scanned images, and reducing digital noise.
- *Make general compositional changes,* including cropping, compositing, and simple replacement or removal of objects.
- Make heroic changes to the image. This can include reshaping objects, broad compositional enhancement, experimentation, or even collage.
- Make targeted corrections to the image using selection and masking.
 Usually you will want to exercise all general color and tone corrections before singling areas of the image for complicated masking correction.
- Make enhancements to the image for sharpness, softness, saturation, brightness, and other generalized "final touch" effects such as framing, adding copyright, etc.
- Save the working, layered version of the image. Saving layers allows you to return to the image for additional changes, repurposing, or exploring the techniques used. Be sure to give the file a new name when saving, so you do not save over the original.

Purposing and Output

Once the image is saved with layered corrections, you will use that version of the image to target specific output types as needed. You will purpose the working version of the image for output as needed for uploading to web sites and printing.

Simplify the image as appropriate for use in the medium you have selected.
 This step may include flattening the image or merging layers, altering the color mode, or removing extraneous image information (paths, channels, alphas, etc.; don't worry if you don't know what all these things are at this point). During the process of simplifying, be sure to retain all components

- that may be important to your output, like vectors for high-resolution offset printing.
- Optimize the image resolution and color for output/use. Make color, tonal, and color space adjustments if necessary, and resize the image according to the target resolution. This step can include such changes as setting white and black points and making device-specific color changes (e.g., conversion to CMYK).
- Save the image in output file format. Not all files are alike. Some services and
 output devices will require specific file types, and some file content will
 require file types that retain qualities you have created in the image (e.g.,
 vector components). Make considerations for profile handling as part of
 your work flow and intended output, and be cognizant of whether you will
 embed a profile (usually you will).
- Package the image for output use. Copying the image file(s) to portable
 media applies only if you will be physically delivering the file on media to a
 service. Many times you will be able to upload images via FTP or email. Any
 changes made to the file should be saved with the working version of the
 PSD so you retain only one working version of the image.

This checklist may seem long, but each step will often not be very involved. Some steps you will do naturally, some take just a moment, and some are just reminders for maintaining a positive work flow. Practicing correction by following the steps in the list can ensure that you make all adjustments and corrections that you intend to and successfully reach your goals for the image.

As the focus of this book is Layers, this book assumes that readers are familiar with a staple Photoshop toolset made up of commonly used tools. The appendix titled Photoshop's Essential Tools List included at the back of this book describes approximately what this toolset encompasses. Please use that appendix for reference as necessary to be sure you are working with recommended tools.

The Logic of Layers

Now that we have outlined a basic work flow, it is time to start wrapping the process of working with images around layers. As mentioned in Chapter 1, layers are a vehicle for instituting nondestructive change in images. In other words, you can keep the original image information intact while making virtual changes over it. Used correctly, layers are a far more powerful tool than Undo or Histories in allowing you to reverse changes at any time—not just during an image-editing session. With layers it is possible not just to undo or reverse sequential changes, but to adjust the editing sequence and intensity of applied changes as you go by reordering layers, adjusting opacity, and toggling visibility. The power of layers is greater if you approach them with

a solid understanding of when to use them and how to organize them with naming, grouping, merging, duplication, clipping, and linking.

When to Create a New Layer

Ideally you will want to create a new layer for every change that you intend to make in an image. That is, if you are going to make a general color adjustment, make a new layer; if you are going to sharpen, make a new layer; if you are going to make a spot change to any image area, make a new layer; if you are making dust corrections to a scan, make a new layer (not one for each speck, but one for all of them). Some layers will force themselves on you. For example, when you use the Paste command, Photoshop will create a new layer. This is as it should be.

The goal of layer creation is to keep each logical step in the process separated so you can return to the image in the future, see what you did, and perhaps reverse or re-create these changes and the process in another image. That is, layers can be used to archive your work flow in steps that you took to achieve the result, they can help you save time and effort if you want to make a change in the developed image without having to redo all the corrections, and they can provide a means of learning from your own efforts by reviewing your process—now or years from now.

Naming Layers

A very important means of keeping layers organized is being consistent with layer naming. When new layers are created, they are created with a generic name (e.g., Layer + number or the type of Adjustment layer). Several practices can help you make better use of layer names: naming the layer by purpose, entering the parameters used, and numbering the order of creation.

Naming the layer by purpose is simply typing in a name that has to do with what you used the layer to accomplish. For example, a layer used for dust removal would be named "Dust Removal"; a layer used to isolate an object would be named for the object. When using functions like Gaussian Blur on a layer to soften an area, you may want to note the settings used in the layer name. Finally, you might also consider numbering the layers. Though you will often work from the bottom of the stack upward in order, that will not always be the case. See Figure 2.2 for a simple example of layer naming according to suggested practice.

This type of simple naming scheme has potential to be very helpful in that it can help you know what a layer is for without having to examine the content (e.g., toggling the view for layers, increasing the size of the thumbnails, zooming in to the image). Naming layers as you go to hint at what they are all about will help keep them organized and let them act as an outline or running history for your editing procedures. In that way, investing some time up front helps save lots of time later on in reproducing or duplicating results without extensive trial and error.

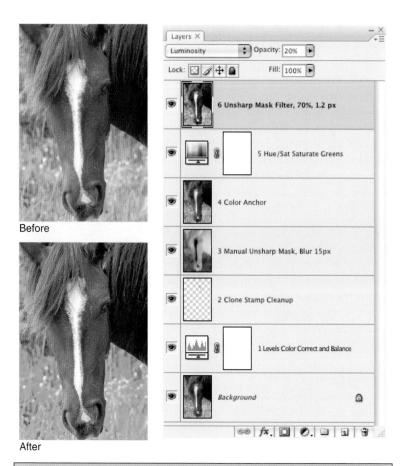

FIG 2.2 If you start your layer organization with layer numbering, you can track what was done to an image in order by looking at the layer names.

Whereas including some information in the layer name makes sense, including too much information can make the layer names bulky and difficult to read. A number, brief purpose, and settings (if applicable) will often be all you need.

There are several ways to edit layer names. You can often change them when creating the layer depending on how they are initiated, but you can also edit the names after the layers are created. The following exercise has no other goal than to explore the various opportunities for naming layers; there will ultimately be no change in the visual appearance of the image on screen.

☐ Try It Now

- 1. Open a new image using the settings from Figure 2.3.
- Choose Duplicate Layer from the Layer menu (Layer>Duplicate Layer). This will open the Duplicate Layer dialog with the As field prenamed Background Copy (see Figure 2.4).

FIG 2.3 This will create a small, white image named Layer Names that is just 600×600 pixels. It will be more than enough to explore layer naming.

FIG 2.4 Other means of invoking duplication may not force open the Duplicate Layer dialog. If the dialog does not open, it is likely that you were using another method.

 Change the As field by typing over the current default name. Change the name to 1 Duplicate Background, and click OK. This will close the dialog and complete creating a duplicate of the Background layer with the new name (see Figure 2.5).

FIG 2.5 By default the name is highlighted, and just typing will replace it.

- 4. Click and drag the 1 Duplicate Background layer to the Create a New Layer button at the bottom of the palette. This will create a new layer with the name 1 Duplicate Background Copy at the top of the stack identical to the other two layers, except in name.
- Had you held down the Option/Alt key (Mac/PC) when dragging in the previous step, the result would have been that the Duplicate Layer dialog would have opened as in step 2.
- 5. Open the Layers palette menu (find the menu button at the upper right of the palette) and choose Layer Properties. The Layer Properties dialog will appear. Change the name of the layer to 2 Duplicate Background II (see Figure 2.6). Click OK to accept the changes and close the dialog. Note the name will change for the current layer in the Layers palette.

FIG 2.6 The Layer Properties is similar to the Duplicate Layer dialog, but with fewer options, and the layer name is in the Name field.

- Double-click the Background layer in the Layers palette. This will
 open the New Layer dialog with the name Layer 0. Click OK to accept
 the changes with the default name. You could have changed the
 name there, but you will change your mind shortly.
- 7. Double-click directly on the name Layer 0 in the Layers palette. The name of the layer will be highlighted in the palette (see Figure 2.7). You can type in a name change directly on the palette. Call it Original Background, and then press Enter or Return on your keyboard to accept the changes. Your image will look like Figure 2.8.

There are alternatives for getting to the Layer Properties. Option/Alt and double-clicking on a layer will open the Layer Properties. You can also open a menu for the layer: on a Mac, hold down the Control key and click on a layer (not a Background); on a PC, right-click on a layer. Note that if you click on the layer or thumbnail, you will get a different menu.

FIG 2.7 Double-clicking the layer name allows you to change the name directly on the palette.

FIG 2.8 The exercise should have left you with these three layers: Original Background, 1 Duplicate Background, and 2 Duplicate Background II.

Any of these methods of naming your layers may come in handy at various points in the process of editing. You will develop favorites with experience. But the bigger point is to use layer naming opportunities to note what step(s) a layer contains so that you can tell at a glance.

Leave this image open; we'll use it in a moment for another quick exercise with layer grouping.

Grouping Layers

When you begin to work with layers extensively, the number of layers you use can easily start to get unwieldy. It may sound funny to those who currently don't use layers at all, but you can easily end up with hundreds of layers in an image. The advertising photography work I have done, which requires intense correction of models (changing face and body shape and contour, along with color correction, pore reduction, lens correction, and the like), often entails several submissions of an image, with revisions. I make a habit of saving every step in the hours of intense correction, so it is unnecessary to start over again when the revisions come back. Trying to repeat everything from scratch is not a very pleasant thought, and would be sheer tedium. The working version of images could end up with hundreds of layers and often with several images in various editing stages that would be used for different parts of a composite. More recently I was designing an interface for a web application, and the demo image had over 2000 layers. When you use them often, and in the right way, layers almost become addictive.

One thing that happens when you get a lot of layers in an image is that the Layers palette gets confusing just to look at, let alone navigate. Equally problematic is scrolling to the layers you need, as you can't see them all on the screen at one time once you get over 25 or so—depending on the size and resolution of your screen and the Layers palette settings for the thumbnail size. To keep a bulking layer stack more manageable, and to keep layers more organized, you can store layers in layer groups. Groups work like folders in a file structure; they allow you to expand and collapse the view of the content so you can choose to see the layers in a group or hide them from view (see Figure 2.9).

Layer groups were known as layer sets in Photoshop 7. They are essentially identical features.

You can create a layer group from existing layers or create a group and add the layers as you go. At any time you can show or hide the content of the groups or duplicate or move them like any other layer (even between images), and they can be nested up to five deep. A little practice with them will get you familiar with how they work, and we can get familiar in a short exercise. Again, the goal of this exercise is just to experience groups, not to change the image in any way. Do this exercise continuing from the point at which we left off in the previous exercise (Figure 2.8).

☐ Try It Now

 Highlight the two upper layers (2 Duplicate Background II and 1 Duplicate Background). To highlight one layer at a time on a PC, hold down the Ctrl key and click the layers in the Layers palette; on a

FIG 2.9 The toggling arrow immediately to the left of the layer group allows you to expand or collapse the view for the content of the groups. These two Layers palettes represent exactly the same image.

Mac hold down the Command key and click the layers in the Layers palette (see Figure 2.10). You can also highlight multiple consecutive layers at once by clicking the upper layer to highlight it and then pressing Shift and clicking the lower (or vice versa; you can start with the lower and Shift+click on the upper).

FIG 2.10 Highlighted layers are shown here in blue. The color of your highlighting may be different depending on system preferences.

Highlighting layers one at a time is useful for selecting layers that are not consecutive.

- 2. Choose New Group From Layers from the Layers palette menu. This will open the New Group From Layers dialog, which will allow you to rename the group. Accept the default group name (Group 1) by clicking OK. This will create the new layer group with the highlighted layers contained in the group. View the layers by clicking the arrow to the left of the group to expand the group (see Figure 2.11). Leave the group collapsed for the next step.
- 3. Click and drag the Group 1 group to the Create a New Group button at the bottom of the Layers palette. When you release, this will immediately create a new group called Group 2 containing Group 1. If you had held Option/Alt while you dragged you would have the option to rename the group. After creating Group 2, toggle the Expand/Collapse arrow for the old group, Group 1, to reveal the original layers in Group 1, inside Group 2 (see Figure 2.12).

FIG 2.11 Even though the layers are hidden in the Layers palette, they remain visible in the image. Choosing New Group From Layers in the palette menu is the same as using the Create a New Group button in step 3 without the dialog appearing for the option to rename the group.

FIG 2.12 Group 1 is now nested inside Group 2. Although both groups are visible here, collapsing Group 2 will hide Group 1 in the Layers palette as well as the layers in the group ... try it!

- Drag Group 1 to the Create a New Layer button. This will duplicate
 Group 1 as Group 1 Copy, and both groups will remain inside Group 2
 (see Figure 2.13).
- 5. Click and drag Group 1 Copy over Group 1. As you drag the cursor, note when Group 1 highlights (see Figure 2.14) and release the mouse button. This will move Group 1 Copy inside Group 1.

FIG 2.13 The Create a New Group button in step 3 created a group around the layers dragged to it. The Create a New Layer button simply duplicates the layer—it just happens to be a group in this case.

FIG 2.14 After you drag the copy, expanding Group 1 reveals its contents.

Layers in any group remain fully editable. The entire advantage is that the groups can be collapsed so there is less to search through, and groups can be organized so you can quickly find what you need. If you find all this naming by "Group" a little confusing, please see the previous exercise, and exercise your right to rename the groups as you please—you can name groups in the same ways you can name layers. Perhaps this illustrates the benefit of naming layers as you go as well.

Again, leave this image open and available for use with the next exercise.

Be aware that this exercise is illustrating basic concepts of grouping and layer naming. The order in which you create and stack layers often matters to the result. Moving layers around in the stack willy-nilly just to accomplish a neat grouping may have an effect on the image result. Always view the image on screen while moving layers to be sure the layer movement doesn't affect the image result!

Merging Layers

Just as there are reasons to create layers, there are reasons to delete and combine them. Combining layers in Photoshop is referred to as merging. Merging combines the content of two or more layers into a single layer. This saves on file size and simplifies the image by reducing the number of layers in the stack.

Layers can be merged from various groupings: linked layers, grouped layers, visible layers, active (highlighted) groupings, and simple pairs can all be merged. Usually you will want to merge layers that do the same thing but somehow end up separate, or you will want to merge layers that you otherwise really don't have a good reason to keep separate. Let's use the image from the last example, starting from where we left off, to have a look at some ways to merge layers and the result.

Try It Now

 Make sure Group 1 Copy is the active layer in the image, then choose Merge Group from the Layer menu. This is the same as pressing Command+E/Ctrl+E. The content of the group will be merged into a single layer named Group 1 Copy (see Figure 2.15).

Often problems that occur in applying changes happen because the wrong layer is active. Your first place to check when a change doesn't behave as you expect should be which layer you have active to be sure it is the layer you really want to work on.

FIG 2.15 By "make sure Group 1 Copy is the active layer," I mean click on the layer so that it is highlighted in the Layers palette. An active layer is the "live" layer in your image, or the layer you are currently working on.

- 2. Click on the 1 Duplicate Background layer in the Layers palette to make it the active layer, then choose Merge Down from the Layer menu. You will notice that the menu item you are choosing is in exactly the same place as Merge Group was in step 1, but it has a different name because of the image context. The merge commands are named with context sensitivity, and the names will change according to the actions that are available (see Figure 2.16).
- Undo the changes from the last step by pressing Command+Z/ Ctrl+Z (you can also step back in the History or choose Undo from the Edit menu). This will restore the 1 Duplicate Background layer.
- 4. With the 1 Duplicate Background layer active, hold down the Shift key and click the Group 1 Copy layer. Both the 1 Duplicate Background and the Group 1 Copy layer should appear highlighted (see Figure 2.17).
- 5. Choose Merge Layers from the Layer menu as in step 2. Note that the resulting layer is named 1 Duplicate Background, as per the upper layer in the merge. If you compare steps 2 and 5, the dominant name changes depending on how you merge layers.
- Choose Flatten Image from the Layer menu. This is the ultimate merge.
 The entire contents of the image will be merged as a Background layer (whether or not a Background layer existed in the image previously).

FIG 2.16 Note that the resulting layer from the merge is Group 1 Copy, as per the lower layer in the merge.

FIG 2.17 With two active layers being merged, the naming result is different compared to simply merging down.

- Although it is all well and good to merge these layers and groups to see how they react, it is important to remember that you are performing permanent adjustments that will prevent you from further editing of individual layers that are merged.
- 7. Choose the Type tool, set a color and font (size and style), and click on the image to make a new Type layer. Make the font large and bold—a little oversized, as it will come in handy later (the next exercise). Type in your copyright (e.g., Copyright © 2009 Richard Lynch). For an "appropriate color" use black.
- 8. Press Command+E/Ctrl+E. This is the shortcut to merge the Type layer down. In this case the Type layer will merge with the Background.
- 9. Choose the Move tool (press V) and move the copyright into position.

Wait ... can't do that? How about just deleting the copyright. But you can't do that either?! Perhaps that drives home the idea of the importance of layers and the purpose of merging. You had superfluous layers in the image before—just duplicates of white squares. You could create more layers and merge them and it didn't make a bit of difference in the result. However, when you have your copyright, you'll want to be able to move it around and maybe shut off the view of it or remove it for some purposes. As soon as you merge it with another layer, the content becomes permanently affixed. You want to keep all distinct changes in separate layers so you have the opportunity to move or delete them when necessary.

Just so you know you aren't too far up a creek without a paddle:

- 10. Press Command+Z/Ctrl+Z to restore the Type layer so you can edit the copyright position without having to start over.
- 11. Choose the Move tool (press the V key), and move the copyright where it belongs.

I hope that we've touched on a few valuable lessons here and you already begin to see not just how to create layers, create groups, and combine and name layers and groups, but also a little about how managing your corrections in layers can be important. Funny ... we haven't even made any changes that affect the visible content of your images yet! We're getting closer, but there are still a few more fundamentals to explore. You can close that image for now ... no need to save it; but you may want to run through those exercises again to solidify these fundamentals.

Moving and Activating Layers

We've made some layers active by clicking them in the Layers palette and even did some click—drag movements to duplicate layers. Moving and activating different layers in the image will become more important as you work with your images, but this Layers introduction would be remiss to leave out information about moving layers in the palette and activating/navigating to different layers in the stack via keystrokes. Activating layers is simply making them the layer that is currently poised to accept a change, as we did in earlier exercises by clicking on a layer in the Layers palette. Moving layers is shifting their position in the layer stack, which you might do for a variety of reasons, from organizing, to giving a layer more or less influence, to just getting them where you expected them to go in the stack after creating them. Moving layers can simply be drag and drop, like you did in the Layer Group exercise. Click on a layer and drag it up or down in the layer stack. Some of the common shortcuts you might use for navigation are in Table 2.1.

TABLE 2.1 Layer navigation shortcuts.

Purpose	Mac Shortcut	Windows Shortcut
Move an active layer up in the layer stack	Command+]	Ctrl+]
Move an active layer down in the layer stack	Command+[Ctrl+[
Move an active layer to the top of the layer stack (or layer group)	Command +Shift+]	Ctrl+Shift+]
Move an active layer to the bottom of the layer stack (or layer group)	Command +Shift+[Ctrl+Shift+[
Activate the next layer up in the layer stack	Option+]	Alt+]
Activate the next layer down in the layer stack	Option+[Alt+[
Activate the next layer up in the layer stack (keeping the current layer(s) selected)	Option +Shift+]	Alt+Shift+]
Activate the next layer down in the layer stack (keeping the current layer(s) selected)	Option +Shift+[Alt+Shift+[
Activate the top layer in the layer stack	Option+.	Alt+.
Activate the bottom layer in the layer stack	Option+,	Alt+,

Moving layers is often most handy for inverting the order of two layers in the stack (moving up one or down one). Knowing how to select the top or bottom layer with a shortcut can help you quickly navigate images with a lot of layers, jumping from top to bottom in a flash. We can test out some of the shortcuts for moving and activating layers in the following sections.

Clipping Layers

Probably one of my favorite layer types (and not everyone will share this preference) is the Clipping layer. It is really just an easy way to target changes so they affect the content of one particular layer. That is, say you have an object that you have separated into a layer above the Background. You would like to make a change to the color of the object, but not the Background. Although there are many potential solutions, Clipping layers offer the opportunity to target an adjustment only to that layer while keeping the changes in their own layers. If you have to make several changes to the layer, Clipping layers may be the only way to get it done and keep the changes distinct without duplicating masks.

The implications are farther reaching than simply being an alternative to masking. You can use Clipping layers as masks, but more as organizational tools for your corrections. The best way to see them work is through example, so let's see what they do in a simple exercise.

☐ Try It Now

- 1. Make a new 600×600 pixel image as you did earlier, using the settings as you did in Figure 2.3.
- 2. Fill the image with red. To do this choose Fill from the Edit menu. When the Fill dialog appears, choose Color from the Use menu on the dialog and when the Choose a Color dialog appears, change the color to R: 255, G: 0, B: 0 using the RGB fields. Click OK on both dialogs to apply the color. This will fill the Background layer with red (see Figure 2.18).
- 3. Change the foreground color to blue (RGB: 0, 0, 255). To do this, click once on the foreground color swatch at the bottom of the Tools palette on the left of your screen. When the Color Picker displays, enter the RGB values in the RGB fields (press 0, Tab, 0, Tab, 255) and click OK to close the dialog.
- 4. Choose the Type tool (press T on the keyboard), then click and drag on the image to create a text box. This is a variation on making a Plain Text layer, which will give you more control over how the type fits into the image without using returns to control line breaks.
- 5. Type "Boy, do I love clipping layers!" and fit it large in the image using the type box (resize the box using the sizing handles) and type choices (change type size, leading, kerning, scaling, style, and more in the Character palette: Windows>Character). Notice the layer names itself Boy, do I love clipping layers! (see Figure 2.19).

FIG 2.18 There are other ways to fill the background and other ways to choose the color. We'll mix up techniques as we go, to delve into nooks and crannies in the interface.

FIG 2.19 If you are not familiar with using type and sizing, this screen shot of my Character palette will give you an idea of what to do, but different type faces will display very differently and will likely need some adjustment.

- 6. Duplicate the Background layer. Fill it with yellow (RGB: 255, 255, 0) using the Fill function with either the Foreground Color or the Color option on the Fill dialog. This will change the area behind the type to yellow. Rename the layer Yellow.
- 7. Press Command+]/Ctrl+] to move the Yellow layer above the Type layer. The entire image will now be yellow.

 Now press Command+Option+G/Ctrl+Alt+G. This will make the Yellow layer and Type layer into a clipping group. The type will be colored yellow, and the Background layer's red will show as the area around the type.

The yellow color from the Yellow layer is applied over the type, and only to the type, after the conversion to a Clipping layer. That is, the Type layer content acts as the base or background for the clipping group, with the solid part of that layer being the canvas for the group.

You can change isolated areas of the image by grouping/clipping. Instead of using the layer fill, take it up a notch to make it really do something in an image.

Try It Now

- 1. Open the Sample_3.psd file on the CD.
- 2. Duplicate the Background layer and rename the layer Burn Source.
- Click the Background layer in the Layers palette or press Option+ [/Alt+[to activate it.
- 4. Create a new blank layer by clicking the Create a New Layer button on the Layers palette. This will create a new layer between the Background and the Burn Source layers. Name the layer Clipping Mask. Change the Mode of the Clipping Mask layer to Multiply. You won't see anything change in the image on screen yet.
- 5. Press Option+]/Alt+] or click on the Burn Source layer to activate it.
- Press Command+Option+G/Ctrl+Alt+G. This will group the Burn Source and the Clipping Mask layers.
- 7. Choose the Brush tool and a soft brush, then activate the Clipping Mask layer and click on the image over the leaves at the edge of the image in any color. As you fill in with paint, those areas of the image will burn in and become darker (see Figure 2.20).

FIG 2.20 Edge burning is a technique commonly used to hold the viewer's eye in the image.

8. After painting and darkening the edge, reduce the opacity of the brush to 50 percent, and paint in a little tighter on the next circle of leaves, leaving the bud area the lightest (see Figure 2.21).

FIG 2.21 Reducing the opacity of the brush will keep the next round of burning a little lighter to gradate the result.

9. Add a Hue/Saturation adjustment to the whole image with +70 saturation and +180 hue. To do this press Option+./Alt+. to select the topmost layer. Then choose Hue/Saturation from the Create New Adjustment or Fill Layer menu at the bottom of the Layers palette. When the Adjustment layer is created, you can move the sliders to the requested position (see Figure 2.22).

FIG 2.22 Even though there is a Clipping layer below this adjustment, it affects the whole image—not just the

You can go much further with this by stacking multiple corrections in the Clipping group. Each will act on the content of the bottom layer in the group in the order of the stack. Hold onto that image to continue into the next exercise.

Linked Layers

Yet another potential organizational tool is layer linking. It is really somewhat subservient to other types of layer organization (like groups). Linking allows you to make layers behave as a unit, whether consecutive or not (unlike groups, because layers in the group have to be consecutive). This can be handy for keeping layers in registration and moving in unison on the layer plane. Lets add a copyright that blends with the image rather than using a flat color.

Try It Now

- 1. First thing we are going to do is gather the visible image to a new layer. I sometimes call these layer snapshots (not to be confused with History Snapshots) or Stamp Visible. With the Hue/Saturation layer active, press Command+Option+Shift+E/Ctrl+Alt+Shift+E. This creates a new layer and gathers the visible content into it—almost like flattening, but without losing the other layers. Name the layer Snapshot.
- Create a new Copyright layer using the Type tool. I'll just be using Copyright © 2009 here so I can make the type big. Big type will be important to seeing the point of the exercise clearly. You don't need to place it perfectly at this point, you'll have the chance to move it later.
- 3. Invert the order of the Copyright and Snapshot layers so that the Snapshot is above the Copyright layer, then make a clipping group from the two layers. At present you will see no change in the image. The next several steps will add effects to make the type stand out.
- You may have noticed that as we go along and have done things once or twice I give fewer details. For example, here I am not telling you how to invert the order of the layers or how to make the clipping group. This is because I assume that you are absorbing some of the materials as we go along, and if I always tell you everything you might get a little lazy, clicking buttons and pressing keys and never remembering a thing. You may occasionally have to look back to earlier exercises or tables for a reminder of how to do something.
- 4. Add a levels correction to the clipping group to lighten the Snapshot. To do this, hold down the Command+Option+Shift/Ctrl+Alt+Shift keys and click the Create a New Adjustment or Fill Layer menu button on the Layers palette, then choose Levels from the menu that appears. Holding down those keys will open the New Layer dialog. Check the Use Previous Layer to Create Clipping Mask checkbox,

- and click OK to create the layer. When the layer is created, locate the Adjustments palette, and push the Center/Gray Levels slider to the left to lighten the Snapshot layer. You will want to move the slider to about position 2.0.
- To give the copyright more relief, add a drop shadow to the copyright. To do this, activate the Copyright layer, and then choose Layer>Layer Style>Drop Shadow. The Layer Styles dialog will open, but just accept the defaults by clicking OK.
- 6. Catch up on your layer numbering, as we have been remiss! Number the layers in order of creation. At this point, your layers should look like Figure 2.23.

FIG 2.23 With this setup, we are almost ready to start seeing what linking layers does.

7. Activate the Copyright layer. Choose the Move tool and be sure the Auto-Select option in the Options bar is not checked.

- 8. Move the copyright around in the image and watch what happens. The type glides around under the Snapshot layer and reveals different parts of the snapshot layer as it moves. If you wanted the Snapshot to move with the type, you could link them and they would move together ... but that wouldn't make much sense for this image. Move the type where you want it to be. Now lets look at the advantage of linking.
- 9. Click on the 2 Clipping Mask layer to activate it, then hold down the Command/Ctrl key and click on 1 Burn Source and 4 Snapshot to highlight all three layers. Click on the Link button at the bottom of the Layers palette. Your layers should look like Figure 2.24.

FIG 2.24 After layers are linked, they will have a Link icon to the right when any of the linked layers is active.

10. Click on the 2 Clipping Mask layer so that it is the only one of the linked layers technically active. Then click and drag on the image. Watch the layers, where you'll see the three linked layers moving in

- unison, and then look at the image where ... oops. Something went wrong. It looks like we left off something that needed to be linked. The Background needed to be included in the linked set, otherwise you get misregistration. You can try to align it, or just stop where you are and undo the movement in the History palette, or choose Edit>Undo (Command+Z/Ctrl+Z).
- 11. The Background layer can be linked as it is, but you won't be able to move any of the linked layers then, as it is locked. You need to double-click the background to change it into a regular layer, and then link it (or link and then unlock—either way will work). To add to the linked layers, any of the linked layers and the Background need to be active at the same time. To do that, click on 2 Clipping Mask and then Command/Ctrl and click on the Background. Once these two layers are active, click the Link button. A Link icon will be added to the Background layer. See Figure 2.25.

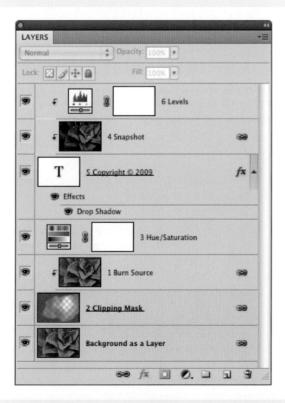

12. Click the Background so it is the only active layer, then click and drag with the Move tool in the image and you will see that all four of the linked layers move in perfect unison while they glide over and around the copyright text.

FIG 2.25 With all of the layers you need linked, the result will be much more predictable and all will remain in registration.

The key here is that these layers are not consecutive in the Layers palette, and linking allows you to control their registration regardless of the order of the layers in the palette. Linked layers can even be in separate groups ... so the plot thickens. Would you really work with an image this way, sliding it out of the image frame? Well, no, not exactly like that. You would more likely have objects grouped, and the background is substituting here for an object for the sake of discussion. However, one last thing I have not mentioned.

13. With the Background layer (Layer 0) active, choose Edit>Free Transform. Hold down the Command/Ctrl key and click and drag one of the corner handles of the transform box an inch or so in any direction. When you release, all of the linked layers will transform at the same time.

So you would also be able to take your linked objects in nonconsecutive layers and distort and reshape them in one move—in perfect registration. You may be beginning to see the value of linking. It is not likely that you will be using it often, but when you need it, it serves a unique and powerful purpose.

If you still have the transform box active from the exercise, click on the Cancel Transform button on the Options bar or press the Esc button on the keyboard. Keep this image open for the next exercise.

Smart Objects

Smart Objects were a new layer type introduced in Photoshop CS2. You merge layers into a Smart Object similar to the way you create a layer group (see the Convert to Smart Object command on the Layers palette menu), and the resulting Smart Object acts like a merged layer and a group at the same time—though the content is handled much differently compared to a group. The kicker is, the contents in the layer are not actually merged: the contents are stored in a separate PSB image. You can access the content and make changes, but to edit the content, you double-click the Smart Object layer and the content of the object opens as another image. You can then save the object as a PSB (Photoshop Object) and use the objects in other images.

Smart Objects can be really handy if there is some type of layer grouping that you use in different images. For example, say in your exploration of layers you hit on a combination of Adjustment layers that seems to you to correct every image you took in a photo session (unlikely). You could create a Smart Object from the layers, save it, and then incorporate it into all of the other images from the session. Another more probable use is developing templates. For example, say you were selected to shoot some youth league team pictures. You might make a frame like a baseball, softball, or soccer sports card and then import it to the individual team player shots. Simpler uses might be for

things like ... a copyright, which we've touched on a few times already. But the really interesting thing about doing something so simple with a Smart Object is, you can make one object and use it in different images, size and change it, and never alter the original.

Try it Now

- 1. Start with the image from the last exercise as left off in Figure 2.25.
- 2. Click on the Copyright layer to make it active.
- 3. Remove the Drop Shadow effect for the layer. You could leave this in, but in this image it will cause some issues, and you may not always want to use a drop shadow. Best to apply effects as needed. To remove the effect, and as we'll be using it again, Command+click/Right-click on the FX symbol and choose Copy Layer Style. This will put the style on the clipboard, effectively saving it so it can be reapplied. Then Command+click/Right-click and choose Clear Layer Style. This removes the style from the layer.
- Convert the Copyright layer to a Smart Object. To do this choose Convert to Smart Object from the Layers palette menu. The layer will convert to a Smart Object (see Figure 2.26).

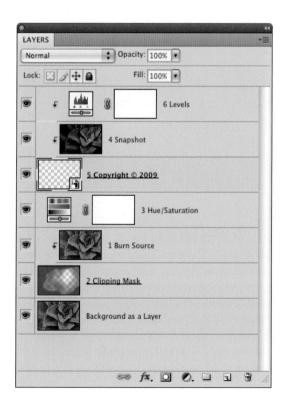

FIG 2.26 The Smart Object layer has a small icon in the lower right of the thumbnail. The thumbnail shows a preview of the Smart Object.

- Command+click/Right-click on the Smart Object and choose Paste Layer Style. This will reapply the style you removed.
- Double-click the thumbnail for the Smart Object. This will open an alert/dialog that explains a little about working with the Smart Object. Click OK. The content of the Smart Object will open in a new document window (see Figure 2.27).
- 7. When the Copyright is open, choose the Type tool, and change 2009 to 2010.
- 8. Save and close the Smart Object image. When you close it look at the image you were working on ... the date will have changed. See Figure 2.28.

FIG 2.27 Do read the alert! It gives you some information about how the Smart Object works.

FIG 2.28 The change to the Smart Object is updated to the image when it is saved.

You can resize the Smart Object in the image where it is placed using transform, scaling, rotation, and more, and the original is unaffected. Multiple instances of the same Smart Object in an image can be updated at one time if the Smart Object is duplicated in the image (as you might do with buttons in web design or other graphic elements). Smart Objects can also be imported to an image. These can be files you've created in Photoshop and saved as Smart Objects (like our copyright), other image files (PSDs, PDFs, TIFFs, JPEGs), or graphic elements that you may have created in a dedicated illustration program like Adobe Illustrator. To import a graphic as a Smart Object, use the Place command in the File menu (File>Place). The Place command is what

you would use to import a card design to multiple images (discussed briefly earlier as a possible use of Smart Objects). The original objects, again, remain unchanged after you place them in another image, and you can edit them and update the placed objects, or leave them as is. Smart Objects have many creative uses in graphic development and making presentation templates or custom printing sheets, but have fewer uses when it comes to image correction.

Summary

We have only just begun to explore some of the more serious functionality of layer creation and organization in this chapter. With the basics you have learned here you should begin to see some possibilities for organizing your layers in four types of groups (Groups, Clipping Groups, Linking, and Smart Objects) and should begin to see the flexibility of adjusting content in the layer stack. Coupled with layer naming, you have all the tools you need to keep your layers in order and sensible as a record of your corrections. We will look at examples throughout the book that reinforce these basic exercises in real-world editing situations and image correction, starting with the very next chapter, in which we begin to explore using layers to isolate image areas and objects in your images to facilitate correction.

ne of the fundamental values of working in Layers is isolating image areas for change. This gives you the freedom to correct image areas independently and revisit changes as part of image development and work flow. Once you use layers to isolate changes, you can make adjustments and then fine-tune the adjustments in nondestructive ways that are impossible using selection alone.

Layers allow you to isolate changes in many different ways. In fact, the bulk of this book is really dedicated to describing how different layer features enable change in images. This chapter looks at the simplest concepts behind isolating change and the nondestructive editing work flow, including the purpose and use of Adjustment layers, and the idea of isolating objects and areas within images in the simplest form. As we go, we'll look at several key concepts for image correction that apply to just about any image you will work with to form the core of your correction work flow. This includes adjusting dynamic range, color correction, and color balance as an initial application of layers in your images.

The idea of light leaving a fingerprint is something I talk about to teach the idea behind the theory. If you talk with other people who are not familiar with this book about "light's fingerprint," there is a good chance they will have no idea what you are talking about, unless they have read this book or attended my classes.

Isolating Correction in Adjustment Layers

Adjustment layers are based on correction functions, but instead of applying the adjustments directly to the image, adjustment settings are retained in a separate layer that you can readjust later, temporarily hide, or even remove at any point in the processing. The ability to change your mind later is key to nondestructive work flows. The point again is that the correction or change remains distinct within the layer stack and never directly changes the original image pixel information.

One of the first steps that I suggest in working with any image is making a general Levels correction. The correction helps make the most of the dynamic range (brightness from white to black) and helps establish color balance that can bring out richness in image color. The technique of Levels correction applies to the whole image, but on occasion may apply to isolated image elements as well. In this case, the Levels correction is a useful way to demonstrate a simple application of Adjustment layers. This correction works on just about any image, and sometimes really works wonders.

Corrections work better from general to specific. Instead of attacking specific issues first, be sure you have made good general corrections. This will keep you from making changes to multiple parts of an image when a general correction would have sufficed.

First, let's look at some background theory about how the correction works by learning something about what I call light's fingerprint.

Light's Fingerprint

When an exposure is captured, the camera captures a fingerprint of the lighting for the scene. Natural lighting at sunset or sunrise, when lighting tends to color objects with warmer tones of yellow and red, is an example of light creating an effect in a scene. But, taking that further, if your light is pure red, everything in the room will reflect only the red light, and everything (with any red in it to reflect) will appear red. Objects with no red at all will appear black.

Objects in a scene reflect the quality and color of the available light. If the light isn't completely neutral (with even amounts of red, green, and blue light), lacks full spectrum (absolute black to absolute white), tends to favor a particular color over a range of tone, and/or has multiple light influences (different colors of ambient and direct light, for example), the scene reflects those qualities of the light. As a scene can reflect only the colors in the original light source(s), a capture serves as a reliable fingerprint of the general qualities of the lighting in the scene.

This fingerprint is a valuable clue to detecting the correct color for your image. If you examine the fingerprint and learn how to read it, you can identify deficiency of the light, and you can correct image color.

Image Histograms (found by looking at the Histograms or by looking at the Levels dialog) are exactly what you need to evaluate the quality of the light and the fingerprint it has left on the scene. A histogram (see Figures 3.1–3.3) shows a definitive mapping of exactly how the light fingerprint reacts with the objects in the scene. By examining light's fingerprint as a clue, we can easily determine how to correct image color.

This Levels correction can work wonders on an image, and it is useful in almost any image. The changes compensate for exposure and lighting conditions and improve color balance and the dynamic range of images, without a lot of complicated measurement. In fact, in most instances you don't even have to look at the image to make the adjustment. The results are nondestructive, as the correction is made in layers. The following section outlines the details of how to make that levels change.

Detailing the Levels Slider Changes

Making the Levels slider adjustments is a fairly simple process, once you have an outline for what to do. The histogram on the Levels dialog will become your visual guide to all you need to know to make the basic adjustment. Additional changes can be made that reflect user preferences once you get used to using the tool.

The characteristic to look for in Levels histograms is shortened tonal range. Shortened tonal range is represented by a histogram that does not have information (or so little consistent information that it is more likely image noise than detail) across the entire range of the graph, with a gap at either the light end (right, highlights) or the dark end (left, shadows) of the graph or both. A shortened tonal range in any of the channel components indicates that the light source was not full spectrum.

Levels is an extraordinary tool for making adjustments in this situation. All you do to correct a shortened range is move the sliders (black/shadow and white/highlight) to maximize the range of each component. Move the right, white, slider to the left to a position at which the graph shows anything more than image noise; this will make whites brighter. Move the left, black, slider to the right, again to a position at which significant information is displayed in the graph; this will make shadows darker. See the examples in Figures 3.1–3.3 for the Red, Green, and Blue channels.

After setting the sliders, you commit your changes by clicking OK on the Levels dialog. The tails and anything outside the range of the black and white sliders are cut off, and the image information will be redistributed over the tonal range. The new range of the graph is extended as in Figure 3.4.

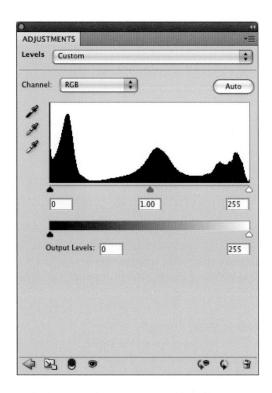

FIG 3.1 The Red histogram shows a full range from black to white and needs no adjustment.

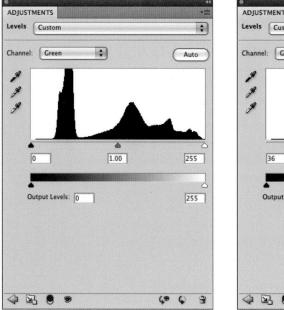

FIG 3.2 The Green channel shows a tail to the left, or shadow portion, of the green spectrum. To make the adjustment, move the black (left, input) slider to the right to compensate and clip the tail as shown.

FIG 3.3 The Blue channel also shows a tail to the left, or shadow portion, of the spectrum. Move the black (left, input) slider to the right to compensate as shown.

FIG 3.4 The image information is redistributed evenly after Levels changes are accepted so that the color range is broadened.

Let's take a look at the correction in a hands-on exercise.

Try It Now

Applying Levels for Color Correction

- 1. Open the image you want to correct. For this exercise, open Sample_4.psd on the CD.
- 2. Choose Layer>New Adjustment Layer>Levels. This opens the New Layer dialog box.
- When the New Layer dialog appears, leave the defaults and click the OK button. This will accept the settings, create a new Levels Adjustment layer, and display the Levels dialog controls in the Adjustments palette.

Display the Adjustments palette by choosing Adjustments from Photoshop's Window menu. The Adjustments palette is new to Photoshop for CS4.

- 4. Select Red from the Channel drop-down list. This reveals the histogram for the red component. See Figure 3.5.
- 5. Make a Levels correction for the component. Do this correction by evaluating the histogram and moving the sliders. See Figure 3.6.

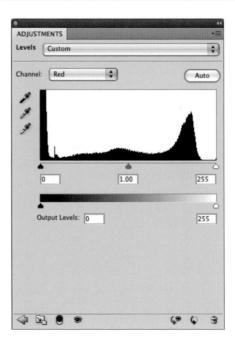

FIG 3.5 Your histogram in the Adjustments palette may look somewhat different depending on your color settings, but it should display an obvious tail to the right of the graph for the Red channel in the Sample_4.psd image.

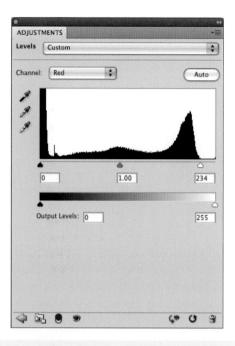

FIG 3.6 Make the correction for the tail by pushing the white slider to the point in the graph right where the graph begins to ascend. Err toward the tail, not the graph, as every bit of detail that falls to the right of the white slider and the left of the black slider represents lost image information and potentially lost details.

- Repeat step 5 for the green component. Do this by selecting Green from the Channel drop-down list and making the Levels correction. See Figure 3.7.
- 7. Repeat step 5 for the blue component. Do this by selecting Blue from the Channel drop-down list and making the Levels correction. See Figure 3.8.

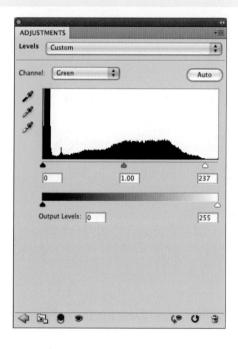

FIG 3.7 The changes to all three channels in this image are somewhat similar. It is not always the same for every image; sometimes the individual channels are very different.

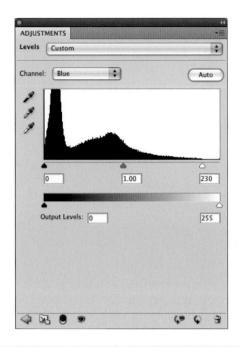

FIG 3.8 Working with the separate channels as described will fix accurate black and white points in the image as well as performing a general color balance based on the dynamic range and fingerprint of the light.

8. Make a tone adjustment to the image midtones. To do this, choose RGB from the Channels drop-down list and make an adjustment with the middle (gray) slider to brighten (left) or darken (right) the image. See Figure 3.9.

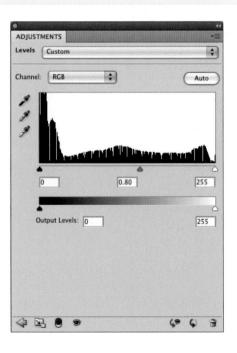

FIG 3.9 Brightening or darkening the image is more subjective than channel adjustments and is up to the viewer. Be sure you are making judgments on a calibrated monitor.

You can compare the before and after for the correction by toggling the view for the Levels Correction layer (click the Eye icon just to the left of the layer in the Layers palette). This Levels adjustment for the three channels is one you can often make almost strictly by looking at the appearance of the histogram and adjusting it accordingly—without looking at the image, just as we have done here. If you toggle the Show/Hide icon for the layer on the Layers palette as suggested, the change in the image should appear to improve image dynamics, contrast, and color.

A Levels adjustment will not always work well with images that have inherent color casts (sunsets) or when color filters have been used to achieve color-shifting effects that are desired, as it will tend to counteract the desired color shifts.

Tails on the histogram usually represent image noise rather than image detail, which is why you can generally cut an entire tail. However, sometimes you will crop none, some, or all of a tail, depending on the image, desired color shift, and length of the tail. Usually you cut less of a very long tail. After making the Levels adjustment for each of the channels, evaluate the change by eye, on screen (preferably on a calibrated monitor!). If the changes seem extreme, you can moderate them by changing the position of the sliders in the Levels layer (click it to show the current settings in the Adjustments palette) or by adjusting the opacity of Levels layer. Lowering the opacity will reduce the intensity of the correction. These after-the-fact adjustments could not be done if the Levels were applied directly to the layer content. Try the following exercise, continuing from the last step in the previous exercise.

Try It Now

- 1. Click on the Levels adjustment layer to be sure it is active.
- 2. Change the Opacity of the Levels 1 layer to 50 percent using the Opacity slider on the Layers dialog.
- 3. Duplicate the Levels 1 layer and name the duplicate Levels 2.

This is a really simple example of something Adjustment layers allow you to do: compare two results. Toggle the view for the Levels 1 layer off and on, and that will allow you to see the difference between applying the Levels change at 50 or 100 percent. But the next steps are truly unique to Adjustment layers.

- 4. Change the Opacity of Levels 2 to 100 percent and toggle the view to off.
- 5. Change the Opacity of the Levels 1 layer back to 100 percent.
- Click the Levels 1 layer thumbnail. The Levels adjustment settings will display in the Adjustments palette.

- 7. Adjust the midtone RGB slider to brighten or darken the image.
- Take a Snapshot using the History palette (open the History palette and click the Create New Snapshot button). It will be named Snapshot 1.
- 9. Toggle the view for Levels 1 (to off) and Levels 2 (to on).
- 10. Take a second Snapshot.
- 11. Click on Snapshot 1 and then Snapshot 2 in the History to compare the two adjustments.
- Toss out the Levels correction you don't want by dragging it to the Trash in the Layers palette.

This is unique, because if you applied the Levels correction directly to the Background without using an Adjustment layer, you'd have had to write down the changes you made, undo the changes, and redo them. That is the advantage of Adjustment layers in a nutshell: you can make repeated changes and comparisons to your adjustments without starting over. Even in this simple exercise, it saves several steps; in a more complicated correction, you can multiply the savings exponentially.

Even more advanced adjustments can be made with Levels using the center, gray, sliders for each channel. Moving these sliders allows you to adjust midtone color balance. However, using a separate correction for Color Balance will give more control and a better overall result. We will look at Color Balance later as we get more specific with corrections.

Keep that image handy; either save a version with the Levels correction or leave it open for the next exercise. Now let's look at how layering can be an advantage in isolating objects.

Isolating Image Objects

Isolating image elements is simply moving objects to separate layers so the objects can be controlled individually. The basic idea of isolating objects in your image is as easy, conceptually, as making a selection of an image area and then copying and pasting that image area to its own layer. The ability to create the isolation and execute it in a controlled way can give you ultimate control over image composition.

To complete basic isolation of an object, you will use any one of the selection tools—or a combination of them—to create a selection. Once the selection is created, you can copy the content of your selection to the clipboard (press Command+C/Ctrl+C (Mac/PC)) and then paste it back into the image (press Command+V/Ctrl+V). Photoshop will automatically make a layer and insert the content from the clipboard. Other methods, such as Command+J/Ctrl+J (New Layer Via Copy) or Command+Shift+J/Ctrl+Shift+J (New Layer Via

Cut), will also work to create the new layer from the selected area. The method of getting the area selected is less important than getting the area isolated on its own layer.

With the object isolated, you will be able to target changes more easily to that area directly. Because of the isolation, you will be able to do this in a variety of ways, using additional layers or using later techniques that we will explore, such as clipping groups or masking. Isolating a single element in an image is relatively simple, and it can open the door to many other image changes. Sometimes it will be desirable to take apart an image into a variety of smaller components for the sake of correction and/or composition adjustment. Although it may seem that taking an image apart object by object can be a pain, it is not something you will do with every image; but when necessary it can lead to better corrections and more flexibility with the end result.

For example, Figure 3.10 shows the same still life of some pears used in the Levels adjustment exercise. This image was shot on the spur of the moment. There were probably about 20 images in the series, and admittedly it didn't seem any of them represented what was desired—as sometimes happens. Though I didn't get exactly what I wanted, it seemed that instead of setting up the shoot all over again, I could alter the result by making some changes to the composition.

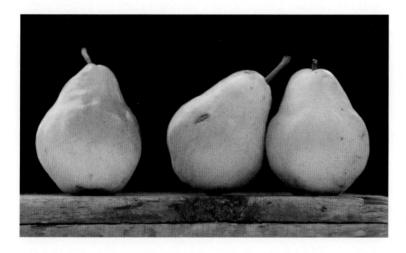

FIG 3.10 The original shot of some pears on an old crate. It seems too crowded, and begs experimentation.

To make the desired changes I broke the image down into several components to handle separately: the background, the foreground wood, the wood plateau, the two pears to the right, and the pear to the left. Ultimately the pear to the left was eliminated by the change, giving the image a bit more starkness. I borrowed color from the pear that went missing, and stems were borrowed from other images. The breakdown of steps to re-create the image and the resulting layers are shown in Figures 3.11 and 3.12.

FIG 3.11 (1) The original, (2) a new background, (3) fabricated wood top, (4) copied wood face (with repairs), (5) two pears isolated, (6) pear pair enhanced, (7) pear pair recolored, and (8) two pears flipped and positioned.

You will rarely go to such lengths as rebuilding an image to get the result you want, but you may see a key here in getting what you need, and part of the advantage provided by layers. The separation of objects goes one step further than merely selecting the object and copy/pasting it to its own layer. Once the object is isolated, you put yourself in position to have ultimate control of the composition. See the result in Figure 3.13.

One key point about making such adjustments: there is a difference between photography and shooting a picture. In your photography, you can remove an object from a scene by just moving it out of the camera's view, and the background fills the space. When you isolate an object in Photoshop layers, the layer from which you plucked the object either still contains the object or has a hole where it was. The background doesn't magically reappear when

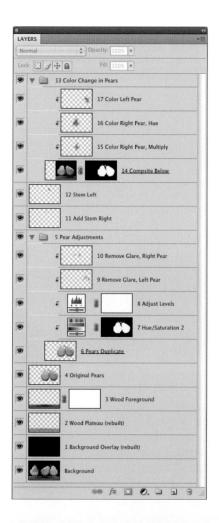

FIG 3.12 The actual layers used in the adjustment, roughly reflecting the numbered steps in Figure 3.11—some of the steps take several layers to complete. More advanced techniques included here, such as clipping and masking, will be looked at in later chapters.

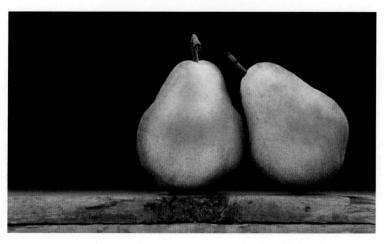

FIG 3.13 The final result is cropped, color corrected, patched, and reorganized using the power of layers.

the object is removed. In the case of the example, the background is pretty simple, and it can be repaired by re-creating it. Making the repair to patch the hole left behind can be more difficult as the complexity of the background increases. But to build some confidence in the strategy, let's look at how it applies to the sample image continuing from the point at which you left off in the last exercise.

Try It Now

- Choose the Polygon Lasso by pressing L and Shift+L to scroll the Lasso tools, or choose the Polygon Lasso from the toolbar. Change the settings on the Options bar to Feather 0 Pixels, and check the Anti-alias box.
- Feather and Anti-alias are both means of softening the edge of the selection and do not usually need to be used together. Softening the selection either way will tend to blend the edges of selections with the surrounding area rather than making hard, noticeable edges.
- 2. Open the image window so you have some room around the edge of the image to apply the tool (Figure 3.14).
- 3. Make a selection of the wood facing. To do this click outside of the image to the left, then move the cursor and click right at the top of the facing at the edge of the image. Continue moving and clicking across the top of the facing, following the contour of the wood. When you reach the right side of the image, click outside the image, then outside the lower right corner of the image, then outside the lower left corner, and then on the starting point to complete the selection (see Figure 3.15).
- Activate the Background by clicking it in the Layers palette, then Copy and Paste to create a new layer with the wood facing. Name the new layer 2 Wood Facing.
- Activate the Background layer again. Create a new layer and fill with black (Edit>Fill Set Content to Black). Call the new layer Black Background.
- 6. Shut off the view for the Black Background layer so you can see the pears.
- 7. Select the Polygon Lasso tool, and use it to follow the contour of the two pears to the right of the image, using short segments between clicks (see Figure 3.16). You can use other selection tools if you feel more comfortable. The goal is to isolate the pears. Technically you will not have to make an incredibly tight selection around the part of the pears that is over the black, but try to make the selection as tight as possible.

- 8. Activate the Background layer, Copy, and then Paste. This will create a new layer with the pair of pears. Name the new layer 4 Isolated Pears.
- 9. Move the 4 Isolated Pears layer above the 2 Wood Facing layer in the layer stack, and turn on the view for the Black Background layer. The layer stack should look like Figure 3.17.

FIG 3.14 Depending on your setup in CS4 new features may already show the image in a larger window. To test out resizing, choose Window>Arrange>Float in the Window menu. When the image is floating, click and drag the image window controller at the lower right of the image to make the document window larger.

FIG 3.15 Going outside the boundaries of the image with a selection tool (as shown here) will make sure you select tightly to the edge of the image.

FIG 3.16 Using short segments with the Polygon Lasso can make a selection that is rather smooth and is fine for the purpose of this exercise.

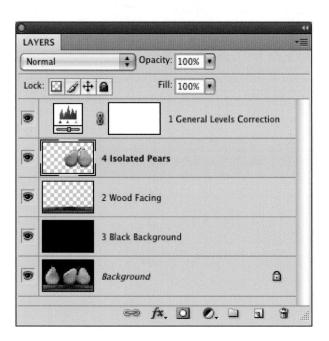

FIG 3.17 In a few quick steps, the components of this image are isolated into separate layers.

This simple example isolates the pair of pears and gives you the freedom to move them in the image and change the composition. Using the Move tool, try placing the pears in a different position, or even flip the pears horizontally (Edit>Transform>Flip Horizontal). You'll want to either keep this image open or save it to continue with the exercise in the next section.

The basics of re-creating the pear image required isolating each of the image areas and/or replacement of those areas with suitable substitutes. The additional effort of re-creating the image proves more fruitful than trying to do something such as stamp out the pear on the left with the Clone Stamp. It would be painstaking to fill in the area behind the pears using the Clone Stamp and make associated repairs look right. It is worth trying to make the Clone Stamp correction to see what I mean. Inevitably it would look uneven, blotchy, and repaired. Re-creating the entire black background from scratch does several things, including providing the opportunity to remove any distracting imperfections from the black background. It is also a lot quicker.

Of course this replacement is not perfect. We could build back in the wood platform and add noise to the background to make it appear more like the original. In the pear example in Figures 3.11–3.13, I used quite a few different types of layers, some which will not be apparent by the screenshot of the Layers palette alone. Some of the layer changes employ Modes, which we will look at later in Chapter 5, and more than one includes a mask or clipping group, which we will look at in Chapter 4. As these techniques are covered in later chapters, it isn't appropriate to cover them here, but we will look at similar examples in chapters to come.

Adding Layers for a Change

Layers that act like Adjustment layers because they serve to make changes in the image, but actually are also similar to isolation layers, can be added to an image. Objects are added to separate layers, either from scratch (using Paintbrush, Clone Stamp, or Healing tools) or as image areas (copied from other images or even cloned from elements in the same image). The objects are added to layers to give freedom in adjusting, positioning, repairing, and replacing objects, as well as offering flexibility in masking and positioning in front of or behind other image elements in the layer stack.

Additions for change in the example are represented by layers such as the Remove Glare layers in Figure 3.12. For these adjustments, new layers were created, and then repairs were stamped over select areas of the pears using a combination of the Clone Stamp and Healing tools. Pear stems were borrowed from different shots in this same series of images so the stems would reflect the same or very similar lighting qualities. Color adjustments were added by sampling color from the pear that was removed and painting it back over the existing pears using different layer modes (which, again, we'll discuss in Chapter 5).

The most obvious use for this type of "added change" layer is to repair damage or to patch plain ol' ugly areas of an object or area. You could do this directly to objects without adding layers, but keeping the changes separate in layers offers opportunities that you would not have with direct, permanent application of image changes.

Simple Layer Repair Example

If you still shoot film, have tried to convert old photos to digital, or have ever had a dirty sensor or lens, you will be no stranger to correcting minor imperfections in your images that come in the way of dust and debris. Digital shooters may not see as much dust as they see other minor imperfections in their images, like litter, crumbs, etc., though sometimes they might see annoying and persistent spots resulting from dust on the sensor. You can often make quick work of dust and minor debris corrections, no matter where it comes from, by applying the Clone Stamp or Healing tool directly to an image background. However, applying these corrections to a blank layer offers much more flexibility. Once you are sure the correction is the way you want it, you can commit the change by merging the layers, or just leave them in separate layers. The advantage here is that if you muff up part or all of the correction, you still have the opportunity to fix it. You also have the opportunity to use tools in combination with one another such as using both the Clone Stamp and the Healing tool for a correction.

The pears in the example image we are currently working on had some obvious imperfections that needed to be taken care of. Of course, you could do this before taking the image apart into separate objects. One large dent in the middle of the three pears needed some fixing. This is taken care of with simple layered repair.

☐ Try It Now

- 1. Continuing from the previous exercise, create a new layer above the 4 Isolated Pears and call it 5 Clone Stamp.
- 2. Create a new layer above the 5 Clone Stamp layer and call it 6 Healing.

If you are unsure of the positioning of the Cloning and Healing layers, see where they are in Figure 3.18.

- 3. Shut off the view for the 1 General Levels Correction layer; leaving the layer visible may affect cloning corrections.
- 4. Activate the Clone Stamp layer by clicking on it in the Layers palette. Choose the Clone Stamp and set the options to Sample All Layers—if you don't, it will not stamp to a blank layer. Apply the tool to make a correction of the damaged areas.

To apply the Clone Stamp, note the color and shape of the damage, and try to find a spot in the image that will make a good replacement. Set the brush size to just slightly larger than the width of the problem area, and use 50–80 percent hardness (leaving a soft edge to blend

In Adobo

corrections). Usually I set the tool to Aligned (check the box), which I the alignment angle and distance between the brush and the sam, point constant. Sample the area you will be using to replace the damag by holding down the Option/Alt key and clicking on the area. Move the brush over the damage and apply. It is best to apply in short bursts, and it is a good idea to resample from different areas often to avoid obvious patterning and to blend in texture, contour, and detail from multiple directions. Doing so will help create unique corrections of the areas.

5. Activate the Healing layer by clicking on it in the Layers palette, and then choose the Healing tool. Set the brush and Options like you did for the Clone Stamp, but make the brush 100 percent hard—the nature of the tool blends in the application. Make a sample and apply the tool to make a second correction over areas corrected with the Clone Stamp to blend in the corrections.

The resulting layers and image can be seen in Figures 3.18 and 3.19, and you can check your work against the Sample_4_corrected.psd image on the CD.

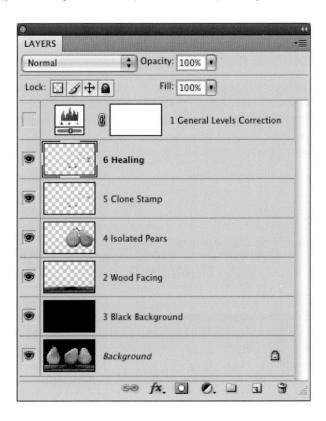

FIG 3.18 The Layers palette shows the separate correction layers for Clone Stamp and Healing. Be sure to clone and heal to the blank layers with the tools set to Sample All Layers in the Options bar.

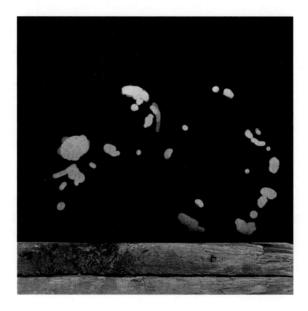

FIG 3.19 If you shut off the 4 Isolated Pears layer, you can see what the Cloning and Healing layers look like without the rest of the pears.

Applying the Healing tool directly to a problem can lead to similar results, but it has been my experience that applying the Clone Stamp first to neutralize the ugliest part of the damage and then applying the Healing tool will yield better results (less noticeable edges) more consistently.

The most difficult parts of this correction will be the damage near the edges of the pears—where the pears meet the black of the background. The problem will be that the Healing tool will try to do too much: it will pull in some of the black background as part of the repair that it tries to make. There are several things you can do to eliminate this problem:

- Use only the Clone Stamp in those areas near edges.
- Make a selection around the area you want to correct to exclude the black from the background.
- Make a selection around the area you want to correct, including the
 replacement area, then isolate that on its own layer via Copy/Paste (see
 Figure 3.20). You can shut off other layers to limit what sampling takes into
 account, or change the tool option to Current Layer so that only content
 from the current layer is sampled in the repair.

Following these techniques you can make freehand corrections to this image in infinitely different ways, each equally as convincing. Check your handiwork by toggling the view for the correction layers. You may want to group them so you can toggle the view as a group. This will let you compare before and after, and should you want to flip the pears horizontally, you can flip the whole group (see Figure 3.21).

FIG 3.20 A distinct advantage of using Healing with layers is that you can limit what gets sampled for use in the correction.

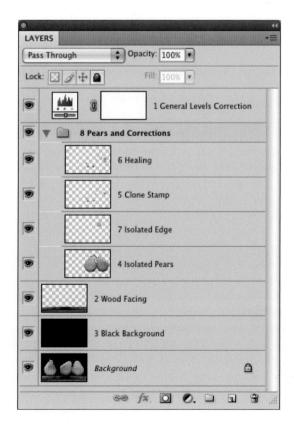

FIG 3.21 This shows the final layer set for this set of examples, including the Isolated Edge layer and Pears and Corrections grouping.

The Art of Color Balance

Although Levels are excellent tools for normalizing color, they may not always produce the best correction for color casts if you use them only to extend the dynamic range. A tweak to color balance will often do quite a lot to enhance your image's color.

The idea of the Color Balance function is to allow you to shift the balance between opposing colors: cyan balances against red, green against magenta, and blue against yellow. These adjustments can be made using separate ranges: highlights, midtones, and shadows. Working through a Color Balance correction by gauging the changes on screen can often clear up muddy appearances caused by lighting conditions. The Color Balance dialog is a friendly, easy way to make these changes. Rather than trying to calculate a result, you'll work with Color Balance interactively. The goal is to achieve more vibrant, balanced color.

☐ Try It Now

- Open the Vanishing Point.psd file on the CD. This image was originally provided in the Samples folder in the Adobe Photoshop CS3 program folder and on the installation CD with the Sample images.
- Treat this as a new image and do a Levels correction as described earlier in this chapter. You won't be able to do to much, but you'll see a small change in the image.
- Open Color Balance by choosing Color Balance from the Adjustment Layers submenu (Layer>New Adjustment Layer>Color Balance).
- 4. Start with the Midtones (under the Tone Balance panel), and slide the Cyan/Red slider between -50 and +50, watching the effect on the image. Narrow down the range that looks best by swinging the slider in smaller ranges until the best position is achieved based on the screen preview. The "best" position is where the color seems most balanced against the extremes (which you use +50 and -50 to preview).
- 5. Repeat step 4 for the Magenta/Green slider.
- 6. Repeat step 4 for the Yellow/Blue slider.
- Click the Highlights radio button on the Color Balance dialog and repeat steps 4 through 6. This will make adjustments to Color Balance for the Highlights.
- 8. Click the Shadows radio button on the Color Balance dialog and repeat steps 4 through 6. This will help you make adjustments to Color Balance for the Shadows.
- Repeat steps 4 through 8. This will allow you to review earlier adjustments in the context of the changes you made to the Shadows.

The steps here might seem an oversimplification, but this is really all you have to do with Color Balance to achieve the desired result. The critical part of this exercise is that you have to be able to trust your monitor, so it will need to be calibrated (and hopefully tested against output as well). Depending on your choices, the Vanishing Point.psd image will show a dramatic difference after Color Balance, even with small movements of the sliders. Changes will influence color, saturation, dynamics, and even details in the image. You can see the effect on details usually in the highlights (the back of the dog's head—or if you try to apply a Color Balance change to the pear image, you will see some variation in the specular highlights where the light is reflecting from the source). The color result of a correction on the Vanishing Point.psd appears in the corrections on the CD. You'll want to toggle the view for the Color Balance 1 layer to see the difference before and after the application. Figure 3.22 shows the Color Balance settings used to make the change.

Summary

In this chapter we have begun to use Layers to actually make a difference in image appearance, first with an isolated Levels correction, then with isolating objects in the image for control of the composition, and then for making isolated corrections. The Levels correction and Cloning/Healing corrections are techniques you can use on virtually all your images. Object isolation may not be something you will do every day, but the basic concept of isolation is something you may use all the time—actually we used a variation at the very end of the section on Healing corrections by isolating the edge area.

Thinking about your images and your corrections as made up of separate, layered corrections is the key concept that should be coming across here. Layers offer opportunities for isolated correction. Separation poses advantages while making the change, as well as having additional advantages once the correction has been created, in that it can be changed later.

Changes to this image need not be limited to the corrections shown in this chapter, and other corrections can certainly be considered. Think about what you would like to see in this image, and imagine how that requirement might be solved with additional layers or those you have already created. Attempting to make some or all of those additional changes is good practice with layers. In fact even practicing thinking about how you will make corrections (and specifically what corrections you want to make) will help make you better at applying changes and choosing techniques.

A valuable thing to do with the information in this chapter is to begin applying the changes to your own images. Choose one or more of your images and test out selective enhancements using layers. You don't have to do everything from this chapter to every image, but you should make an attempt to try out everything to see how the techniques might apply to your corrections:

- Start with making a Levels Adjustment layer to correct image color.
- Attempt to isolate an image area by selection, copy, and paste.

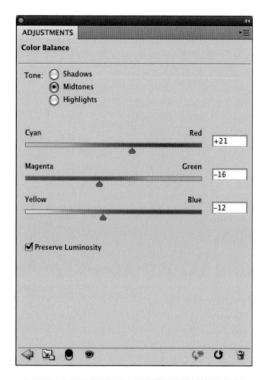

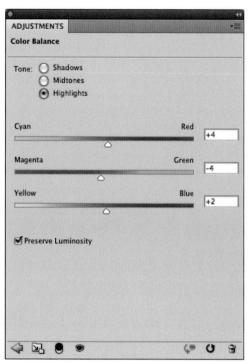

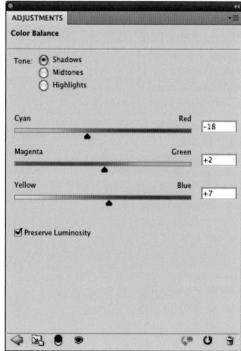

FIG 3.22 Color Balance influences many parts of the appearance of your images. When it is corrected for this image, the scene will appear to gain some depth of color.

- Adjust the position of an object if you are really daring. See what it does to the image and if you can make it work.
- Locate some image area(s) that you want to improve with simple cloning corrections, and create new layers to help you incorporate the change.
 Then stamp out and heal problem areas.
- Fine-tune color and remove color casts with Color Balance.

Keep in mind that working with additional images can be an exercise without a real goal of achieving improvement in the image: it is enough at this point to perform the techniques as exercises or practice. Do, however, make serious corrections if they are warranted in your images to exercise the true value of layers.

If you have additional questions about the techniques, visit the forums at photoshopcs.com to discuss how to use the techniques and ask questions.

Masking: Enhanced Area Isolation

In the previous chapter we looked at using Layers to isolate image corrections and target changes. That chapter covered the idea of applying corrections via separate layers, using Adjustment layers, and isolating image objects on their own layers. This chapter looks at some additional types of isolation using layers and masking to create flexibility with layers and correction.

Masking provides power in correction. Simply put, masking blocks off areas of an image from change or hides them from view. It is similar to masking off woodwork when you go to paint a room or masking windows and chrome when you go to paint a car. Masking is different from erasing image areas, as erasing is permanent (destructive) removal; using masks hides pixels temporarily and is nondestructive. One of the most basic types of masking is something we did in the exercise at the end of Chapter 1. In that exercise we used a duplicate of the Background layer to mask the Drop Shadow layer (see Figure 4.1).

More sophisticated means of masking are comparable to the simple masking we explored in the exercise, just with more finesse. All types of masking

FIG 4.1 The simplest type of masking with layers is using the content of an upper layer to hide the content of the lower—the content of the lower layer is still there, but it is hidden from view. In this case the image masks the parts of the red shadow that run below it in the Layers palette and effectively behind it in the image.

share the same concept: masking acts to block image content from view without removing or destroying image content; this is unlike erasing, which is permanent and destructive.

Expanding on Process

We have advanced in the chapters from discovering where functions are to applying functions just for the joy of seeing them work and then to seeing how they work to achieve a purpose. In this chapter, we'll advance even further by exploring functions as part of the Layers work flow working with the image in Figure 4.2.

Looking back at our outline for correction (Chapter 2), it is a good idea to start corrections by evaluating the image. A developed hit list of corrections you intend to make for this image, roughly conforming to our previous outline, might look like this:

- 1. Clean up pollen and dust specks.
- 2. Reduce the significant digital noise.
- 3. Enhance the natural color and tone.
- 4. Add soft focus to go with the softness of the image.
- 5. Sharpen to enhance contrast.
- 6. Add color enhancements (paint in color).

Though the image is not a terribly good capture, when all is said and done, this image will have gone through enhancement to bring out what is lurking there. The result will be something like Figure 4.3, remarkably similar to the original capture in composition, but greatly enhanced in other ways.

FIG 4.2 Even though this image initially appears to be substandard, there is potential in the soft lighting and gentle tones and several interesting possibilities to enhance.

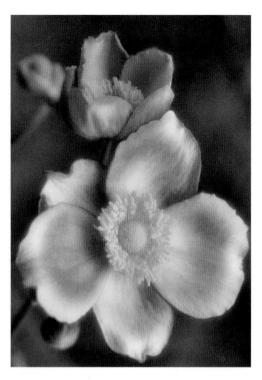

FIG 4.3 Following the corrections list, this image takes a dramatic turn for the better.

The image may seem to need a lot of corrections, but the results will be worth the effort and it will offer the opportunity to learn how to apply more layer techniques. We'll look at masking as it applies to layer transparency, layer clipping, Adjustment layers, and proper layer masks. We'll use layer masking to paint in effects, affect image sharpness selectively, and change image color selectively. Let's take each step in our hit list in order and explore corrections for this image fully to help you see the application of layers in process.

Clean Up

There are some obvious detail problems in this image that can be immediately wiped out, like the obvious dust speck and several smaller areas where pollen has been scattered. You will want to clean these areas up using the Clone Stamp and Healing layer techniques discussed in the previous chapter. You can probably get everything done here with one or the other of these tools, but you can set up the two-layer technique if you want.

Try It Now

- 1. Open the Sample_5.psd file on the CD.
- Create a new layer and call it 1 Spot Adjustments. Choose the Healing
 or Clone Stamp tool and make corrections for the obvious problems.
 If you use both the Clone Stamp and the Healing tools, consider
 creating separate layers for each and name them appropriately so
 you can better blend the applications.

If you need more detail or to review the techniques, please see the exercise in the previous chapter. When you have finished the cloning/healing, save the image so you can come back to it as we continue working through the hit list. One of the new techniques we'll explore thoroughly here is reducing image noise.

Reducing Image Noise

There are several ways to reduce noise in your images; probably few of them are obvious beyond the Reduce Noise filter. One of the key factors to keep in mind when addressing noise is that noise is just the opposite of blur. You can see this in a quick exercise.

Try It Now

1. Open a new blank image (choose File>New). Be sure the image is RGB and 1000×1000 pixels. After choosing your settings for the new file, click OK. For settings see Figure 4.4.

FIG 4.4 The New Image dialog with settings for step 1.

 When the image opens, fill with 50 percent gray. Use the Fill function (Edit>Fill), and select 50% Gray from the Use drop-down list. Leave the Blend Mode at Normal and the Opacity at 100 percent (see Figure 4.5). Click OK.

FIG 4.5 The Fill dialog with settings for step 2.

3. After the fill, apply some noise to your image with the Add Noise filter (Filter>Noise>Add Noise). When the Add Noise dialog opens, make the Amount 10 percent and the Distribution Uniform. Leave the Monochromatic box unchecked. When you have completed the settings (see Figure 4.6), click OK on the dialog. Your image will fill with noise.

FIG 4.6 The Add Noise dialog with settings for step 3.

4. Now open the Gaussian Blur filter dialog (Filter>Blur>Gaussian Blur). Set the Radius for the filter to 25 pixels and click OK. This will mediate all the noise you added in step 3, and you'll be back to flat gray, eliminating the noise (Figure 4.7).

FIG 4.7 The Gaussian Blur filter dialog with settings for step 4.

I hope that you see from this quick example that you can obliterate noise with blur. However, applying blur to everything in your image will lead to a blurry image. You'll obliterate detail as well as the noise. Often you'll need to be selective about just what to blur. There are many ways we could go about this, and we'll look at a method that allows us to explore noise reduction while maintaining the advantage of layers by continuing work on the Sample_5.psd file you saved earlier in this chapter after making the initial cloning/healing corrections. Go ahead and close the Noise Example image without saving.

Try It Now

 Create a new layer above the Healing/Clone Stamp layers, call it Manual Masking, and number it accordingly. This exercise assumes you have used one layer for healing/cloning, so it will be named 2 Manual Masking. This layer will be the canvas for defining the mask you will create in the following steps. 2. Choose the Brush tool and press D to set the default colors (the foreground will be black). Be sure the brush you have selected is round, 100 percent hard, and 100 percent opaque and turn off all brush dynamics (see Figure 4.8). Try to use a larger brush 20–30 pixels in diameter. Use either the Brush Preset Picker on the Options bar when the tool is selected or the Brushes palette (Window>Brushes). This brush will be used to outline the mask you are creating.

FIG 4.8 Uncheck the boxes under Brush Presets to shut off all brush dynamics. Choose a brush that is 100 percent round, set the Diameter to between 20 and 30, Angle to 0, Hardness to 100 percent, and Spacing to 1 percent.

3. Begin applying the brush to the image to outline the petals (see Figure 4.9). You want to get pretty tight to the petals to create a solid outline. Most of your movement will be freehand, but short line segments can often be easier to control. To create line segments, hold down the Shift key and click between points to draw a straight line between clicks. Complete the outline (see Figure 4.10).

FIG 4.9 Use the brush to define the general outline. Come back and fill in with a smaller brush in tighter areas to complete the outline.

FIG 4.10 Complete the circuit, outlining all the way around the petals.

- Brush size can be changed with keyboard shortcuts. Increase brush size with the] key, and decrease brush size with the [key.
- 4. Choose the Magic Wand tool. Set the Tolerance to 10, check the Antialias box, check the Contiguous box, uncheck Sample All Layers, and be sure the 2 Manual Masking layer is active. With all that done, click on the flowers. This will select the area inside the black outline you created.
- 5. Expand the selection (Select>Modify>Expand) by half the diameter of the brush selected for step 2 (e.g., 10 pixels if you used a 20-pixel brush). This will push the selection out over the outline you created.
- Invert the selection (Command+Shift+I/CtrI+Shift+I (Mac/PC))
 and then Fill with black. This will invert the selection so it is over
 everything but the flower petals and will fill the area around
 the flowers with black (see Figure 4.11). Deselect by pressing
 Command+D/CtrI+D.

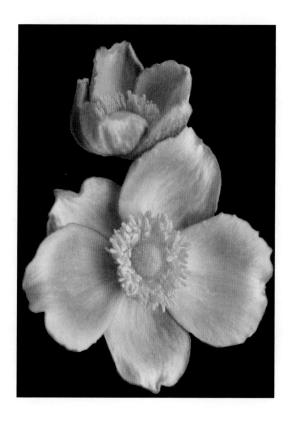

FIG 4.11 Once filled with black, the flowers are visibly isolated and we can use this as a selection and mask for additional changes.

Composite Layers

Composite layers are useful in certain circumstances to either provide a point to freeze your changes as a culmination of previous layers to continue working from or provide image information to enable additional changes. What composite layers do is collect whatever is visible in the image into a new layer.

To capture the composite layer, make sure the image shows exactly what you want to capture in the composite (you may need to toggle layer views), then create a new layer and press Command+
Option+Shift+E/Ctrl+
Alt+Shift+E. Pressing these keys will stamp the visible content to the new layer. Usually you will want to rename the new layer with an appropriate name!

Sometimes you will capture the composite of the entire image with all of the layers on to have a point to move forward from cleanly after making a lot of changes. Other times, such as in this example, there are specific layers to take a snapshot of. Because a mode was applied to the Dupe Manual Mask layer, it only appears desaturated because of the calculation the layer performs: there is no layer that actually has the desaturated content. Making a composite

- 7. Duplicate the 2 Manual Masking layer and rename it. I called it 3 Dupe Manual Masking Blurred and Desaturate. You will use this layer to make additional refinements to the mask.
- 8. Change the mode of the 3 Dupe Manual Masking Blurred and Desaturate layer to Color and apply a Gaussian Blur to soften the edge (I used 3.5 pixels in the example). The change in the mode will desaturate the area under the mask; blurring will soften the edges and ensure that the changes based on this mask will blend in at the edges of the petals.
- 9. Shut off the view for the 2 Manual Masking layer, be sure the 3 Dupe Manual Masking layer is active, and capture a composite by pressing Command+Option+Shift+E/Ctrl+Alt+Shift+E. This will reveal the content under the 2 Manual Masking layer and then create a new layer with the current visible saturated and desaturated content collected. Name the new layer 4 Composite.
- 10. Hold down the Command/Ctrl key and click on the layer thumbnail for the 3 Dupe Manual Masking layer. This will load the solid part of the layer as a selection.
- 11. Activate the 4 Composite layer, and duplicate the selected area to a new layer: Command+J/Ctrl+J will do the trick. Name the new layer 5 Copied Masked Area from Composite. This will isolate just the desaturated area of the image into its own layer.
- 12. Duplicate the 5 Copied Masked Area layer, and name it 6 Duplicate of Copied Masked Area.
- 13. Group the 6 Duplicate of Copied Masked Area layer with the 5 Copied Masked Area layer by pressing Command+Option+G/Ctrl+Alt+G. This makes a Clipping group from the layers. Apply a Gaussian blur of 6 pixels to the 6 Duplicate of Copied Masked Area layer, then apply Add Noise at 2 percent using Gaussian distribution. Your layers should look like Figure 4.12. The blurring will soften the area around the flowers, mitigating the noise, and the Add Noise application will help rough up the texture of the area again so it is a better fit to the rest of the image.

Remember this compositing technique as another means of organizing content in layers! It is frequently a handy technique.

Steps 1 through 6 create the template for the mask you need to isolate the area that is changed in the later steps. Making the Clipping group masks contains the blur to the masking shape, rather than allowing the blurred edges to bleed into the petals. Applying blur softens the noise, and adding noise back roughs up the blurred image area so it doesn't seem unnaturally smooth. The result should show a slightly softer peripheral area with greatly reduced noise (see Figure 4.13).

allows you to regroup the image information in one place and commit it to tangible pixels. When you have gathered image information in a composite, blurring will affect the desaturated masked area directly and in isolation from the rest of the image.

FIG 4.12 Some layers (1, 2, 3, and really the Background as well) are becoming extraneous to the result by the end of step 13 because of the 4 Composite layer, but they provide valuable clues as to how the result was achieved.

FIG 4.13 Masking and blurring helped reduce noise without compromising important detail.

The main concept to keep in mind here is that Blur and Noise filters can work well together in reducing the appearance of noise in your images and maintaining a realistic appearance. A secondary concept is isolating the image area(s) that you want to affect. Here we used manual masking techniques, selection, and Clipping layers to achieve isolated effects.

Again, you will want to retain this image so we can continue making corrections. Now let's look at enhancing natural color.

Enhancing Natural Color and Tone

After taking quite a while to examine some options with noise, we'll step back to what should be a more familiar area of Levels corrections. You want to apply a Levels correction as an Adjustment layer masked to the flowers to make the most of the color and tone as captured and balance the color and light. As you have already defined the mask, applying it is easy. A second part to this color enhancement will be using Hue/Saturation to emphasize and control colors in the image.

Try It Now

- Command+click/Ctrl+click the 3 Dupe Manual Masking layer icon to load the layer as a selection again. Invert the selection. The inverted selection targets the flower.
- 2. Choose Layer>New Adjustment Layer>Levels from the program menus; when the New Layer dialog appears, name the layer 7 Levels Correction for Flowers and click OK. The Levels layer will be created with a mask that targets the flowers using the selection loaded in step 1. Make your best effort in the Levels correction (consulting the instructions from the previous chapter if you need to).
- Choose the Eyedropper tool (press I), and set the Sample Size option on the Options bar to 5 by 5 Average. The settings for the Eyedropper affect samples we will be making in later steps on the Hue/Saturation dialog.

Setting the Sample Size for the Eyedropper affects the way sampling tools behave on other tool dialogs.

- 4. Command+click/Ctrl+click the 3 Dupe Manual Masking layer again to load the layer as a selection. Invert the selection (Select>Inverse). This selects the flowers again.
- Choose Layer>New Adjustment Layer>Hue/Saturation. Move the Saturation slider to 110. This creates a Hue/Saturation Adjustment layer targeted to the flowers and saturates the colors that already exist in the flower.

- 6. Choose Magenta from the Edit drop-down list on the Hue/Saturation dialog. We are going to work a little more with the petal color in a particular color range, and this is the first step in narrowing the range.
- 7. Click in the image over the pink area of the petals. Then click the Add to Sample eyedropper on the Hue/Saturation dialog. This tool will adopt the settings you chose in step 3 and allow you to expand on the color range selected in step 6. Click and drag the sampler across one of the flower petals (see Figure 4.14). This will select the color range for the petals.
- 8. Drag the Saturation slider to the right until the pink area of the image is just about to burst with color. I chose 120 for Saturation and 13 for Hue. We will be softening the look a bit, so making the color strong is OK as it will be moderated.

FIG 4.14 The initial click sets the standard range, while the click-and-drag samples a range of color to add to the initial sample.

The Hue setting of 13 was merely a preference, but checking a range of hues by moving the Hue slider should tell you how successful your range selection was for the petal color.

This Hue/Saturation technique can be used in combination with masking and color range selections, making it a very versatile tool. You might, for example, consider making a change to the center of the flower by choosing another color to edit on the Hue/Saturation screen, creating another range using the sampling tools, and making an adjustment. You may need to combine this with additional masking to achieve the result you are looking for (Figure 4.15). For example, if you set the color range and make a hue adjustment, and it changes other parts that you don't want it to, you can easily block the changes by adjusting the mask.

FIG 4.15 Because there is a lot of yellow in the eye of the flower, it is virtually impossible to isolate the change by a color range selection alone. Here the color change is made to the whole range and then a mask is added on the Hue/Saturation layer to reveal the change only over the center of the flower. (a) All yellows adjusted. (b) The mask added to Hue/Saturation. (c) The masked result.

Masking in this case allows you to make a change and then localize the change to the area you want to correct. This is just a small hint as to the enormous power of masking. Hold on to that image, there is more to come as we work on soft-focus effects.

Add Soft Focus

Whereas there are certainly parts of this image that are in focus, the very shallow depth of field and lighting make the nature of this image a little soft. I find it is usually better to go with the flow and not try to force a softer image to pretend to be tack sharp. There are ways to make this image look sharper, and we'll look at that a bit later. Enhancing the soft focus may be more natural and helpful in making this particular image look its best.

Soft-focus effects are achieved photographically by scattering light. Soft-focus filters and soft-focus lenses help achieve the effect, and similar effects can be had by using a UV filter and smearing the outer edge with Vaseline (leaving the center of the lens clear). The latter may seem like quite a sloppy solution, but the reasoning is all the same: disburse some of the light passing into the lens and diffuse it.

To have light you have to have brightness. That is, darker parts of your image will tend to have less light to disburse, and lighter parts will have more. The logical solution for creating soft-focus effects would be to make a selection of image content based on brightness and then copy that to its own layer and blur. After applying the effect, use layer opacity to control the intensity and layer modes to refine the effect you want.

Following this logic, we can look at a slightly more advanced and satisfying result for this image. Remember that we have already blurred the background, and maybe we want to contain further blurring and effects. We can do that by compounding masks, as we'll do in the following exercise.

Try It Now

- Create a Composite layer at the top of the layer stack and name it 10 Composite Color Enhancements (see Figure 4.16).
- Once again, load the mask we made for the flowers as a selection.
 You can do this in a variety of ways, but—as we haven't done it
 quite this way—hold down the Command/Ctrl key and click on the
 mask for the Levels or Hue/Saturation layers created in the previous
 section.
- 3. Copy the content of the 10 Composite layer to a new layer using the selection you just loaded. Copy and Paste will work, as will

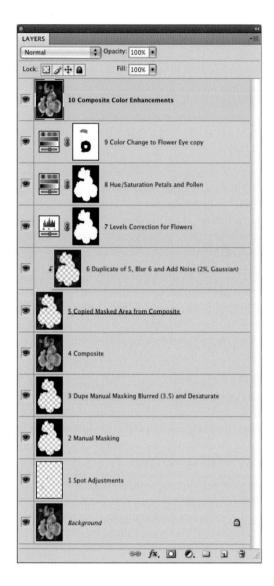

FIG 4.16 Using one layer for the spot corrections early on and adding the color change for the eye of the flower, there are currently 10 layers in this image, including the new composite. You may have fewer or more layers depending on the choices you made in processing.

- Command+J/Ctrl+J. Name the new layer 11 Copied Composite Using Blurred Manual Mask, or a similar name.
- 4. Blur the content of the 11 Copied Composite layer using Gaussian Blur and a radius of 30 pixels. This will turn the image to a horrible blurry mess—however, this is not the immediate goal.
- 5. Open the Channels palette (Window>Channels). This shows a display of the RGB information for the image at a glance (see Figure 4.17).
- 6. Hold down the Command/Ctrl key and click the thumbnail for the Green channel in the Channels palette to load it as a selection.

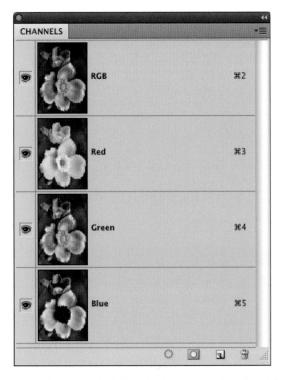

FIG 4.17 The palette controls and options for the Channels palette are very similar to those of the Layers palette, but Channels are quite a different animal, representing the RGB light components of the current image composite.

Green is at the center of the visible spectrum and as such shares similarities to what we might expect to see as a luminous conversion to black and white, so that is why it is being used. Other channels could be an option, as could Luminosity, which is a component of LAB mode. We'll look at Luminosity advantages later in this book.

- 7. On the Layers palette (you can close the Channels palette if you want), be sure the 11 Copied Composite layer is active, and then click the Add Layer Mask button at the bottom of the Layers palette. This will create a mask for the layer using the Green component. This will block the soft-focus effect in darker portions of the image.
- 8. Lower the opacity of the 11 Copied Composite layer to 50 percent. This will allow you to see through the blurring even more.
- Duplicate the 11 Copied Composite layer and change the mode to Softlight, then name the layer 12 Duplicated Copied Composite. This added layer will enhance the soft-focus effect. Your layers should look like Figure 4.18.

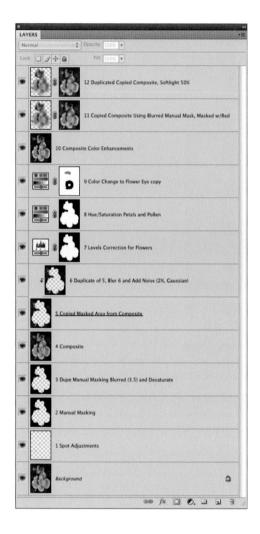

FIG 4.18 Check your layers after step 9 against these. You should have them in the same order with the same names.

The last few steps in the procedure here lower the effect of the blur by masking and use of opacity and then increase the contrast to compensate for some of the dynamics lost in the blur (Softlight mode). You can control this effect further by making adjustments to the layers you added using Opacity or Modes, increasing/decreasing the amount of blur, or changing the masking (e.g., for variations you could use the Red channel for the mask instead of the Green or load the mask before making the blur).

This image has come quite a way already, but there is still a ways to go. Be sure to save it off at this point so you can continue with the corrections in the next section. Try toggling the views on and off for the 11 Copied Composite and 12 Duplicate Copied Composite layers just to see the difference before and after the soft-focus addition. You can also compare before and after for the whole process (see the Before and After sidebar).

Before and After

There are several different ways to compare before and after. Here are three:

- 1. Toggle off the views for all layers other than the Background layer. To do this, you can click and drag the cursor over the Layer Visibility Indicators in the Layers palette.
- 2. Use the History palette to toggle between the original and the current state of the image by clicking the appropriate states in the History to undo/redo changes. Click the default Snapshot at the top of the palette to return to the original state and the last item in the History to return to the current state (see Figure 4.19).

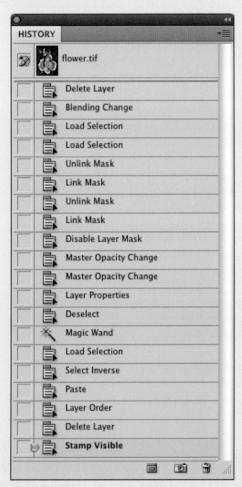

FIG 4.19 The History palette retains only as many states as you have entered in the preferences, but it does maintain the initial state of the image as well. Toggle between the initial state and the last one on the list to see before and after by clicking the Snapshot and the last step in the history.

3. Duplicate the Background layer and drag the duplicate to the top of the layer stack. Name it Before, and toggle the view as needed.

Any of these methods will work, depending on how you like to work and how you use layers; some methods may prove convenient at different times.

Color Enhancements

Color enhancements for this example image come in two types: enhancement of natural color, as we looked at earlier in this chapter, and enhancement by addition, which we'll look at here. In this image, adding some muted color to the additional objects in the scene, like the stems and buds in the background, will make them seem less distant, and more a part of the image, while giving the image a little more dynamic overall look. We'll take a look at this color adjustment and how to do it with layers by painting in color enhancements.

Try It Now

- 1. Create a new layer at the top of the layer stack and call it 13 Green.
- 2. Choose the Paintbrush tool and a small soft brush, then double-click the foreground color swatch on the toolbar and choose a green (I chose RGB: 15, 120, 20). Lower the Opacity of the brush to 50 percent. A 50 percent brush opacity will be only partially opaque and will layer color as you apply it. Applying over the same area more than once darkens the color and yields density changes that may prove pleasing in the final result.
- 3. Paint on the 13 Green layer over the areas of the image that should be green. I painted over the buds and stems to the left. Don't worry about the coverage being 100 percent or whether it is completely even—in fact you may not want it to be (see the comments after the exercise).
- Apply a Gaussian Blur to the layer, just a few pixels (five or so). This will smooth out and blend in the color.
- Set the layer to Color mode and adjust the Opacity until it seems pleasing.
- Add a Hue/Saturation layer as a Clipping layer grouped with the 13
 Green layer. By moving the Hue slider you can try variations on the
 color to see if there is a shade you like better. Your layers should look
 like Figure 4.20.

By repeating these steps with other colors, you can add color to other areas of the image, such as the petals. Consider opportunities for layering color. For example, in this image I used yellow to create some highlights on the buds; blue complements may have worked as well. Add a new layer for each of these colors so you can control Opacity and Blur separately for each color.

Experiment with adding color on multiple layers, using different layer modes and brushes. For example, I often use the Fade control and other brush dynamics for size to taper brush strokes and apply other randomizing brush effects. Whereas the layers themselves are acting as masks by locating color

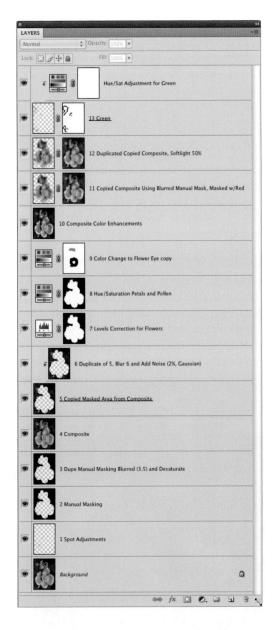

FIG 4.20 You added two layers, each with a layer mask, during this set of steps. Only the mask on the 13 Green layer is affecting the visible content of the image.

where the brushes are applied, layer masks can confine changes after the fact. There is a lot of room for creative application of color and we can't possibly cover it all, so experimenting is key to seeing what you can accomplish.

Sharpen and Enhance Contrast

Sharpening an image is sometimes understood as an action or application of filters done to make an image magically appear to be more in focus. That

is not really what sharpening does. Sharpening is meant to enhance edge contrast and detail that already exist in an image. If an image is utterly out of focus, soft and blurry, then there are no strong edges, nothing to sharpen, and applying some means of sharpening may actually end up making the image look worse—depending on how the sharpening is applied and at what strength. The goal of sharpening is never to snap an out-of-focus image into sharpness.

Sharpening will do several things very well. It will:

- enhance the appearance of sharpness already in an image, to make it appear even sharper;
- enhance edges in images that are going to print to help counteract dot gain (by which ink bleeds into the paper and softens images);
- enhance existing contrast.

On the negative side, sharpening can also:

- cause edges to exhibit haloing, in which edge contrast is enhanced too much and appears to create a glow around the edges (see Figure 4.21);
- cause image damage by blowing out highlight detail (making color run to absolute white) or blocking up shadow detail (making color run to absolute black) while it increases and enhances contrast.

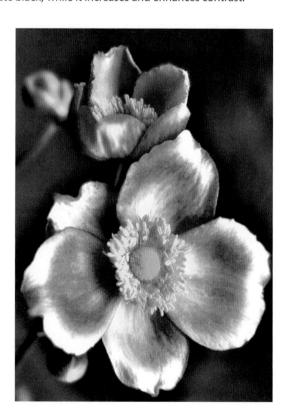

FIG 4.21 This exaggerated sharpening displays a dark halo around the flower petals; the edges of the petals blow out, noise is enhanced, and detail is lost. Be careful with sharpening or your images can sustain similar damage.

The upshot is that sharpening can do just as much harm as good if you use it incorrectly. We'll look at best practices for using the Unsharp Mask and how to use it for both enhancing sharpness and enhancing image contrast. Later we'll look at a much different means of sharpening by combining several techniques that we have already looked at.

Unsharp Mask can work wonders in some images that are already reasonably sharp and can work well with fine detail like fur. For the following exercise, continue working with the image we've been using throughout this chapter.

☐ Try It Now

- Create a new layer at the top of the layer stack, call it 14 Unsharp Mask.
- Copy the visible content to the layer by pressing Command+Option+ Shift+E/Ctrl+Alt+Shift+E. This puts the visible content of the image on one layer so the filter can be applied.
- 3. Open the Unsharp Mask filter (Filter>Sharpen>Unsharp Mask).
- 4. In the dialog, set the Amount to between 50 and 100 percent, the Radius to between 1 and 3 pixels, and the Threshold to 0.

Higher Amount and higher Radius will affect more pixels more intensely. The settings noted here work with most images (4–8 megapixels). Use higher Radius and Amount settings for larger images; use lower settings for smaller images.

5. Click OK.

Depending on your settings and how you have handled the image thus far, sharpening may have given you pleasing, somewhat pleasing, or sorta ornery results. The fact is that very little of this image will need sharpening, and because of the nature of the image and added noise, you may actually experience unpleasant enhancement of noise. Sharpening does not play favorites, it enhances everything in the image.

Your choices are to use the same measures we've been looking at throughout this chapter to control the result: masking or opacity. Here it may be best to mask the change to the part of the image that benefits most: the eye of the flower.

Try It Now

 Be sure the 14 Unsharp Mask layer is active, and click the Add Layer Mask button at the bottom of the Layers palette. This will add a mask to the layer.

Unsharp Mask

The Unsharp Mask filter causes a lot of confusion because of its name. It seems incongruous that a filter called "unsharp" is used for sharpening an image.

The word unsharp comes from darkroom practice. A blurred, inverted copy of a negative was sandwiched with the original to create an edge mask. During exposure in the darkroom, that unsharp mask was used to enhance edge separation, increasing the apparent sharpness of the results. The Unsharp Mask filter attempts to mimic the results of this type of masking using a digital calculation.

- 2. Fill the mask with black. You can do this by using the Paint Bucket tool with black as the foreground color, or choose Fill from the Edit menu and use Black as the Content.
- 3. Choose the Brush tool and a medium-soft brush, change the foreground to white (press D with the mask thumbnail active), and paint over areas you would like to sharpen selectively (following the exercise, that would be over the eye of the flower). Painting white into the mask reveals those areas (check Figure 4.22 after the next segment of the exercise for a thumbnail of what the mask should look like).

Another means of applying Unsharp Mask is using a smaller Amount (10–30 percent) and broader Radius (50–100 pixels). This will enhance the local contrast in your image. This can often work well with images that seem a little flat, but can still be abused and may lead to trouble. There are other techniques that we will look at in later chapters using layer modes that will also enhance local contrast.

Local contrast is part of how objects and colors play against one another. Enhancing local contrast is not as radical as flatly enhancing contrast in an image, as it depends on object and color proximity.

There is an alternative to applying a layer mask that yields identical results, but can sometimes come in handy: using a Clipping layer instead of a mask. Try using Clipping groups instead of standard layer masks.

☐ Try It Now

- 1. Duplicate the 14 Unsharp Mask layer by clicking on it in the Layers palette and toggling the view for the original layer 14 to off, and change the name of the new version to 14 Unsharp Mask II.
- 2. Toss out the mask on the new version of the layer. To do this, click on the thumbnail for the mask and drag it to the Trash on the Layers palette. A dialog will appear asking what you want to do with the mask (see Figure 4.22). Click Delete.

FIG 4.22 Click Delete to remove the layer mask without changing the content of the layer.

- Create a new layer by clicking the Create New Layer button on the Layers palette. Call it 15 Unsharp Mask Masking.
- 4. Press Command+[/Ctrl+[to move the new layer below the 14 Unsharp Mask II layer.
- 5. Activate the 14 Unsharp Mask II layer again by clicking it in the Layers palette and press Command+Shift+G/Ctrl+Shift+G (this was Command+G/Ctrl+G for Photoshop CS or earlier, or for Elements users). This creates a Clipping group from the 14 Unsharp Mask II and 15 Unsharp Mask Masking layer.
- Choose the Paintbrush tool, pick a brush, activate the 15 Unsharp
 Mask Masking layer, and paint on it to reveal the sharpened contents
 of the 14 Unsharp Mask II layer. Your layers should look like Figure 4.23.

With this type of masking it is the solidity of the lower layer (rather than the tone of the mask) that controls what can be seen. You can set up Snapshots in the History palette to compare the two methods of sharpening, as we did in the Applying Levels for Color Correction section of Chapter 3.

Additional Manual Sharpening

One thing you will be able to do here (for practice, fun, learning and if you have the time) is to try to sharpen up the edges of some of the petals that seem soft. Much of this is an artistic decision, but one that relies on a simple idea: lack of sharpness is apparent where edges are blurry. Fix the edges and you improve the sharpness of the image.

A manual way to enhance edges and create sharpness where it seems to be lacking is to paint in new edges using our Clone Stamp and Healing layers. This is not something you will do often, but it can work in this image, and several of the petal tips could do with some sharpening!

☐ Try It Now

- 1. Create a new layer at the top of the layer stack and call it 16 New Edges. This will be used to hold your new adjustments.
- 2. Choose the Clone Stamp and a brush that is relatively hard—relative to the image. For this image I set the brush hardness to 80 percent and chose a brush of 45 pixels without brush dynamics (uncheck other Dynamics options in the Brushes palette).

An absolutely hard brush will make an absolutely hard new edge, a softer brush will make a softer edge; 80 percent seems to work well with this image because it enhances the look of the edge without seeming impossibly sharp in comparison.

FIG 4.23 You've added three more layers by exploring sharpening. Either of the #14 layers should be visible via the Visibility toggles. Leaving both on will produce different results based on the differences in the respective masks. Shutting both off will remove the sharpening.

- 3. Sample from another portion of the petal, and then use that sample to stamp a new edge in the areas where you want the petal to be sharper (see Figure 4.24).
- 4. Create a new layer for the Healing tool and blend in the new edge by applying Healing to the area between the new edge and the petal. This brush can be about the same as the one chosen for the Clone Stamp, but should be 100 percent hard.

FIG 4.24 Applying the Clone Stamp allows you to make a new harder edge that seems to have more focus, and applying Healing next to that allows you to blend in the new edge seamlessly. (a) Clone Stamp to build the edge. (b) Heal along the seam created by cloning. (c) The result.

FIG 4.25 Applying the Clone Stamp allows you to make a new harder edge that seems to have more focus, and applying Healing next to that allows you to blend in the new edge seamlessly with the rest of the petal. (a) Before. (b) After.

Figure 4.24 shows the technique described in steps 3 and 4 and the immediate result of the edge creation. Continue to build and blend. You can do this right on the same Clone Stamp and Healing layers. See the before and after in Figure 4.25.

Summary

Throughout this rather rambling exercise you have looked at many implementations of layers and masking and the type of separation and application advantages they provide in a real-world situation. Six desired adjustments have led to a plethora of changes and the creation of many layers in my sample image (see Figure 4.26). The resulting layers along with a few additional adjustments that were discussed can be perused if you open the Sample_5_complete.psd image on the CD.

Throughout this chapter, we have looked in some depth at a variety of ways masking is applied in images. The basic concept is, indeed, "masking hides," but it can hide and reveal and becomes a particularly powerful tool when used in combination with layers for the purpose of corrections.

What can be a mask?

- Layer content: Content in a layer above in the layer stack masks what is below.
- A Clipping group: Clipping groups mask what is grouped above based on the content of the bottom layer in the group.

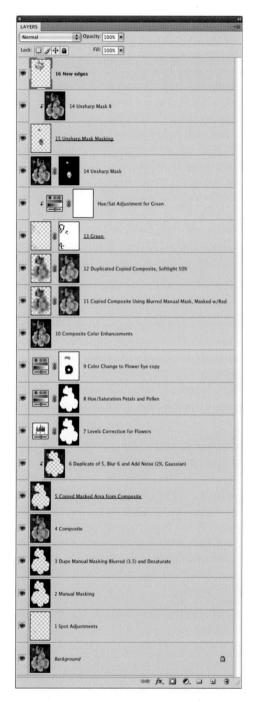

FIG 4.26 Your layer stack may differ from the one shown here depending on the steps you have chosen to include throughout this chapter and how you chose to handle them, but the results should be similar.

- Layer opacity: The opacity of layers lets you adjust the intensity of how masked layers affect an image.
- Layer mode: This will allow you to vary the means by which an upper layer combines with layers below (we'll look at this in more depth later), effectively masking how layer changes are applied.
- Selection: Selection masks changes so that the selection defines the active area of active layers. Changes can be applied only within the selection.
- Layer masks: Layer masks hide and reveal portions of the layer they are
 associated with. Black hides, white reveals, and gray hides as a percentage
 gray or as a semitransparent mask.
- Adjustment layer settings: Settings on the Adjustments palette for various types of Adjustment layers allow users to mask based on a color or tonal range.
- Channels: Channels store layer masks and selections, but can also become masks themselves.

In addition to this list, there are more advanced masking options left to dig into, like Blend If. The real challenge is to take some of what you have learned about masking in layers in this chapter and apply it to your own images.

It isn't so important to remember the various means of masking or even the terms. What is important is that masking is a layer property and that you know you can use it instead of erasing image details or instead of applying changes directly. Either erasing or applying directly ends up permanently changing details, which is directly opposed to the advantages of nondestructive editing as we intend to explore it in this book. In short, use masks instead of the eraser.

Keep in mind that the correction list you develop for each photo drives your layer creation and the steps you take in making adjustments to your images. Creating the list of what to correct takes a disciplined eye. Some image needs will be obvious, and others may be found as you work through corrections. For now, if you start making those lists in your mind and on paper every time you look at an image, you will begin to see your work flow layout before you like a map. It is hoped that, with Layers, you can make all the topographical lines fit together without much trouble. Think about what you are doing with each step, and help yourself with later adjustments by letting layers define the order of changes in the image.

If you get stuck at any time and have questions, visit the forums at http://www.photoshopcs.com!

S omewhere just beyond isolating objects into their own layers and more advanced blending lies the genus of layer-based effects. Effects encompass a broad range of enhancements and adjustments from solid color fills and stroked outlines, to drop shadows and bevels, to combinations

of these that create more complex layer styles. Application can be wild effects (often used with type, see Figure 5.1) to more moderate doses of change that add separation between image objects and subtle image enhancement.

FIG 5.1 A fairly simple application of standard styles can radically change the appearance of type.

It is useful to know what Styles and Effects are, where to find them, how to apply them, and how they act. Further utility comes from methods for using and controlling these effects using multiple layers, Fill and Opacity controls, and Global Settings and considering application of manual effects—which leads nicely into other topics of correction.

Styles are akin to filters in that you can waste hours and hours applying and adjusting them, and then undoing and applying again. They can become addictive when doing creative projects. However, there is a practical side to Styles, and we'll look at an overview of effects in this chapter from the standpoint of practical application in image enhancement and touch on the implication for broader creative effects.

The Basics of Effects and Styles

The difference between Styles and Effects is that Effects are the separate functions that can be applied to a layer, and a Style is a preset for any effect or combination of effects. Photoshop has 10 total effects (Table 5.1) and comes with a few canned/prefabricated styles that you can apply just by choosing an effect from a menu.

TABLE 5.1 The basics of Effects and Styles.

3	Drop Shadow	Adds a shadow on the outer perimeter of the layer content. Affects the appearance of content only in layers below the layer on which it is applied.
5	Inner Shadow	Adds a shadow inside the perimeter of the layer content. Affects the appearance of content only in the layer on which it is applied.
53	Outer Glow	Adds a glow around the content of the layer on which it is applied. Affects the appearance of the content only below the layer on which it is applied.
	Inner Glow	Adds a glow inside the content of the layer on which it is applied. Affects the appearance of the content only in the layer on which it is applied.

TABLE 5.1 (Continued)

33	Bevel and Emboss	Adds highlights and shadows to a layer to affect a raised (Up) or lowered (Down) appearance. Can be used in several modes, including Outer Bevel (applied to the outer perimeter affecting only layers below), Inner Bevel (applied to the inner perimeter affecting only the current layer), Emboss (applied as both Inner and Outer Bevels), Pillow Emboss (applied as Inner Bevel Up and Outer Bevel Down), or Stroke Emboss (applied to Stroke effects only). May affect the layer on which it is applied as well as layers below depending on the settings you choose.
*	Satin	Applies shading to the inner perimeter of the layer. Supposed to give a satin look. Affects the appearance of content in the layer on which it is applied.
*	Color	Fills the layer content with a color. Affects the appearance of only the layer on which it is applied.
	Gradient	Fills the layer content with a gradient. Affects only the layer on which it is applied.
	Pattern Overlay	Fills the layer content with a pattern. Affects only the layer on which it is applied.
\$	Stroke	Strokes the outline of the current layer content using color, a gradient, or a pattern. Strokes can be Outside, Inside, or on Center. Affects the layer on which it is applied, layers below, or both depending on the settings.

Styles can be created and saved, or you can download them from the Internet or buy collections and load them to apply at will (from such sites as actionfx .com). These canned styles work well usually for more creative applications and far less frequently for photo enhancements. The list of styles loaded can be found in the program on the Styles palette.

Let's try applying a style.

Try It Now

- 1. Open the Sample_6.psd image on the CD.
- 2. Click on the Wild Type Effectz layer in the Layers palette if it is not already active.
- 3. Choose Styles from the Windows menu to open the Styles palette (see Figure 5.2).
- 4. Locate the style named Chrome Satin in the Styles palette, and apply it by clicking the thumbnail.

New Style... Text Only

√ Small Thumbnail Large Thumbnail Small List Large List Preset Manager... Reset Styles... Load Styles... Save Styles... Replace Styles... Abstract Styles Buttons **Dotted Strokes**

Glass Buttons Image Effects

Text Effects Textures

Web Styles

Close Close Tab Group

Photographic Effects Text Effects 2

FIG 5.2 The Styles palette by default shows a thumbnail view of the default styles as shown here. To return to the defaults, choose Reset Styles from the Styles palette menu.

To find style names, roll your cursor over the styles one at a time. You can also view the names of the styles in the palette by choosing Text, Small List, or Large List from the Styles palette menu. Text lists the styles by name only; Small List and Large List list styles by thumbnail and name.

That is all there really is to applying a style: locate and click. However, there is a little more to working with styles, as we'll see. In the following steps we'll add another effect to the existing style.

- Choose Inner Glow from the Add a Layer Style menu located at the bottom of the Layers palette or off the Layer menu (Layer>Layer Styles>Inner Glow). This will open the Layer Style dialog (see Figure 5.3).
- 6. Change the Blend Mode for the Inner Glow to Color Burn, change the color to Red (RGB: 255, 0, 0), and change the Size to 20 pixels. This will intensify and burn in the red at the edge of the letters. To change the color to Red, click the Set Color of Glow swatch in the Structure panel and choose the color in the Color Picker that appears.

FIG 5.3 The Inner Glow style to the left of the Layer Style dialog will be checked and highlighted. The Inner Glow options will be displayed at the center of the screen.

To check your results, see Sample_6_Corrected.psd on the CD. You can experiment with other settings, but at this point you have replicated the results from Figure 5.1. To see how each of the effects contributes to the result of the style you have applied, uncheck the box next to the effect at left to toggle the view for individual effects in the style. To adjust the settings for any of the effects, just click the name of the effect to reveal the options, and change them as desired in the dialog by adjusting any of the settings. For example, if you change the Gradient Overlay from -90 to 180° , you will get a much different effect (see Figure 5.4).

You can manage separate effects in the style by toggling the view for the effects in the Layers palette (see Figure 5.5). You can shut off the view for individual effects or for the whole grouping of effects with the Visibility toggles. In the example, shut off the Bevel and note the difference in the effect on the image. You can toggle the effect to compare, but leave the visibility for that particular effect off before continuing on.

FIG 5.4 Changing the options for any of the Effects will change the result for the Style accordingly.

FIG 5.5 Click on the Visibility toggle (looks like an eye) to the left of the Effect you want to hide/show in the Style to manage the views in the Layers palette without opening the Layer Style dialog.

This only scratches the surface of what Styles can do. The small change you made by shutting off the view for just one of the effects suggests the potential for variety. Be careful with the amount of time you devote to playing around with styles and effects and set a limit beforehand for your experimentation, or you can lose hours of what would otherwise be productive work time correcting images.

Don't close this file; you'll need it in a moment.

I personally find styles most useful for storing favored settings. For example, I occasionally use a Bevel effect that sets both the Highlight and the Shadow to black and multiply in combination with the Inner Shadow effect. I like the opportunity the combination gives me to tune the beveling effect. Storing that as a style allows me to apply it with a click. Likewise, you may find half a dozen or so practical settings for reuse, but Styles are more often a creative tool than a correction tool.

Vector Masks

Vector masks are similar to Layer masks but are controlled with vector content. Vectors are used in the Sample images in this chapter to define the content of the Type layers. This is done for several reasons, the most prominent of which is that not everyone will have the type face that I used (Plug-NickelBlack). If you didn't have the type face and I left the Type layer as it was, Photoshop would choose a substitute. I converted the type to vectors using Convert to Shape (Layer>Type>Convert to Shape). This command will make perfectly defined type shapes. Though the result can no longer be edited as type, it does have the advantage that it can be infinitely scaled.

Part of what makes vector components in your images distinct is that vectors are not resolution dependent. Vectors act more to corral pixels than to define them absolutely. You will find that vectors are used more often for logos and illustration than for image correction (though some like to use the Pen tool to help define selections). The advantage to defining illustration elements as vectors lies in the ability to scale them infinitely: if you design a vector logo, it will look its best on a business card or billboard, and it won't develop the fuzzy edges you would get with pixel-based design.

Saving Styles

If you hit on a style that you want to save and perhaps use in the future, you can save the style. Not only that, you can save style libraries that you create for specific purposes or to help you manage styles that you find handy. Say, for example, that you like the effect created for the type in Figure 5.4 in the previous section. You can save the effects as a style and store it for future use.

- 1. Double-click the Effects item in the Layers palette under the layer for the image you were just working on (see Figure 5.6). This will open the Layer Style dialog.
- 2. Click the New Style button at the right of the Layer Style dialog. This will open the New Style dialog.

FIG 5.6 Double-click right on the item named Effects in the Layers palette just below the Wild Type Effectz layer.

3. Name the new style something that you will recognize, and click OK (see Figure 5.7). Options at the bottom of the New Style dialog allow you to save Blending options (Opacity, Blend If, Channel targeting) as well as the effects. We'll look more at Blending options in Chapter 7.

FIG 5.7 Naming the Style may be the most difficult part of this segment of the exercise. Try to make names for your styles that clarify what they achieve, and maybe include the separate Effects or settings in the name.

Now that you have stored the style, you can access it from the Styles menu any time you need to.

- With the previous image still open, click and drag the Effects item to the Trash at the bottom of the Layers palette. This will remove the effects from the image.
- Open the Styles palette and click on the style you saved in the last segment of the exercise (you should be able to locate it by name). This click will apply the style to your image.

Take a look at the Layers palette. You will notice that, if you completed the preceding exercise, the view for the Bevel is included in the saved style, but that its visibility is off. In other words, the style is stored exactly as it was when you saved it and even if an effect within the style is off it is not removed when it is stored.

Managing Styles

You can download styles from the Internet and load them into Photoshop to have ready-made styles at your disposal. It is easy to build a library of thousands of freebees by downloading them from the Internet and loading them into Photoshop. But keep in mind that all styles are not created equal. Some designers with experience really know what they are doing and how to have a style render with quality and do very useful things. Don't just download everything in sight, or you will have a huge library that you can't filter through for practical application.

I've included a styles set on the CD put together by my good friend and Photoshop Styles/Effects master, Al Ward (actionfx.com). You can use this set to practice loading styles and to see the kinds of effects that good styles can produce.

Try It Now

- 1. Open Photoshop and insert the CD from *The Adobe Photoshop CS4 Layers Book* into your CD-ROM.
- Open the Preset Manager for Styles. You can do this by choosing Preset Manager from the Edit menu and choosing Styles from the Preset Type list or by choosing Preset Manager on the Styles palette menu. If you use the Styles palette menu, the Styles will be preselected.
- 3. Click the Load button on the Preset Manager screen. This will open a Load dialog (much like a standard Open dialog).
- 4. Locate the CD in the Load dialog, click the ActionFx-CS4_Set_01.asl file in the Styles folder, and then click the Load button on the Load dialog. The styles will populate in the Preset Manager screen.
- 5. Close the Preset Manager by clicking Done. The styles will be loaded on the Styles palette. You can use them with a click. Test some out!

In addition to the Load option described, you also have the option to load by replacing the current styles, which will remove the current styles before loading the library that you pick. To return to the default library of preset styles, choose Reset Styles.

Periodically you may want to save your styles set as a library so you can use it with some flexibility. Depending on how you like to work, you may save several libraries to group your styles, or a single library with your most used effects. Saving will allow you to return to a set should you inadvertently delete it or replace the styles in your palette. To save a Style library, just choose Save Styles from the Styles palette menu. When the Save dialog appears (see Figure 5.8), name the file (leave the .asl extension on the filename), and you can save it anywhere you'd like.

FIG 5.8 It may be best to save to a folder that gets backed up periodically, or to the Photoshop Styles folder inside the Presets folder in the program directory/folder. Click the down arrow to the right of the Save As field to view more options.

Manual Effects

Although layer styles are handy for quick application of effects, there are built-in limitations to them. You are not limited to creating effects by using layer styles. You can create effects manually so long as you understand how to create them. In fact, making your effects manually can offer a measure of flexibility that you simply can't get from applying the canned effects, with more potential for variations.

- 1. Open the Sample_6.psd file again from the CD. We'll want to start from scratch here with the original image.
- 2. Click on the Background layer to activate it in the Layers palette if it isn't active already.
- 3. Create a new layer and name it Drop Shadow.
- Hold down the Command/Ctrl key and click on the vector mask thumbnail for the Wild Type Effectz layer. This will load the vector mask as a selection (see Figure 5.9).

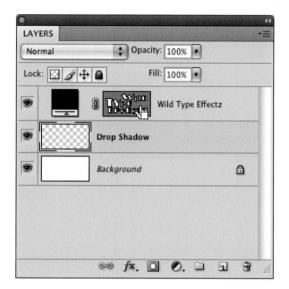

FIG 5.9 Holding down the Command/ Ctrl key and clicking the vector mask will load the mask as a selection.

- 5. Fill the selection with Red (RGB: 255, 0, 0). You can do this by setting the foreground color and then using the Paint Bucket tool or with the Fill function (Edit>Fill) with the color set to Foreground. The selection will fill in the active Drop Shadow layer.
- 6. Deselect (press Command+D/Ctrl+D). If you don't deselect, the selection will contain the action in the steps that follow.
- 7. Apply a Gaussian Blur of 5 pixels. This will soften the edge of the color added in step 5.
- 8. Change the Opacity of the Drop Shadow layer to 75 percent. This will lighten the drop shadow.
- 9. Offset the content of the Drop Shadow layer down and to the right. To do this choose the Move tool (press V), hold down the Shift key, and press the down arrow on the keyboard and then the right arrow. You can use the Offset function instead if you want (Filter>Other>Offset). The result should look something like Figure 5.10. This offset will simulate the angle between the object (in this case, type) and the light source.

FIG 5.10 The reddish drop shadow is one of the simplest effects to create manually.

Holding the Shift key when using the arrows on your keyboard will move the content on the active layer 10 pixels at a time rather than one.

All other effects can be created manually using layers, sometimes with steps very similar to those we used in this example. For example, you can make inner shadows and glows by clicking the Wild Type Effectz layer in step 2, making a Clipping group with the new layer created in step 3, and inverting the selection in step 4.

The real advantage to making effects manually is that the effects are actual pixels rather than virtual ones so you can treat the effects more like an editable part of the image. If you want you can apply layer styles to the layers on which you have created the effects. You also have freedom of movement and adjustment without having to visit the Layer Styles dialog.

You can see from the nine steps above used to create a drop shadow that it probably is not worth the trouble if you can get a similar effect with a one-click layer style. However, there are ways to simplify creating manual effects, and we'll look at those next.

Automated Manual Effects Tools

On the CD you will find a file named Layer Actions.atn, which is a set of actions that will create several layer-based effects with a click. The actions are time-savers because they will run through a series of steps that have been prerecorded. For example, the steps above for creating the drop shadow have been recorded for the Drop Shadow/Glow action, and you can replay it with a single click and some minimal user input. First you'll need to load the actions.

- Start with Sample_6.psd. Either open it fresh from the CD or revert the file to the original image state by clicking the thumbnail in the image history.
- 2. Load the Layer_Effects.atn action into the Photoshop Actions palette. You will have to load the actions only once. To load the actions you can drag the file from the file system to the Actions palette in Photoshop, or open the Actions palette (Window>Actions or press Option+F9/Alt+F9), and choose Load Actions from the Actions palette menu, then locate the actions file on the CD. Choose Layer_ Effects.atn and then click the Load button. The actions will populate in the Actions palette. The actions should appear like Figure 5.11.

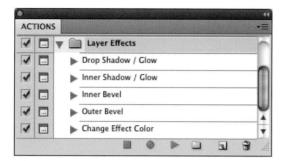

FIG 5.11 You may have other actions in your Actions palette, but Layer Effects will load as an action set, containing Drop Shadow/Glow, Inner Shadow/Glow, Inner Bevel, Outer Bevel, and Change Effect Color.

We load actions several times throughout the book to simplify lengthy procedures and provide tools for completing repetitive tasks, like making manual drop shadows. Come back to these steps if you need a refresher on loading actions later.

- 3. Set the foreground color to Red (RGB: 255, 0, 0). This color will be used by the action to define the color of the effect.
- 4. Activate the Wild Type Effectz layer by clicking it in the Layers palette.
- Run the Drop Shadow/Glow action. To do this, click the Drop Shadow/ Glow action in the Layer Effects set on the Actions palette, then click the Play button at the bottom of the Actions palette (see Figure 5.12).
- 6. Follow the instructions as they appear on screen. Use the default Offset (110, 110) and change the Gaussian Blur radius to 5 pixels to match the results of the previous exercise. This will create a drop shadow that falls to the lower right.

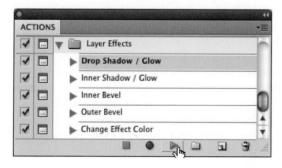

FIG 5.12 Click the Play button at the bottom of the Actions palette to play the active selection.

Now that the actions are loaded, the process is several steps easier. In the case of applying a bevel, it is many steps easier. But the true glory of knowing how to apply layer effects manually is not just in being able to apply a simple drop shadow or bevel to some isolated type. Benefits come in as flexibility in placement and control as well as options you gain for applying layer styles in combination with manual effects, or even applying the styles to the effects themselves. Part of what distinguishes manual effects from layer styles is that you will have a difficult time applying compound effects if you use only layer styles. We'll look at a more complicated example in the next section, which combines layer styles, manual effects, and masking.

Close this image without saving before proceeding.

Combining Manual Effects and Styles

In keeping with the layer mentality, it is sometimes best to apply effects to separate layers rather than all at once as a single style on a single layer. However, there are times when layer styles do everything you need them to and times when you will want to use both manual and canned effects to orchestrate your results.

Say, for example, you want to create an effect on your type so that it looks like the type is transparent. That is, the effects that appear in the background will be seen through the type. You could try reducing the opacity of the layer, but what you'll find is that it reduces the opacity of the effect as well. Combining style and effect application in various ways will help get the desired results.

In this example we will build an effect that looks like translucent type using a combination of layer styles and draw on everything we have touched on so far in this chapter.

- 1. Open the Sample_6.psd image again from the CD.
- 2. Click the Wild Type Effectz layer in the Layers palette to activate it.
- 3. Apply the Type effect saved earlier in this chapter by clicking it in the Styles palette. The text shows it saved as Wild Type Effect in Figure 5.7, but you may have used another name. The result for the image and Layers palette should look like Figure 5.13.
- 4. Drag Bevel and Emboss, Gradient Overlay, and Drop Shadow to the Trash on the Layers palette. This should leave you with only Inner Glow and Satin effects, as in Figure 5.14. This removes those effects from the style as it is applied in the image.
- Choose Color Overlay from the Add a Layer Style menu at the bottom of the Layers palette. This will open the Layer Style dialog with Color Overlay selected.

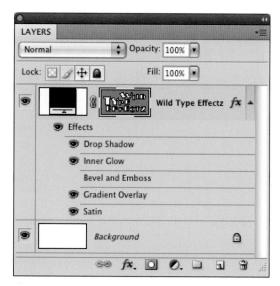

FIG 5.13 After applying the saved style, the image should display the properties inherited from the stored style.

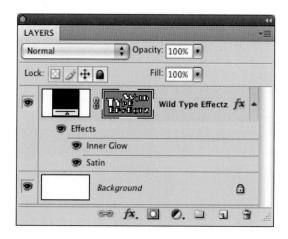

FIG 5.14 After removing the effects, the image will visibly revert to what it looked like when it was opened, but two effects are still being applied—you just can't see them because of the black color of the layer.

- Double-click the Set Color of Overlay swatch to the right of the Blend Mode drop-down list, and set the color in the Color Overlay to RGB: 110, 170, 240 in the Color Picker when it appears (Figure 5.15).
- The remaining effects make specific results in the image. The Satin will leave a slight sheen on the letters. The Color Overlay provides the base color. The Inner Glow provides the reddened edges.

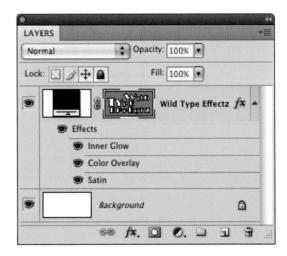

FIG 5.15 The color suggested was sampled from the "I" in WILD in the image after step 3. You should now see the results of all three effects: Inner Glow, Color Overlay, and Satin.

- 7. Change the Foreground color to Black (RGB: 0, 0, 0). This will be used in applying a manual drop shadow in the next step.
- Apply a manual drop shadow using the Drop Shadow/Glow action provided with the Layer Effects action set loaded earlier in this chapter. Use an Offset of 120, 120 and a Gaussian Blur of 10 (the default blur) (Figure 5.16).

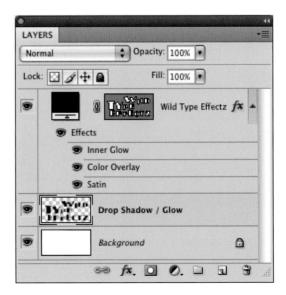

FIG 5.16 The result at this point shows a plain drop shadow in black, as if the Type object were very much opaque.

- 9. Copy the layer style applied to the Wild Type Effectz layer. To do this on a Windows PC, right-click on the Effects item under the Wild Type Effectz layer and choose Copy Layer Style from the menu that appears. On a Macintosh, hold down the Control key on the keyboard and click the Effects item, then choose Copy Layer Style from the menu that appears.
- 10. Paste the layer style copied in the previous step to the Drop Shadow/ Glow layer. To do this, activate the Drop Shadow/Glow layer, and follow the instructions in step 9, but choose Paste Layer Style. Alternatively you can choose Paste Layer Style from the Layer menu (Layer>Layer Style>Paste Layer Style). Pasting the style applies it to the layer.
- 11. Shut off the Visibility toggle for the Satin effect for the Drop Shadow/ Glow layer, and lower the Opacity to 70 percent. This will remove the Satin's sheen from the drop shadow and fade the drop shadow a bit. At this point the results should look like Figure 5.17.

FIG 5.17 Copying the layer style from one layer to another makes sure the settings are similar between the drop shadow and the original object. Only appropriate effects should apply, so the Satin is turned off, as the drop shadow will not reflect the sheen. However, the type is still not acting translucent.

- 12. Duplicate the Drop Shadow/Glow layer, rename the layer Translucence, and move it to the top of the layer stack. This layer will be used to make the letters seem translucent.
- 13. Load the Wild Type Effectz vector mask as a selection. To do this hold down the Command/Ctrl key and click on the vector mask thumbnail in the Layers palette. This will be used to mask the translucent effect to the letters only.
- 14. With the Translucence layer still active, click the Add Layer Mask button at the bottom of the Layers palette. This will use the selection you just loaded to define the mask and target the Translucence layer to the type only.
- 15. Lower the opacity of the Translucence layer to account for the opacity of the type object. The more you lower the opacity, the more opaque the type will appear (Figure 5.18).

FIG 5.18 Setting the Translucence layer to 35 percent opacity (half the original 70 percent opacity of the drop shadow) makes the letters about 50 percent transparent.

At this point we have successfully combined manual effects and layer styles in a way that would probably be more difficult and more time consuming using either alone. Check your results against the Sample_7.psd file included on the CD.

The layer styles do the bulk of the work in this example by simplifying the application and making the result more consistent; but without the help of the manual drop shadow the result becomes more difficult to achieve, as well as less flexible. As with most results in Photoshop it is not a single tool or application that provides the best results, but combinations.

To finish off the example to conform with the technique of using layers for organization, you may want to add numbers to the layers so that you know what order they were created in. You may also want to add some notes as to the settings used for the offset and blur. With these final additions, the Layers palette would look like Figure 5.19.

Fill versus Opacity

Fill and Opacity seem similar if you don't know exactly what they do. Let's try the following to make the difference more clear.

FIG 5.19 Comments and numbering help round out the Layers advantage.

- 1. Open the Sample_6.psd image one more time.
- 2. Click the Wild Type Effectz to activate it, and choose Outer Glow from the Add a Layer Style menu at the bottom of the Layers palette.

- 3. When the Layer Style dialog appears, change the Blend Mode to Normal (or perhaps Dissolve), the Size to 100 pixels, and the color to Red (RGB: 255, 0, 0), then click OK.
- 4. Go to the Opacity for the layer on the Layers palette and swing the slider from 100 to 0 percent and back again to 100 percent. The whole content of the image will fade and return.
- Try the same thing you did in step 4 with Fill (leaving Opacity at 100 percent). Only the actual content of the layer will fade and return, the effect remains the same.

Opacity affects the entire layer, and Fill affects the content of the layer only—not the styles that have been applied. Although Fill may work to accomplish your goals, it will often be best and make most sense to use Opacity for your control unless you are affecting how styles appear separately from layer content. In the latter case, use Fill.

Summary

Layer Styles and Effects are layer-specific tools that carry with them a plethora of possibilities. The effects are the tools, but the real catalyst here is layers. Layers are the means by which layer effects and styles can be assimilated and propagated in images for corrective and creative purposes. They are also the means of creating new sources to which additional effects and styles can be applied to (such as the shape for the drop shadow and the mechanism for creating translucence).

In the seemingly simple examples in this chapter, we have used vector and layer masks, manual and layer-based styles and effects, Visibility toggles, opacity, and modes. The results achieved are not so much an application of any one item as an orchestration of various functions and capabilities that culminate in the result. This is the *modus operandi* for much of Photoshop correction: results are born in the application of tools in unison. Layer styles are a powerful tool in their own right, but will often work best with layer modes. One of the hardest things to envision when using layers may be what Layer Modes achieve. We look at them in the next chapter.

Layer styles can help do many things, from adding a creative frame to an image in varying complexity, to creating text effects, to driving some image enhancements. Things that come to mind as practical corrections are simple exercises in separation in which you add a drop shadow or glow to burn or dodge an edge around an isolated object, or in which beveling or embossing may actually help enhance contour.

Creative application of styles, on the other hand, opens endless possibilities. Though not technically "styles," there are examples of applying manual styles throughout this book in various examples. These effects include everything

from simple dodge and burn, and application of techniques for soft focus (like those we looked at in Chapter 4), to more elaborate calculations such as manual sharpening techniques, and beyond.

One of the key concepts for looking at layers in this chapter is the concept of orchestrating layers to achieve a result. It is not often practical or desirable to try and achieve a result in your images all at once with one application of one tool, or even one application of one layer or one effect. Most effects and results can be achieved in more than one way. In the examples in this chapter it took only a few layers to achieve the translucence effect, but the example is steeped in the broader vision you will need to develop by practice to use layers effectively. As we have seen, the background and lower layers are a stage to build on. Older layers in the image can be borrowed from, reused, and generated to create varied results. Envisioning the result is the key to success, and layer styles are just another building block to use in achieving your vision.

Please visit http://www.photoshopcs.com for more information and resources for Photoshop Styles. Post your questions on the forum!

ayer Modes are an enigma. Located in a drop-down list at the top of the Layers palette in a very prominent spot next to Opacity, the positioning suggests that modes are one of the most important tools in the Layers palette. For users who are experienced in applying the modes, this is true. However, few people know modes well enough to use them effectively. Many times people don't stray from the Normal mode as the rest is mostly a mystery. The modes have names, but the names alone don't really explain how to work with them or what they do. Unless a mode change is part of a tutorial, layer mode use will more likely be done by trial and error: people experiment with modes by selecting different ones from the list to see what happens, and they either keep the result or try another mode. This kind of hit-or-miss application is fine, and can produce pleasant surprises, but it will gobble up huge amounts of your imaging "play" time. In a way, this type of experimentation with modes is very similar to how some people use filters. There is, however, a better approach to applying layer modes: actually knowing what they do and when they can be helpful and which to use.

In this chapter, we'll look at a general overview of Layer Modes, what they are, how to apply them, and what they can accomplish. We'll look at ways that you can use layer modes every day for image enhancements and improvements by using them to target your corrections.

Layer Mode Behavior

Layer blending modes can be a creative or practical tool for combining and enhancing images and layer content. However, as the misunderstood half-sister of Styles and Filters, Modes proffer little more to most users than a means for experimentation. Like winery visitors lining up at the tasting bar after a tour, users swish and sample anything that gets poured in a glass, hoping something will stand out to their palette—and then spit out what doesn't. Here, too, experimentation can be fun, but better understanding of the modes and what they do can turn fruitless experimentation into selective choice.

Modes, put simply, are a means of blending the content of two or more layers. It can help to start thinking of modes as a means of turning layers into image calculators. When a layer is set to a particular mode, the content of the layer acts in that mode on the content of the visible layers below it in the layer stack. The visible result is a direct correlation to a cold calculation built into the mode. Most layer modes are not really useful for everyday correction, but some are, and when they are useful, they are very powerful tools. The whole problem in making calculations work for you is deciding what to do—and what mode you'll want to use to accomplish the result. So making use of modes productively depends on knowing how they act.

Though it is often what users look for, flat descriptions of the numeric calculations that modes use may be the least helpful means of really understanding what a mode accomplishes. It is often difficult even for the mathematically inclined to envision how a calculation applies as a visual result. Descriptions of the effect may be slightly more helpful, but not entirely intuitive. A combination of description and a simple example may be most helpful, and that is what we will look at here to start you thinking about how to employ modes.

Figure 6.1 shows two simple layers that will be used as the source images for comparing how the modes behave when applied to tone. You can find these layers in the Sample_8.psd file on the CD, already stacked in an image if you want to play along. Figure 6.2 shows two layers that can be used to evaluate how modes behave when applied to color and tone. You can find these set up in the Sample_9.psd file on the CD.

FIG 6.1 There is more to modes than evaluating how black, white, and gray combine, but simplicity can be a valuable teacher. This should reveal how tone and even color channels will behave in a particular mode.

FIG 6.2 These color swatches pit one color rainbow against another to show color behavior. It is perhaps prettier exploring the full harmonics, but far harder to intuit.

To test the modes, all you need to do is change the mode of the upper layer in the test file (and, when applicable, opacity) to see the effects modes have on what we see in the result on screen. Simply open one of the sample images, activate the Upper layer/Calculation layer, and choose a mode from the Mode drop-down list on the Layers palette. This will apply the mode and give you some visual sense of what happens when layers are applied with different modes.

To give you a better understanding of each mode individually, I'll list descriptions of what the modes are doing along with the result of the mode applied to Sample_8.psd; then we'll look at some more concrete examples as to how this applies to images and how to apply the modes. I have not included the results here of mode adjustments for the color model in Sample_9.psd. The results for color are, at the very least, three times as hard to envision as they are for tone—though I could argue that they are many more times more difficult than that. If you learn to envision the results in black and white you will have the conceptual building blocks you need to use layer modes as a tool rather than a toy. Sample_9.psd is included on the CD for your experimentation should you feel the need to test color.

All descriptions listed here assume the upper layer is opaque (layers set to 100% Opacity), unless opacity is otherwise mentioned. The name of the mode is followed by the previews and description, which includes practical uses for the modes. This is not meant to define limitations; there may be many creative uses for any particular mode that go beyond the simple descriptions.

Normal

Normal mode is a plain overlay of content in the layer. The result takes on the color/tone of the pixels in the upper layer. This is the default mode of layers and is probably by far the most often used. Layer content is made part of the result as is, not as a calculation (Figure 6.3).

FIG 6.3 Normal mode is a straightforward application of layer content in which the upper layer covers everything below. Used most frequently of all modes.

Dissolve

The result of using Dissolve mode is the color/tone of the pixels in either the upper layer or the lower layer, determined on a pixel-by-pixel basis according to the opacity of the layer. The greater the opacity of the layer in Dissolve mode, the more pixels display from the layer. At 100% Opacity, 100 percent of the pixels in the upper layer display; at 50% Opacity, 50 percent of the pixels in the upper layer display. The layer is dithered so that pixels are either visible or invisible according to the opacity percentage; the opacity percentage dictates the percentage of pixels in the layer that will display. Pixels are hidden in a randomized or dithered effect. This mode may be best for specialized uses for web graphics and in creation of animation effects (Figure 6.4).

FIG 6.4 Shown here at 50% Opacity, Dissolve creates a dithering effect.
Used very rarely, if at all, in corrections/enhancements.

Darken

The results of showing the darkest color value in each channel, comparing the content of the layer on which the mode is assigned and that of the layer(s) below, are shown (Figure 6.5). No portion of the image gets lighter in the comparison. For example, in an RGB image, if the pixel in the layer set to Darken is RGB: 255, 170, 33, and the lower layer pixel is RGB: 45, 165, 44, the result is the lower (darker) of any of these numbers for each channel, or RGB: 45, 165, 33. The result will never get darker than existing values, possibly forming a third color. Used as a means of darkening content when the user does not expect color to darken any more than the colors being applied.

FIG 6.5 No channel becomes darker than either of the 2 pixels occupying a space. Used infrequently in corrections/enhancements.

Multiply

Darkens the result by increasing the darkness of underlying layer(s) based on the darkness of the layer on which the mode is applied. Any tone darker than white in the layer set to Multiply mode darkens the appearance of content (Figure 6.6). Successive applications of the same layer in Multiply mode will produce a continually darker result. No portion of the image can get lighter. Often used with effects of burning in or shading, like drop shadows and the shadow side of beveling. Also useful in creating layer-based color separation for RGB and CMYK (Chapter 8) to simulate the effects of filtering light or ink colors.

FIG 6.6 Each pixel darkens equal to or darker than the pixels occupying the same space in the layer stack. Used frequently in corrections/enhancements for burning in and darkening.

Color Burn

Burns in (darkens) the color of the lower layer based on the content of the layer set to Color Burn, darkening the result. Tends to burn in or enrich color density. No portion of the image gets lighter. The greater the difference between the applied pixel colors and the content (Figure 6.7), the greater the percentage of change. Used for special effects and sometimes for color enhancement.

FIG 6.7 Each pixel darkens equal to or darker than the pixels in the layer on which the mode is applied and the layers it interacts with below. Used infrequently in corrections/enhancements.

Linear Burn

Similar to Multiply but more extreme and linear in application. All portions of the image get darker in areas where the content of the layer on which the mode is applied is darker than pure white (Figure 6.8). Used in calculations, like layer-based channel mixing (see Chapter 8).

FIG 6.8 Each pixel darkens equal to or darker than the pixels occupying the space. A linear application of darkening. Used infrequently in corrections/enhancements.

Darker Color

New as of CS3. Displays the darker of either of two colors in comparing pixels in the layer on which the mode is applied to pixels in layer(s) below (Figure 6.9). The result is defined from the total value of brightness of all channels in the individual pixels; if the pixel in the layer on which the mode is applied is RGB: 255, 0, 0, and the pixel below is 0, 150, 150, the former (red) will display even though it appears lighter on screen (because the average of the channels is lower/darker).

FIG 6.9 Chooses the darker of two colors for pixels occupying a space. Used infrequently in corrections/enhancements.

Lighten

The virtual opposite of Darken. Applying the mode results in showing the lightest color value in each channel, comparing the content of the layer on which the mode is applied to the layer(s) below (Figure 6.10). No portion of the image gets darker. For example, in an RGB image, if the upper layer pixel is RGB: 255, 170, 33, and the lower layer pixel is RGB: 45, 165, 44, the result is the greater of any of these numbers, or RGB: 255, 170, 44, in this case forming a third color. Used as a means of lightening underlying content when the user does not want the color to lighten more than the color being applied.

FIG 6.10 Nothing can become lighter than the RGB values of the two pixels occupying a space in the layer stack, but the color will reflect the lighter of the colors in each channel and can be lighter overall. Used infrequently in corrections/enhancements.

Screen

Brightens the result by increasing the brightness of underlying layer(s) based on the lightness/brightness of the layer on which the mode is applied. Any tone lighter than black in the layer set to Screen lightens the appearance of the content below (Figure 6.11). Successive applications of the same layer in Screen mode will produce a continually lighter result. No portion of the image can get darker. Often used with effects of dodging and brightening, such as glows and the highlight side of beveling. Useful in layer-based color separation for RGB and CMYK (Chapter 8).

FIG 6.11 Each pixel lightens equal to or lighter than the pixels occupying the same space in the layer stack.
Used frequently in corrections/
enhancements for dodging and lightening.

Color Dodge

The layer set to Color Dodge lightens (dodges) the layers below based on the content of the layer, lightening the result. This mode tends to desaturate and wash out color. No portion of the image gets darker. The greater the difference between the applied pixel colors and the content (Figure 6.12), the greater the percentage of change. Used for special effects and sometimes color enhancement.

FIG 6.12 Each pixel lightens equal to or lighter than the pixels occupying the space based on the difference between pixel colors. Used infrequently in corrections/enhancements.

Linear Dodge

This mode is similar to Screen but more extreme and linear in application. All portions of the image get lighter where the content of the layer on which the mode is applied is brighter than pure black (Figure 6.13). Used in calculations, like layer-based channel mixing (see Chapter 8).

FIG 6.13 Each pixel lightens equal to or lighter than the pixels occupying the space. A linear application of brightening. Used infrequently in corrections/enhancements.

Lighter Color

New as of CS3. This mode displays the lighter of either of two colors in comparing pixels in the layer on which the mode is applied to pixels in the layer(s) below (Figure 6.14). The result is defined from the total value of brightness of all channels in the individual pixels; if the pixel in the layer on which the mode is applied is RGB: 155, 155, 155, and the pixel below is 250, 150, 50, the former (gray) will display (the average of the channels is higher).

FIG 6.14 Chooses the lighter of two colors for pixels occupying a space. Used infrequently in corrections/enhancements.

Overlay

Multiplies (darkens) when the layer on which the mode is applied is dark (1–49 percent brightness) and screens (lightens) when the layer on which the mode is applied is light (51–99 percent brightness). This enhances contrast with like content (if you make a composite at the top of the layer stack and set to Overlay) and lowers contrast in inverted content (if you make a composite at the top of the layer stack, invert it, and set to Overlay). Underlying pixel colors at the center of the light and dark range (quartertones at 75 and 25 percent gray) are affected more than the range extremes (0 and 100 percent brightness or 50 percent gray). Useful for manual sharpening effects (looked at later in this chapter). Also useful for intensifying color and contrast (Figure 6.15).

FIG 6.15 Used in many places in this book for layer-based correction/enhancement. Sometimes used in corrections/enhancements.

Soft Light

Similar to Overlay but a weaker application of the tones in the layer on which the mode is applied. Multiplies (darkens) when the layer on which the mode is applied is dark (1–49 percent brightness) and screens (lightens) when the layer on which the mode is applied is light (51–100 percent brightness). Underlying pixel colors at the center of the light and dark range (quartertones at 75 and 25 percent gray) are affected more than the range extremes (0 and 100 percent brightness or 50 percent gray). Useful in some special effects (soft focus) and for intensifying color and contrast (Figure 6.16).

FIG 6.16 Used in some places in this book for layer-based correction/ enhancement. Used occasionally in corrections/enhancements.

Hard Light

Multiplies (darkens) when the layer on which the mode is applied is dark (0–49 percent brightness) and screens (lightens) when the layer on which the mode is applied is light (51–100 percent brightness). Similar to Soft Light and Overlay but a more linear, stronger application of the tone in the upper layer. Useful in some special effects and for intensifying color and contrast (Figure 6.17).

FIG 6.17 Used infrequently in corrections/enhancements.

Vivid Light

Similar to Color Burn when the pixel in the layer on which the mode is applied is darker than 50 percent gray. Similar to Color Dodge when the pixel in the layer on which the mode is applied is lighter than 50 percent gray (Figure 6.18).

FIG 6.18 Used infrequently in corrections/enhancements.

Linear Light

Similar to Linear Burn when the color in the layer on which the mode is applied is darker than 50 percent gray. Similar to Linear Dodge when the color in the layer on which the mode is applied is lighter than 50 percent gray (Figure 6.19).

FIG 6.19 Used infrequently in corrections/enhancements.

Pin Light

Similar to Multiply when the layer on which the mode is applied is darker than 50 percent gray. Similar to Screen when the layer on which the mode is applied is lighter than 50 percent gray (Figure 6.20).

FIG 6.20 Used rarely in corrections/ enhancements.

Hard Mix

Adds a limited color palette effect to the Vivid Light effect. It will posterize the result to appear as one of eight colors: white, red, green, blue, cyan, magenta, yellow, or black (Figure 6.21).

FIG 6.21 Used rarely in corrections/ enhancements. May have a place in special effects.

Difference

Shows the result of calculating the difference between pixel values. A large difference yields a bright result; a small difference yields a dark result (no difference yields black). Useful in image evaluations to show/measure differences between corrections (stack two layers for comparison and set the upper to Difference—everything that is not pure black is different) and in some special effects (Figure 6.22).

FIG 6.22 Can be used for comparing layer content.

Exclusion

Uses the darkness of the layer on which the mode is applied to mask the Difference effect (see Difference above). If the layer on which the mode is applied is dark, there is little change as the result; if the upper layer pixel is black, there is no change. The lighter the pixel in the upper layer, the more intense the potential Exclusion effect. Mostly used for special effects and perhaps masking (Figure 6.23).

FIG 6.23 Used rarely in corrections/ enhancements.

Hue

Overrides the Hue of lower layers based on the content of the layer on which the mode is applied, leaving the Saturation and Luminosity unchanged. Used for color adjustment (Figure 6.24).

FIG 6.24 Used infrequently in corrections/enhancements to adjust hue.

Saturation

Overrides the Saturation of lower layers based on the content of the layer on which the mode is applied, leaving the Hue and Luminosity unchanged. Used for color adjustment (Figure 6.25).

FIG 6.25 Used infrequently in corrections/enhancements to adjust saturation.

Color

Overrides the Hue and Saturation of lower layers based on the content of the layer on which the mode is applied, leaving the Luminosity unchanged. Used for color adjustment and layer-based Luminosity and Color separations (later in this chapter) (Figure 6.26).

FIG 6.26 Used in corrections/ enhancements to adjust or apply and even remove color.

Luminosity

Overrides the Luminosity of lower layers based on the content of the layer on which the mode is applied, leaving the Saturation and Hue unchanged. Used for tone adjustment and layer-based Luminosity and Color separations (later in this chapter) (Figure 6.27).

FIG 6.27 Useful for adjusting tone independent of color.

The figure legends suggest the modes you are likely to use most frequently, with the most success, and occasionally for what purpose. However, the modes that you will find most useful are highlighted in Table 6.1.

TABLE 6.1 Modes.

Useful
Normal Multiply Screen Overlay Soft Light Color Luminosity

This listing is not meant to say "Hey, you can't ever use the layer modes in the Rarely Used column," but rather that you'll have far more luck with the modes in the Useful column and that you will likely get to the point at which you can predict results with them. The modes in the last column are most often just variations of the modes in the first, and the result you get might be better controlled with Opacity or by duplicating layers that use modes listed in the useful column to accentuate effects, rather than reaching for a less predictable or more complex mode. And it is exactly the complexity of some of the modes that renders them less useful: as complexity increases, the visual result gets far harder to predict, and the tools become toys that you must experiment

with to use. Better, too, is that you can concentrate on learning a subset of the modes to reap nearly all the benefits of what modes have to offer.

Even more valuable than descriptions of modes and of which are useful are hard examples of layer mode use that explain what the modes do. Let's take a look at some practical applications of layer modes to see how you might employ them to accomplish some useful results, starting with separating color and tone.

Separating Color and Tone

In our discussion of isolating objects and image areas and using masking, we concentrated on simple isolation based on shape. A whole different realm of isolation can be explored in isolating by qualities in the image, such as color or tone. Layer modes can help make isolation of these qualities possible.

One of the easiest results for you to digest in working with layer modes is applying Color and Luminosity. With these two modes you can isolate the content of a layer so it affects only tone or only color. You can also use this same functionality to isolate content based on those modes. Separation is accomplished quickly with simple layer-based calculations and application of layer modes.

☐ Try It Now

 Open any image. Or you can use the Sample_10.psd image provided on the CD (see Figure 6.28).

FIG 6.28 A version of the cover shot for the first edition of this book will provide plenty of color and tone for exploring the Luminosity and Color separations.

- 2. Flatten the image, if it is not flattened already (choose Flatten Image from the Layer menu). Flattened images will have a Background layer only.
- 3. Duplicate the Background layer and name the duplicate layer 1 Source.
- 4. Create a new, blank layer above the 1 Source layer, and name it 2 Grayscale.
- 5. Fill the 2 Grayscale layer with 50 percent gray (choose Edit > Fill then set the Content Use selector to 50% Gray).
- 6. Change the 2 Grayscale layer to Color mode. Your Layers palette should look like Figure 6.29, and the image will become a grayscale representation of the image, as the gray "color" is being applied to lower layers.

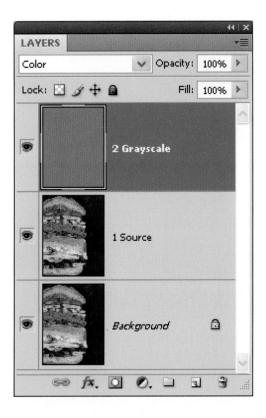

FIG 6.29 Applying gray as a color converts the view of the image to black and white. The result is a display of the luminosity of the image——a representation of the image based on tone. You could use this separated component to adjust the image tone.

- 7. Create a new layer at the top of the layer stack and call it 3 Luminosity.
- 8. Press Command+Option+Shift+E/Ctrl+Alt+Shift+E to stamp the visible image to the new layer. This commits the grayscale change to the new layer.
- 9. Set the layer mode to Luminosity. This completes separation of the Luminosity component. Shut off the layer view for 3 Luminosity (see Figure 6.30 for the layer setup).

FIG 6.30 Your numbered layers mark your progress through the separation. You'll use the 1 Source and 2 Grayscale layers again to achieve the result captured with 3 Luminosity.

You now have the luminosity separated from the color and you can isolate tone changes by toggling on the visibility of the 3 Luminosity layer and applying changes to it. To isolate the color, continue with the steps where you left off.

10. Activate the 2 Grayscale layer by clicking it in the Layers palette. Change the mode to Normal (the image will appear to be flat gray again), then press Command+ [/Ctrl+ [to move the 2 Grayscale layer below the 1 Source layer. The image will become color again (Figure 6.31).

FIG 6.31 Invert the order of the Source and Grayscale layers to prepare for the next steps.

- 11. Change the 1 Source layer mode to Color. What you will see is the color separated from tone over gray (Figure 6.32).
- 12. Create a new layer above the 1 Source layer and name it 4 Color.
- 13. Press Command+Option+Shift+E/Ctrl+Alt+Shift+E to stamp the visible image to the new layer.
- 14. Change the mode of the 4 Color layer to Color.
- 15. Shut off the view for the Background, 1 Source, and 2 Grayscale layers by toggling the visibility, and turn on the 3 Luminosity layer. Only the 4 Color and 3 Luminosity layers will be visible (see Figure 6.33), but the image will be as it was in full color from the two distinct components you created.

FIG 6.32 Color isolated from tone appears over a neutral tone background.

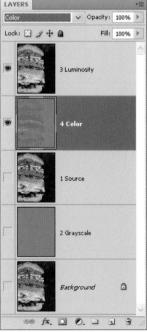

FIG 6.33 The Color and Luminosity components in the image can combine to display the original color image. Switch the Visibility toggle off for either to view the companion component alone.

All that has happened in this example is that you are using Layer Modes to create different views of your image. In this case the views substitute for the color and tone/luminosity in the image. The steps help you isolate the view for luminosity using Layer Modes and then capture a snapshot of that luminosity in a Composite layer. Next you isolate the color and capture a screen shot of that. The newly isolated components simply represent the image in a different form. Because the modes represent color and tone separately, you now have control over color and tone components separately. This can be a great advantage in situations in which the color is right but the tone is wrong, or vice versa. Apply color correction to the Color layer (e.g., you might apply a Hue/Saturation adjustment that would be isolated to the color) and tone corrections to the Luminosity layer (you might apply a Levels correction to the RGB channel to extend the dynamic range of the tone independent of the color).

This calculation for separation of color and tone will work with any RGB image. Open any image and try out the steps, then apply isolated color and tone changes to see how it works.

At the same time the separation shows what setting a layer to a particular mode does. The layer sets in Figures 6.34 and 6.35 show layers that will achieve exactly the same results using a Levels correction, yet offer different

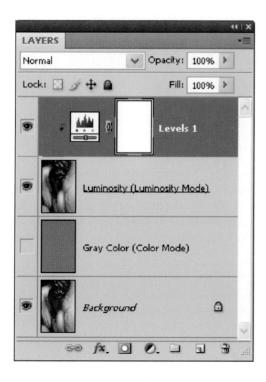

FIG 6.34 Although it takes extra steps to make the separation, the separated component offers other opportunities to make image changes to the isolated component.

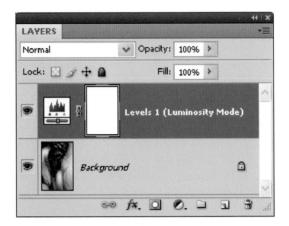

FIG 6.35 If you need to make a direct change to the component using only an Adjustment layer, you can set the Adjustment layer to target content using the modes and skip the separation with the same exact results.

advantages. The layer set with the separated luminosity component will allow changes to the content of the luminosity, such as sharpening or spot and dust correction; the version with only the Levels set to Luminosity saves file size, but does not offer the option of other luminosity adjustments to the pixels.

Here we've used layer modes to extract separate components for color and tone and to look at exactly what modes can do. But this is just the beginning of color-based separation and isolation of image components. We'll look at more color separation in Chapter 8, and there we will apply more modes. Now let's look at layer modes used specifically for correction and the flexibility they offer by working with manual sharpening calculations.

Sharpening Calculation

Layer calculations are a means of pitting information in one layer against another and coming to a new result. These results are often facilitated by layer modes. The previous exercise is an example in which we are able to calculate and extract Luminosity and Color components from the image using a 50 percent gray layer and application of layer modes.

Calculations have many creative and interesting uses, most of which are not immediately obvious. One of the first really useful layer calculations I devised after working with several to extract image components (e.g., luminosity, color, RGB channels, CMYK channels) was using layers and modes as calculations to mimic darkroom effects, such as creating a manual unsharp masking effect.

Unsharp masking was a darkroom process before it was ever a Photoshop or Elements filter. The photographer developing in the darkroom would sandwich an inverted blurred copy of the image negative with the original to enhance contrast in the exposure of image edges. The blur would target change to image edges to enhance contrast, and the result after the application would be a sharper look to the image. It was the mask used to create the effect that was "unsharp," and that is where the name "unsharp mask" comes from.

The layer-based application of an unsharp mask that follows is a little different from the result you'd get in the darkroom or the result you get using the unsharp mask filter, but it is a viable digital alternative that builds on the same concept. We'll borrow a little of what we learned in the last exercise to isolate our corrections to the image tone and create unsharp masking in the following exercise.

☐ Try It Now

- 1. Open a flattened image to which you'd like to apply an unsharp mask calculation, or open an image and flatten it. An interesting image to use with this technique is Sample_11.psd (shown in Figure 6.36).
- Duplicate the Background layer and name the new layer 1 Unsharp Mask.
- Duplicate the 1 Unsharp Mask layer and name the new layer 2 Color. Change the layer mode of the 2 Color layer to Color. At this point the Background, 1 Unsharp Mask, and 2 Color layers all have the same content.

FIG 6.36 This unusual vegetable has shading that renders a strong difference when using this technique.

The role that the two duplicated layers play in the image dramatically changes with their change in mode. Changing the mode of the Color layer makes the Color layer a color lock: the positioning at the top of the layer stack with the original color information allows tone to change below without changing the original color. Though an actual separation of the color has not been completed, the change to mode effectively separates the content and effect.

- 4. Activate the 1 Unsharp Mask layer by clicking on its thumbnail in the Layers palette. Change the mode to Overlay, change the Opacity to 50 percent, and then invert the content of the layer (press Command+I/ Ctrl+I). This layer acts as the inverted negative. We'll blur it in the next step.
- 5. Blur the 1 Unsharp Mask layer using Gaussian Blur. The size of the blur will depend on the resolution of the image and the amount of detail. The more detailed the image, the less blur; the higher the resolution, the greater the blur. Start with a 15-pixel radius for a 3 × 5 image at 300 ppi; use a greater radius for larger images. You can preview the changes as you move the slider.

The result of these steps (see Figure 6.37) is a sophisticated mask based on the content of your image. It is not a mask in the traditional sense, because you have not made a visible selection with selection tools; however, the technique of inverting, blurring, and setting the mode (Overlay) effectively makes the content self-masking to target the effect. This is a more complicated result than what you achieved with the 2 Color layer, but that can be considered a mask as well: masking image color.

The Unsharp Mask layer you have created ends up working much like the sandwiched negative in the darkroom process, pretty much opposite to the way that the Unsharp Mask filter does: reducing image contrast in the quartertones to pull details from shadows and highlights. Unsharp Mask pushes dark areas darker and light areas lighter, sometimes leading to a loss of detail (blowing out or blocking up image areas). Because the effect of this manual unsharpening procedure is nearly the opposite of the Unsharp Mask filter, the manual unsharp effect and the Unsharp Mask filter effect can be used together. Because you can use them in tandem, you can greatly intensify image contrast changes and apply more sharpening than can be achieved with the Unsharp Mask filter alone.

One added benefit to the manual version of sharpening is that, because of the nature of Overlay mode, the result will not tend to blow out (move bright areas of the image to RGB: 0, 0, 0) or block up (move shadow areas of

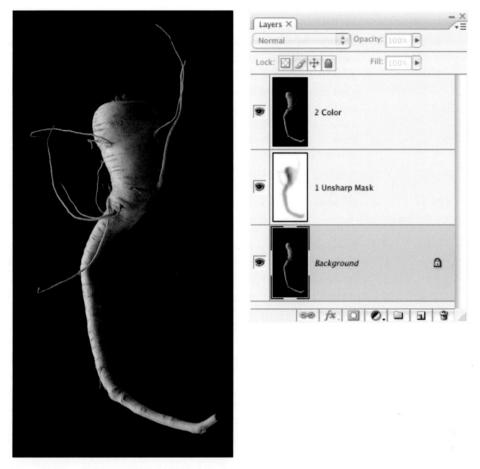

FIG 6.37 Note the changes to the brightness at the right/shadow side of the parsnip and the brightness of the tendrils. This change occurs because of the local contrast enhancement brought about by the application of the blurred layer in Overlay mode.

the image to RGB: 255, 255, 255), as the Unsharp Mask filter can easily do. Tones and colors at the extremes (absolute white, absolute black) and middle (50 percent gray) are less likely to change than the quartertones (75 and 25 percent gray). This can keep you from harming the detail in your image and will likely not cause the type of halo you can get with Photoshop's Unsharp Mask filter.

All that aside, you have successfully used Layer Modes to perform a very complex calculation to enhance the information in the image and simulate sharpening. This is a useful technique that can be replicated with any image, though you are most likely to have success with it on images that are already contrasty overall, rather than images with low general contrast (in which case the Unsharp Mask filter will be more effective).

Summary

We have looked at the basics of Layer Modes in an overview and then jumped into two evolved techniques out of hundreds of variations that can be produced with layer modes. Certainly layer modes are not hard to apply, but I hope that this chapter and these exercises have shown that applying layer modes is not necessarily best to do based on trial and error and that very sophisticated and calculated results can be achieved. It may take some time to develop confidence in using layer modes, and even longer to start thinking in terms of deriving your own original calculations, but the few examples here may start you contemplating mode application rather than simply attempting to arrive at pleasant results by chance. A mode is a means of isolating effects, different from, but similar to, the purpose of selection.

Sticking with the preferred list of modes outlined (and exploring the examples in the rest of the book) will help you maintain focus on the modes that will be most effective in your image corrections and those you are most likely to absorb as part of your work flow. Practice the exercises for separating color from tone and applying manual sharpening using your own images to see how the techniques behave. Simple modes such as Normal (default), Multiply (darken, burn), Screen (lighten, dodge), Overlay/Soft Light (contrast enhancement), Color (lock color or change color), and Luminosity (lock tone or change tone) will become your workhorse tools. Lighten and Darken may be useful for special needs, Linear Burn and Linear Dodge (used in later chapters for channel mixing) will come into play as you have more experience, and Difference might be used in certain circumstances for comparison's sake (as we'll see in the next chapter). The rest of the modes will likely remain as hit-or-miss possibilities. Concentrate on what the "easy" modes do, and you can add the bulk of what modes will enable for you day in, day out.

Just to reinforce the notion of focus for a moment, note that there are section dividers on the listing of modes (see Figure 6.38). These section dividers are really akin to submenus. The first section applies straight color/tone from the layer, the second section deals with darkening, the third section has modes that lighten, the fourth has mixed conditional calculations, the fifth has calculations based on the difference between applied and base pixels, and the sixth has calculations based on color or tone. Understanding the behavior of one of the modes in each of the sections will really yield clues as to what the rest of the modes in that section do—even if they do it very differently. The more complex the mode, the less likely you will use it often.

The visual result of applying a layer mode does not actually reside in any one layer—especially if multiple layers are combining to produce a result. You see the result of the calculation on screen. Keep in mind that to bind effects (and to apply additional modes), you may need to use the composite layer technique (create a new layer and merge visible to the new layer with Command+Shift+Option+E/Ctrl+Shift+Alt+E).

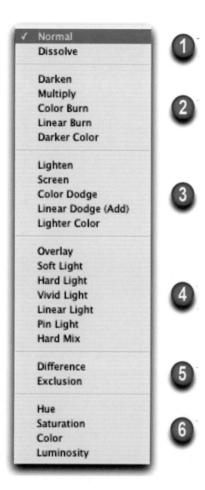

FIG 6.38 Six sections of the Mode menu reflect distinct submenus.

Whereas Layer Modes are certainly a more advanced way to look at image content, the parade of extraordinary layer powers continues in the next chapter with exploration of advanced blending modes.

If you have any questions about Layer Modes and their use, be sure to visit the web site for this book, http://www.photoshopcs.com; bring your questions to the forums, and let me know what you are thinking!

Yet another means of combining and targeting content changes can be found lurking in the Photoshop Layer Style dialog. We have already looked at some of what the Layer Style dialog can do when exploring layer styles in Chapter 5. However, Blend If is a more advanced feature on the Layer Styles dialog that offers opportunities separate from masking and clipping that we will definitely want to explore in order to round out the layer experience (Figure 7.1).

Blend If: An Overview

with Blend If

Blend If is very much an overlooked and even mysterious feature to almost any Photoshop user. If you try looking this feature up in manuals and books, you may not be able to find it. In fact even searching Photoshop Help will not yield a title with Blend If in it (though the feature is referenced by function in "Specify a blending mode for a layer or group" and "Specify a tonal range for blending layers"). Although the tool may not be a very popular target for tutorials and documentation, it is an enormously powerful tool that has been part of Photoshop Layers since the very inception of layers themselves.

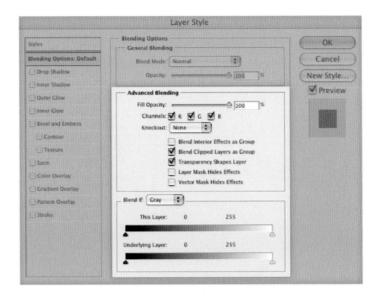

FIG 7.1 The Advanced Blending and Blend If sections of the Layer Style dialog offer additional layer advantages not often explored, but very powerful.

What Blend If can do is help you target changes and corrections based on the color or tonal content of a layer by range. In a way it is like an auto-mask, in that it will mask a layer without you actually having to create a mask or a selection—and these masks can be highly complicated without much work. Setting Blend If adjustments will target change based on positions of a set of sliders (the Blend If sliders on the Layer Style dialog). Before we go any farther, let's take a look at the basic Blend If functionality and how you control it before we really try to look at what it can do.

☐ Try It Now

1. Open a new image that is 720 \times 720 pixels, with a white background (see the New Image dialog in Figure 7.2).

FIG 7.2 The New dialog for the sample image used in this exercise should have the settings shown here.

- 2. Create a new layer and call it Blend If Test.
- 3. Press D to set the default colors (black and white).
- 4. Choose the Gradient tool and be sure the Options are set to Linear Gradient, Normal Mode, and 100% Opacity, and uncheck Reverse, Dither, and Transparency. Choose the Foreground to Background gradient. To do this, click the gradient color bar on the Options panel, and click the gradient in the top left of the Gradient Editor dialog that appears. See Figure 7.3.

FIG 7.3 If the Foreground to Background gradient is not in the dialog, you will want to reset the gradients. To reset the gradients, choose Reset Gradients from the Gradient Editor palette menu found at the upper right of the Presets panel.

- Click on the lower right of the image and drag the cursor to the upper left, then release the mouse. The image should fill in a gradient from black to white from the lower right to the upper left (see Figure 7.4).
- 6. Take a snapshot of the image by clicking the Snapshot button at the bottom of the History palette (Windows>History). Leave the name as the default (Snapshot 1). This will make it easy to return to the state of the image before blending is applied and without having to open the Layer Style dialog to reset.

FIG 7.4 The result of applying the Gradient tool should be a simple black-to-white gradient in the image square.

- 7. Double-click the Blend If Test layer in the Layers palette (anywhere *but* on the thumbnail or over the name). This will open the Layer Style dialog.
- 8. Click on the black This Layer slider and drag it to the center of the slider range at 128 (see **Figure 7.5**).

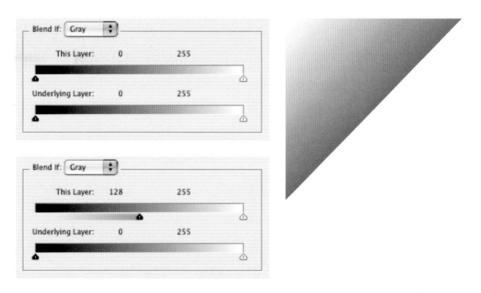

FIG 7.5 As you drag the cursor, the darker portion of the image should disappear from the screen from the lower right corner to halfway across the image. Notice that the layer in the Layers palette retains its content.

The numbers on the Blend If sliders span in levels 0–255. This corresponds to a range from black (0) to white (255) in a grayscale gradient.

The change in position of the slider limits the range of what is visible in the layer (in this case the gradient), so it becomes transparent and blends with what is below based on those slider positions. Blend If does not delete the content of the layer, but instead acts like a mask, hiding the content. In this case the effect falls in a range of tone, masking the shadows in the Blend If Test layer. Everything to the left of the black slider and everything to the right of the white slider becomes transparent. If you shut off the Visibility toggle for the Background layer you can see the transparency. Continuing from the exercise, try the following Blend If slider positions to get a better feel for the way it works:

 Move the black This Layer slider back to 0 and then move the white This Layer slider to 128 (Figure 7.6).

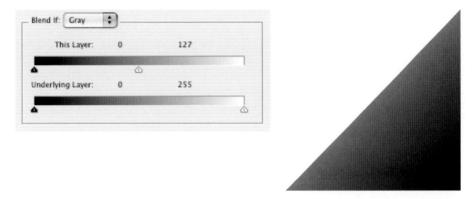

FIG 7.6 The darker half of the content will remain. The gradient between gray and white will become transparent through to the background in the upper right of the image as if the Blend If settings made a highlight mask for the content of the layer.

 Move the black This Layer slider to 192 and then move the white This Layer slider to 63 (Figure 7.7).

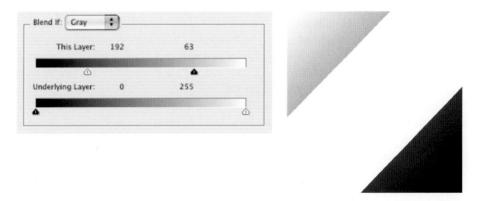

FIG 7.7 The area between the white slider and the black slider will become transparent through to the background in the middle of the gradient range. This Blend If setting is the equivalent of a midtone mask.

Applying layers with Blend If can occasionally be confounding when using the This Layer slider because the results can change as you edit the image. However, when you see the differences between this and masking, you will see that it can be useful and do things that standard layer masking will not. Any changes you make to the layer content for which the This Layer Blend If sliders are set may result in changes in the masking effect in the image. To test this out, make a Levels adjustment to the Blend If Test layer (Image > Adjustments > Levels). When the dialog opens, swing the center gray slider left and right and watch how the image behaves. Because the content of the layer is being adjusted, more or less of it falls into the static range defined by Blend If. Close the Levels dialog without committing the change. Now do the same thing with an Adjustment layer by choosing Levels from the Create New Fill or Adjustment Layer menu on the Layers palette. The direct application of Levels changes the content of the layer so the masking effect is different and changes as you make the adjustment; when you use an Adjustment layer, the content of the layer does not actually change, so the masking effect stays in the same area, though the visible result changes.

The same concepts hold true for using the Underlying Layer sliders. The main difference is that the content of the current layer will blend based on the content of the layers below, rather than the content of the layer on which you apply the blend—layer transparency still affects the current layer. To see the results of using the Underlying Layer sliders, do the following exercise.

☐ Try It Now

- Click Snapshot 1 in the History palette to reset the image and Blend If sliders.
- 2. Double-click the Background layer and rename it White Layer.
- Change the order of the layers in the layer stack by pressing Command+]/Ctrl+] (Mac/PC). See Figure 7.8 for the layer positioning in the Layers palette.
- Double-click the White Layer in the Layers palette to open the Layer Style dialog.
- 5. Click on the black Underlying Layer slider and drag it to the center of the slider range at 128 (see Figure 7.9).
- Move the black Underlying Layer slider back to 0 and then move the white Underlying Layer slider to 128 (Figure 7.10).
- Move the black Underlying Layer slider to 192 and then move the white Underlying Layer slider to 63 (Figure 7.11).

FIG 7.8 The White Layer should be above the Blend If Test layer in the Layers palette after step 3.

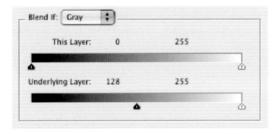

FIG 7.9 The White Layer becomes transparent over the darker area of the lower layer so you can see through it to the darker half of the gradient. Blend If creates a mask in the White Layer based on the shadows below.

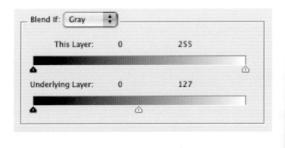

FIG 7.10 The White Layer becomes transparent over the brighter/highlight area of the lower layer so you can see through the white to the lighter half of the gradient. Blend If creates a mask in the White Layer based on the highlights below.

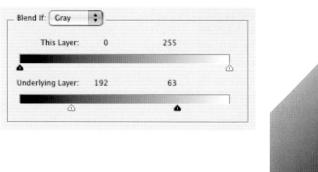

FIG 7.11 The White Layer becomes transparent over the midtone area of the lower layer so you can see through it to the midtone "half" of the gradient. Blend If creates a mask in the White Layer based on the midtones.

These examples are hard-edged applications of Blend If in its simplest form. Other features of Blend If allow partial blending and blending based on color ranges rather than just tone. Partial transparency—the real "blending" form of Blend If—is created by splitting the sliders. Let's look at how to split sliders to have all the basic functions in tow before we apply them to more involved purposes.

☐ Try It Now

- 1. Click Snapshot 1 in the History palette to reset the Blend If for the layers and the layer order.
- 2. Open the Layer Style dialog for the Blend If Test layer by doubleclicking the layer.
- 3. Move the black This Layer slider so it is at 128 (as in Figure 7.5).
- 4. Hold down the Option/Alt key and click on the left of the black slider and then drag it to 0. The slider will divide into two parts (see Figure 7.12).

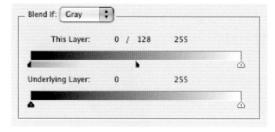

FIG 7.12 Holding the Option/Alt key allows you to split the slider; be sure to click on the side of the slider that is on the side you will be moving toward.

Splitting the slider will blend the result from 0 to 100 percent opacity between the split halves. In this case the gradient will blend smoothly to white by the midpoint (and really a little before) without coming to a hard edge like it did before the split. Splitting the sliders allows you to make a softer transition in blends, similar to blurring a mask or feathering a selection. The idea is that you gain control over how the edges of your blends dissipate, rather than using them as an on/off switch for a particular range, as we have so far. When you use them as on/off switches you may have noticed that the edges might end up hard and blocky, but by splitting the sliders you can better control the blend.

Whereas we have looked at just tone ranges here so far, color targeting can be done by choosing ranges for the Red, Green, and Blue sliders found under the Blend If drop-down list (see Figure 7.13). Of course using color-based blending can get extremely complicated pretty quickly, and may take quite a lot of practice before you can get the results you expect. We will continue to look at tone-based Blend If effects with that in mind.

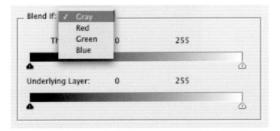

FIG 7.13 Blend If can be adjusted per channel so that blending can be targeted to specific color ranges.

Keep in mind that the difference between standard layer masking and Blend If is that Blend If is based strictly on tonal (or color) ranges. Layer masks will be static in accord with the mask as you create it; Blend If masks can change as the content of the image does without adjusting the settings. Also, Blend If and Layer masks can be used together to isolate image areas and target change. In an instance in which you know you want to target a particular tonal range and the selection or masking would otherwise be very difficult, you could use Blend If to get you close to what you want and then layer masking to touch up and complete the effect.

Knockouts

Another feature under Advanced Blending in the Layer Style dialog is Knockout, another seldom-used feature with a specific ability—seldom covered or explored because it is hidden on the Layer Style dialog. Knockout can behave much like solidity in the base layer of the clipping mask or as a mask, but it does it from the top down rather than from below like a Clipping layer or as a sidecar for layer masks. Take a look at this example to see how it works.

To make a Knockout, try the following using the image from the previous exercise:

- 1. Click Snapshot 1 to restore the defaults you saved.
- 2. Double-click the Background layer and name it White Base.
- 3. Choose the Type tool, be sure you have selected a large type face like Arial Black at 300 points, and change the type color to Red (RGB: 255, 0, 0).
- Activate the Blend If Test layer by clicking it in the Layers palette, then
 click on the image and type the word HOLE in all capital letters. Center
 the type vertically and horizontally on the image. The image should
 approximate Figure 7.14.

FIG 7.14 Align the word HOLE to the center of the image.

- 5. Shift + click on the Blend If Test layer to highlight both the HOLE layer and the Blend If Test layer.
- Drag the layers to the Create a New Group button at the bottom of the Layers palette. Leave the default name, but toggle the arrow to expand the group to see the two layers inside (Blend If Test and HOLE).
- 7. Double-click the HOLE layer to open the Layer Style dialog. Change the Fill to 0 percent (the type will disappear), then choose Shallow from the Knockout drop-down list. The type will appear in white, having knocked out the base layer in the group (Blend If Test). See Figure 7.15.

8. Change the Knockout to Deep. The word HOLE will knock out to the background. As there is no background in this image, it will knock out to transparent (see Figure 7.16).

FIG 7.16 Changing the Knockout setting to Deep will knock out the layer content through all the layers in the image (except the Background if one exists). The checkers in the word HOLE represent transparency.

Shallow knockouts punch through to the bottom of their group if they are in one; Deep knockouts punch through to the Background—or transparency if no Background is available in the image.

Blend If in Compositing

Situations that seem otherwise hopelessly complex may be good situations for considering Blend If. For example, say you have taken a shot of a leafless tree in silhouette against a blue sky and you think it might look better with some other sky, with some interesting clouds, against a sunset, etc. It might seem to be a daunting task to make a selection between all those branches. You might try dabbling with the magic wand, but your results will be pretty sketchy. Blend If offers the opportunity to make the replacement without having to make a potentially unnerving and complex mask or selection. You can use measurements from your image to determine a range you want to replace, and then apply appropriate Blend If settings you make directly from the image.

That makes it sound like a miracle cure to use Blend If ... and there are occasions on which it will produce some amazing results with little effort. On the other hand, getting Blend If to do what you want may require patience first, as well as combining it with masking or other techniques to achieve a result. Like any other tool it is best to think of Blend If as a companion to other functions rather than the Lone Ranger or some other hired gun that will come in and do it all for you. The only way to really get a feel for Blend If is to look at the reality of the way it works and the advantages it affords first hand.

The shots in Figures 7.17 and 7.18 were taken on the same day, one early in the morning at South Street Seaport in New York City, facing nearly east, and the other about 400 miles away near Rochester, New York, facing west. These

FIG 7.17 There is no accounting for weather, and you'll often have to make do with what you get. In this case the drab sky can be replaced with the more interesting one taken later in the day.

images are Sample_12.psd and Sample_13.psd on the CD. They have little in common but the day they were taken. Merging the two images to make the sky more interesting behind the mast and cables would provide a solution to the plain look of the sky. Getting the sky to show neatly around those cables without a lot of manual effort would be significantly more difficult without Blend If.

In the picture of the mast, the rigging is a real problem if you are looking to replace the background. There are many cords crossing the scene, they are different weights and somewhat different tones. The scene is lighter than the image taken at dusk, and the light wraps a little around the ropes. If it were more of a silhouette (plain black against gray) this might be easier. But what we do have going here is that most of the cables are clearly darker than the background. We can make Blend If do much of the work to differentiate between the two tones and then use a little creativity with the method to touch up the results.

FIG 7.18 An image of the sky taken later in the same day is far more dramatic and may be what the first image needs to show some improvement.

☐ Try It Now

- 1. Open the Sample_12.psd image off the CD. This is the mast from Figure 7.17.
- 2. Double-click the Background layer and rename the layer Original Mast in the New Layer dialog, then click OK to accept the changes.
- Open the Sample_13.psd image off the CD. This is the sky image from Figure 7.18. Place the images side by side on screen so both are in view. You may need to adjust your view for the images (Window>Arrange>Float All in Windows).
- 4. Choose the Move tool, hold down the Shift key, and click and drag the sky from the Sample_13.psd image into the Sample_12.psd image. Holding the Shift key will automatically center the layer you are dragging in the destination image. Alternatively, you can duplicate

- the layer from Sample_13.psd to Sample_12.psd using the Duplicate Layer command (Layer>Duplicate Layer) or even Select All, Copy, and Paste. All you are looking to do is to get the two images in the same document. Name the new layer Original Sky.
- Close the Sample_13.psd image, leaving open only Sample_12.psd, which should now contain the source layers from both sample images on separate layers.
- Click on the Original Mast layer and move it to the top of the layer stack by pressing Command+]/Ctrl+]. Your layers should look like Figure 7.19.

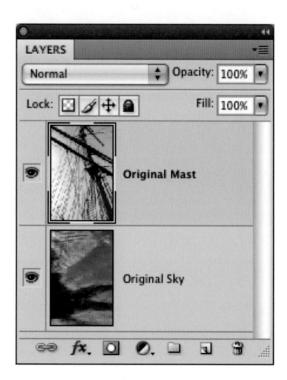

FIG 7.19 The sky in the Original Mast layer will be blended into the sky in the Original Sky layer.

7. Open the Threshold function (Image>Adjustments>Threshold). We will use Threshold to measure the target range for applying Blend If. Swing the Threshold slider to the right and left, looking for the point at which the sky begins to darken in the upper right of the image. Note the number and close Threshold by clicking Cancel so the change is not saved in the image. If you push the slider left you will note that the sky never completely becomes all black; if it had this would define a range for the blend and you would have to get the black slider involved (Figure 7.20).

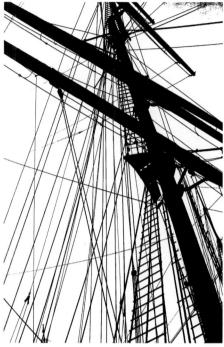

FIG 7.20 At about 186 on the threshold function, the sky at the upper right of the image begins to turn. Your threshold may be somewhat different based on color settings.

Threshold is a tool that is useful in determining measurements of your image content and is an unlikely candidate as a tool that you will generally use in corrections themselves—though you might occasionally use it to help create masks. Threshold turns an image into a pure bitmap in which pixels are either white or black—there are no grays or colors when the tool is applied.

8. Double-click the Blend If layer to open the Layer Style dialog. As you want to drop away the lighter portion of the layer to reveal what is beneath, use the white This Layer Blend If slider and move it to the left to the value you measured in step 7. Then split the sliders and give about 60 levels of blending (see Figure 7.21).

At this point the blending of the two images may not be all that you'd hoped ... and likely this is where some might give up and get disgusted with the tool because it "doesn't work." Actually the tool did exactly what you asked of it by masking off the sky, blending according to the settings you chose. It is the

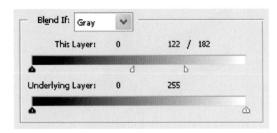

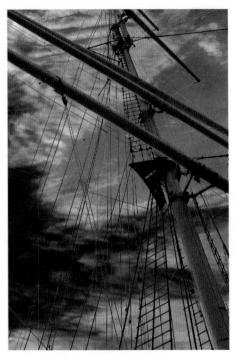

FIG 7.21 After splitting the sliders, visual evaluation suggested a broad blend to try to allow the ropes to transition smoothly, but not so far as to lose the rope details. Additional work will help this adjustment work better and we'll look at that as we continue the exercise.

images that are not getting along. The dark, rich sky is not natural against the mast. The ropes are wrapped with the lighter tone from the original sky and feel out of place. But the sky doesn't have to be so dark, and it will match better in the image and with the mast and ropes after it is lightened up a bit. There is also no reason one application of a single tool has to be an endpoint. A combination of tools and techniques often wins the battle. This is where vision comes in. The problem here is the mismatch of the images, and that's what we have to look at fixing next. In this case we can actually help ourselves by using another simple blend to make the images come together, show more of the original, and mediate between extremes all at the same time. We can just lower the opacity of the sky and tone it down considerably.

- Change the opacity of the Original Sky layer to about 50 percent. This
 will significantly lighten the sky and the ropes will blend better (see
 Figure 7.22). Yet it creates another problem with transparency (which
 we'll fix in the next steps).
- Duplicate the Original Mast layer, name the layer Sky Background, and move it to the bottom of the layer stack by pressing Command+Shift+[/Ctrl+Shift+[. This slides the content from the

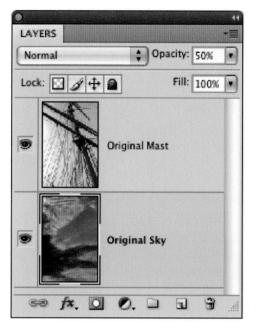

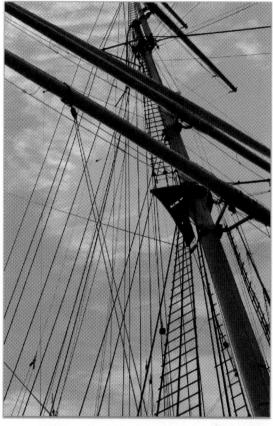

FIG 7.22 Lightening the sky brings the two parts of the image closer, but there is still more to do. The partial transparency (again represented by checked areas) can be backed up and enhanced using the sky in the mast image so the blended image isn't full of holes.

- sky in the mast image below the sky you are replacing it with, though it is still hidden by the Blend If settings.
- 11. Double-click the layer (anywhere but over the name) to open the Layer Style dialog, and reset the styles to set the Blend If back to the default settings. To do this press the Option/Alt key and the Cancel button will change to a Reset button. Click it when it does, then release the Option/Alt key and click OK to close the dialog (see Figure 7.23).
- 12. Make a Levels correction to the image using a Levels Adjustment layer. It should have settings similar to those in Figure 7.24.
- Next, using Color Balance will help you enhance the color and create a balance between the components that is pleasing (see Figure 7.25).

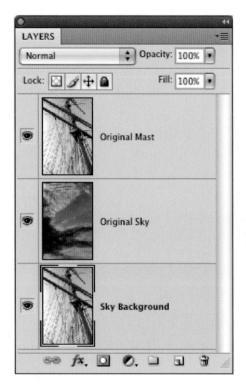

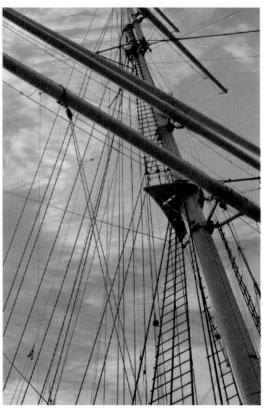

FIG 7.23 Restoring the sky behind the Original Sky layer fills in the blank spots and plugs all the holes while also reinforcing the cables.

The last several steps continue to look at the adjustments you are making as a process. You will end with a layer stack and a final result that look like Figure 7.26.

There are other things you can do to enhance the result further still. The Sample_12_complete.psd image shows a variation that adds some smoothing to the noisy color on the pole and a small mask on the Original Sky layer to allow a brighter portion of the mast to show clearly. You may want to make Hue/Saturation adjustments, Sharpening masks, or other corrections. The point is, every step is an increment to creating the final image, it never gets accomplished with one tool or in one move. If one tool only gets you halfway to the goal you will need to employ others to get yourself farther along the desired path.

You can try this same exercise using the Sky layer as the Blend If layer without duplicating the Mast layer. That is, instead of making the adjustment by putting the Original Mast layer on top and using the This Layer sliders, just use the Original Sky layer as the top layer and apply the Blend If function there

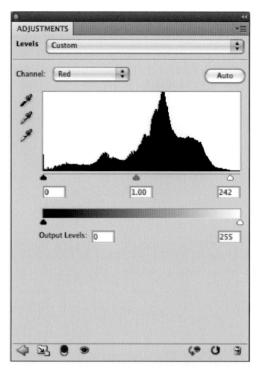

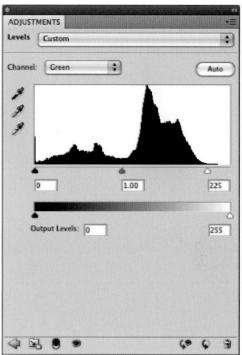

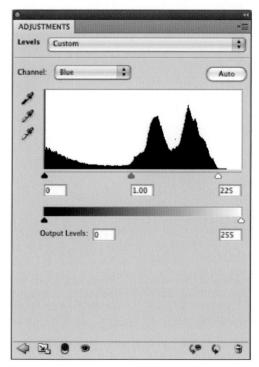

FIG 7.24 See Applying Levels for Color Correction in Chapter 3 for more about how to make Levels adjustments.

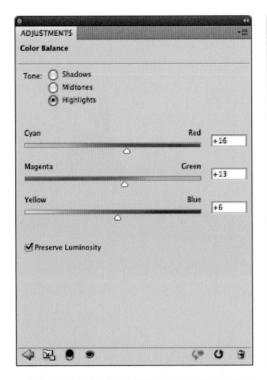

FIG 7.25 Color Balance allows you to tune the shifts in the image to reflect the differences in the lighting and emphasis of the images considered as a composite.

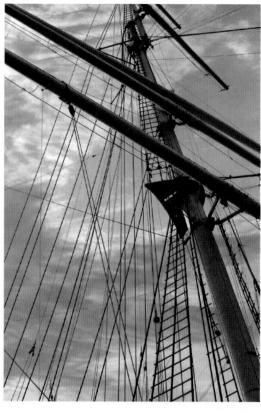

FIG 7.26 With a better matching of the qualities of the two images, blending becomes an effective way to quickly reach a result that would have been painful to accomplish using any manual method or more involved selection.

using the Underlying Layer sliders. The major difference will be that you will use different settings for the blend: instead of using settings for the mast layer that will blend out the sky, you will use settings to blend into the mast image. As it turns out, the opposite settings work just fine (see Figure 7.27).

In either case we are looking to target the range of sky between the rigging in the mast layer. Blend If can accomplish the task because there is enough of a distinct difference between the sky and the rest of the layer content.

Though Blend If can make precise adjustments to specific areas of an image and is handy for some types of targeting and blending, it is a little rigid when it comes to adjustment. The drawback becomes more apparent when you get into a situation in which you know Blend If would be more useful if you could adjust the results like you can with a layer mask. The secret is in conversion.

FIG 7.27 A different perspective on the same adjustment. Blend If can also be used to see through to layers below and create visibility based on underlying content.

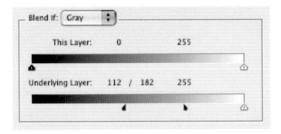

Let's take a look at color masking and working with transitions by creating masks with Blend If.

Blend If as a Mask

Blend If is a very powerful tool for working in exacting ranges, and with the right technique it can be used for everything from coloring black-and-white images, to blending layer content, to substituting for, or working in conjunction with, masking. There are, however, at least two glaring problems with Blend If. First, the range is exact, which doesn't leave any allowance for manipulation to fit shapes. If you have an area that isn't exactly within your range, Blend If won't target it precisely. Second, Blend If is not entirely intuitive when you are working with tone, and it is even more difficult to work with to address color ranges. All isn't black and white or based strictly on tone, so the problem of addressing color is inevitable.

The solution is to stick to using Blend If for what it is superior at: making transparency based on specific ranges. Blend If creates transparency in the current image layer, and you can convert that transparency to a clipping mask, a selection, or a mask by manipulating the results. Once you have converted Blend if to a mask or to solid pixel content (rather than just virtual transparency), the results can be manipulated. For example, you could create a mask using Blend If sliders to target a range of tones to either keep or throw out (based on slider positions). You can do this in a set of steps such as the following:

- 1. Duplicate the layer you want to make into a mask and name it Blend Mask.
- 2. Determine the range of tone you want to use in the layer as a mask using measurement or conceptual ranges (e.g., midtones).
- 3. Create a new, blank layer below the Blend Mask layer.
- 4. Activate the Blend Mask layer and set the This Layer range to the range determined in step 2.
- Merge down, and change the name of the layer to Transparency Mask.
 This will commit the transparency of the Blend Mask layer to the
 Transparency Mask layer.

This is similar to what we did in the previous exercise. Steps 3 to 5 lock the transparency based on the Blend If range according to the original tone. You can now use the Transparency Mask layer as a Clipping group base,

Shift+click it to load a selection, or load the selection and use it to create a mask. Committing the Blend Mask layer allows you to make it a physical element so you can make changes in it—by changing the solidity of the Transparency Mask layer, by altering the selection, or by making adjustments to the mask.

Using this scheme, you can quickly use layer content to convert to custom masks:

- Create a highlight mask based on transparency in the current layer by splitting the black slider to 0 and 255.
- Create a shadow mask by splitting the white slider to 0 and 255.
- Create a mask that targets the lightest half of the image; split the black slider to 128 and 255.
- Create a mask that targets the darkest half of the image; split the white slider to 0 and 128.

Blend If can be very effective in targeting tone. But Blend If can also allow you to convert specific color ranges to masks. To do this you can define ranges of color, desaturate those ranges to tones with the help of Hue/Saturation, and create a wide variety of masks based on color by sampling directly from your images.

Creating a Color-Based Mask with Blend If

The trilobite in Figure 7.28 would prove to be a very tedious selection to make manually. The general shape along with the lumps and bumps could take

FIG 7.28 This trilobite has many ribs that protrude, making a manual selection cumbersome. Techniques for selection and isolation can be made easier using Blend If techniques.

hours to trace in contour with one of the manual tools. The mixture of light and shadow make any kind of selection based on tone difficult or impossible.

To isolate an area based on color in this instance would be much more useful. With a variation on the more straightforward application of Blend If, you can sample the color in the image and then convert that area to a selection or mask via Blend If.

Try It Now

- 1. Open the Sample_14.psd file.
- Duplicate the Background layer and name it Source. You need a duplicate because you will be changing the layer content rather than using nondestructive methods.
- Open Hue/Saturation to apply it directly to the Source layer (Command+U/Ctrl+U). You want to make changes to the layer instead of using an adjustment layer.
- 4. Choose Blues from the Edit drop-down list. You choose Blues here because that seems to be the closest range to the area outside the trilobite; had you been looking to change a green or magenta, you should select that range instead.
- 5. Change the Saturation slider to -100 (see Figure 7.29).

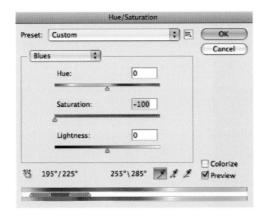

FIG 7.29 This will desaturate the areas that Photoshop considers part of the Blue range. It will not do a very good job desaturating our target range for this image, but we can fix that.

 Click the Add to Sample tool on the Hue/Saturation dialog. Click and drag in areas of the image using the sampler where there is still blue color in the background. All areas of blue should desaturate as you click on them (change to gray). Click OK to accept the changes (Figure 7.30).

FIG 7.30 Clicking and dragging the Add to Sample tool through the background will desaturate the areas you pass over because they will be sampled into the desaturation range. If you see the trilobite start to desaturate, change to the Subtract from Sample tool and click and drag over the areas of the trilobite to exclude them from the color selection and resaturate the trilobite.

7. Activate the Background by clicking it in the Layers palette, then create a new layer (Command+Option+Shift+N/Ctrl+Alt+Shift+N) and fill with 50 percent gray (Shift+F5 will open the Fill dialog). Name the new layer Commit 2. Duplicate Commit 2 and name it Commit 1. See Figure 7.31 for the setup. These layers will be used to commit a series of image changes that create the mask.

FIG 7.31 The layers in your Layers palette should be Source, Commit 1, Commit 2, and Background, in order from the top down.

- 8. Change the mode of the Source layer to Color and merge down. This will isolate the color in a color separation. Everything that was desaturated will be 50 percent gray. See Figure 7.32.
- Change the mode of the Commit 1 layer to Difference. This will show the difference between the saturated and desaturated parts of Commit 1 and Commit 2. Everything that is desaturated (the range we selected) will turn pure black. Merge down to commit the Difference comparison (see Figure 7.33).

FIG 7.32 You will see that the area over the trilobite is still in color, but the rest of the image is flat gray.

FIG 7.33 Anything in the image that is not exactly 50 percent gray in the layer where the mode is applied (anything different from the layer below) will appear as something other than pure black when the Difference mode is applied.

10. Change the name of the current layer to Commit 2 if it is not that already. The layers will look like they do in Figure 7.34.

FIG 7.34 The last few steps produce these results and leave you with only the Background and Commit 2 layers.

- 11. Shut off the Visibility toggle for the Background layer so only the Commit 2 layer is technically visible. Double-click the Commit 2 layer to open the Layer Style dialog.
- 12. Under Blend If on the dialog, click the black slider for This Layer and slide it to the right only one level while watching the image. The black should disappear from sight in the image. Close the Layer Style dialog by clicking OK.
- Activate the Background by clicking it in the Layers palette. Create a new, blank layer. Name it Transparency Mask. Your Layers palette should look like Figure 7.35.
- 14. Merge the Commit 2 layer down into the Transparency Mask layer to commit the transparency.
- 15. Clean up the Transparency Mask layer. You can clear debris and noise outside of the trilobite with a variety of tools. For example, use the Lasso to surround large areas and then press the Delete key, or just use the Eraser tool. Fill holes in the trilobite by just painting with a Paintbrush—it doesn't matter what color you use for the brush, but it should be 100 percent solid and hard.

FIG 7.35 You will see a clear area around the trilobite and some noise in the image, but the Commit 2 layer will appear solid in the Layers palette.

16. Duplicate the Background, name the duplicate Source, and move it above the Transparency Mask, then make a Clipping group from those layers and turn on the Visibility toggle for the Source layer. Your content will be restored to the original look, but without the background. See the layer stack in Figure 7.36.

What is happening here is that you manipulate the color to desaturate the image in areas you want to mask. Then you isolate the desaturated areas with a layer mode calculation and then use Blend If to redefine the visible portion of the layer. You may see how this builds on the information in the previous chapters and rolls the techniques all together. By moving the black This Layer slider to the right, the black areas of the layer are eliminated from view (though not yet deleted). Once the transparency is committed by merging, the exact range of pixels can be manually altered to account for edge blending and other differences that are not guided by strict numeric

FIG 7.36 You can now make changes independently to either the background or the trilobite in isolation from one another based on the mask you created.

relationships. This transparent mask is used as a Clipping layer, but could just as easily be converted to a layer mask by loading the solid parts of the layer as a selection (Command+click/Ctrl+click directly on the Transparency Mask layer thumbnail to load the selection).

A Color Mask action is provided in the Blend If actions included on the CD. This action will help you through the process by running through the steps for the Hue/Saturation and Blend If techniques as discussed in this section. That same action set also has actions that will help you automate Blend If settings so you don't have to go into the Layer Style dialog and adjust settings. These preset ranges can substitute for tone-based layer masks that will target tone ranges in layers below the layer on which they are applied:

- Target Highlights, Full Range (set the Underlying Layer black slider to 0 and 255):
- Target Highlights, Half Range (set the Underlying Layer black slider to 128 and 255);

- Target Shadows, Full Range (set the Underlying Layer white slider to 0 and 255);
- Target Shadows, Half Range (set the Underlying Layer black slider to 0 and 128);
- Target Midtones, Full Range (set the Underlying Layer black slider to 0 and 128 and set the Underlying Layer white slider to 128 and 255);
- Target Midtones, Half Range (set the Underlying Layer black slider to 63 and 128 and set the Underlying Layer white slider to 128 and 192);
- Exclude Midtones, Full Range (set the Underlying Layer black slider to 128 and 255 and set the Underlying Layer white slider to 0 and 128);
- Exclude Midtones, Half Range (set the Underlying Layer black slider to 192 and 255 and set the Underlying Layer white slider to 0 and 63);
- Reset (set Underlying Layer sliders to 0, 0/255, and 255).

These presets can serve a variety of purposes. You may be able to guess at how these will come in handy, but we'll continue to carry over techniques and build on them by looking at specific examples in Chapter 9.

Summary

Blend If provides yet another opportunity to isolate objects, in this instance by creating transparency that can be converted into masks. In this way it can provide a means of blending layers that no other tool will provide. It also provides alternatives to using other tools, such as the Magic Wand or color range tools for making selections, masks, and creating object isolation based on tone and color, and requires less guessing.

Keys to success with Blend If lie in using it in conjunction with other tools and techniques. It won't be the magic bullet for problems all on its own, but it will be a masking helper, selection helper, and companion to other masking and selection techniques. Flexibility is offered by the quick Blend If actions included on the CD, and they will keep you from having to dig into the Layer Style dialog every time you want to try something from the Blend If bag of tricks.

We have looked at quite a few layer-based adjustments in the past several chapters. Some are convenient for shape, others for tone, and still others for color, and some are for general calculations. One thing to keep in mind as you move forward from this point is that it is rarely a single method that does everything you need it to if you are hoping for the best outcome. Best outcomes and quick results may require thinking creatively to use these tools to simplify your tasks. For a given image there will be occasions on which I use every one of the techniques and functions mentioned in these chapters, and there are probably fewer times in which I will use one or two. Get familiar with each of these techniques, and add them to your tool belt. Work on them one at a time to get familiar with and master each. Set aside dedicated time to explore how the techniques might work in a variety of situations. If you

run into one that doesn't seem to fit the mold, you will likely learn from the experience. If you have questions, please feel free to visit the forums for the book at http://www.photoshopcs.com, where you can post questions with example images and we can discuss the results.

One more useful feature is hidden on the Advanced panel of the Layer Style dialog, and that would be the deceptively simple-looking Red, Green, and Blue checkboxes. We'll look at the implications these features bring to layer-based separations in the next chapter.

mage components are separations of an image into distinct color or tone parts. We looked at separating an image into brightness (luminosity) and color in Chapter 6, but there are many ways to separate images into other types of components, including color components of light (red, green, and blue) and ink (cyan, yellow, magenta, and black). Separating images into components can offer advantages in making corrections, such as creating masks, setting up calculations, and converting images to black and white.

Separations provide an essential understanding of how images are composed, stored, and viewed. Being able to work with color components directly as separations is nearly the exclusive reason for channels—to which Adobe has dedicated an entire palette in Photoshop. When the Photoshop user learns to look at channels as component parts of images in the same context as layers (rather than as part of a separate palette), he or she gains many times the potential flexibility. Working with channels/components in layers leads to a better understanding of how they fit into images and how they can be used directly in corrections rather than reaching to a separate part of the interface.

A Historic Interlude

One of my favorite digital lessons is learned from taking a set of blackand-white images created before there was color film and making a color representation of the image. A special case is the photos of one Russian photographer, Sergei Mikhailovich Prokudin-Gorskii.

You can find digitized images in several libraries online: http://www.cs.cmu.edu/~dellaert/aligned/http://www.loc.gov/exhibits/empire/.

Using a special camera that he designed, Prokudin-Gorskii captured images on glass plates three at a time (it is said in rapid succession, rather than all at once). During the capture, color filters separated red, green, and blue color components to different areas of the plate. The result was a single plate with black-and-white representations of the image's core light components (see Figure 8.1).

The solution still offered only black-and-white representations of the RGB channels, was a bit awkward, and required a customized projector to reproduce the color. But really these first color captures mimic what digital cameras do even today, separating and storing color in red, green, and blue light components. About 100 years after they were taken, we can treat Prokudin-Gorskii's images as components of an image and put them back together using Photoshop to re-create their full-color representations.

Working with separations provides some valuable background for what we've already been doing in correcting for different components of light with Levels. It also opens doors to additional techniques for working with color and black-and-white images.

Creating Color from Black and White

The concept of RGB and the idea that an entire world of color can be stored in combinations of three colors really doesn't seem plausible until you see it at work. That is, the 16 million color variations in 8 bits per channel and 35 billion in 16 bits per channel are all produced from the capture of red, green, and blue core components.

In the following short example, we'll look at putting together a Prokudin-Gorskii image from his original black-and-white captures.

Try It Now

 Open the three Samples_15 images off the CD. They are named Sample_15_red.psd, Sample_15_green.psd, and Sample_15_blue. psd. Be sure to keep them in order, or your result will not turn out correctly (Figure 8.2).

FIG 8.1 A scan of an original Prokudin-Gorskii "color" plate taken between 1907 and 1915, 20 years before Kodachrome . . . the first color film. Stacked here from the top down are the blue, green, and red color components.

FIG 8.2 The three sample images represent the red, green, and blue components.

If you'd like an extra challenge, there is a Sample_15_RGB.psd on the CD as well. This image has a scan of the complete glass plate. You can work from that if you'd like, but be forewarned that there are issues of alignment and distortion that have mostly been addressed in the cropped version provided.

- Activate the Sample_15_blue.psd image, then press Command+A/ Ctrl+A (Mac/PC) to select the entire image, then press Command+C/ Ctrl+C to copy. Doing this stores a copy of the image as well as the image dimensions, which helps automate the next step.
- Create a new image (File>New), name the file Prokudin-Gorskii
 Composite, as in Figure 8.3, and be sure to change the Color Mode to
 RGB Color (it will initially be Grayscale). We will use this new image
 to assemble a color image from the components in the other three
 images.

	Name:	: Prokudin-Gorskii Composite			ОК
Preset:	Custom				Cancel
	Size:			A Y	Save Preset
	Width:	1938	pixels	*	Delete Preset
	Height:	2466	pixels	•	Device Central.
	Resolution:	1008.097	pixels/inch	•	
	Color Mode:	RGB Color	8 bit	•	
Backgrou	ackground Contents: White				Image Size:
Advanced					13.7M

FIG 8.3 Your New dialog should look very much like this when opened, as Photoshop will have automatically defined the new image size from the image information on your clipboard.

- 4. Create a new layer, call it Compositing Screen, and fill it with black (Edit>Fill and set the Use content to Black in the drop-down list). This will act as a projection screen for the image components.
- 5. Press Command+V/Ctrl+V to paste the content of the clipboard to the image. Name the resulting layer Blue (Figure 8.4).
- Arrange the Prokudin-Gorskii Composite image and the Sample_15_ green.psd so you can see both on your monitor, choose the Move

FIG 8.4 After pasting the initial component, you will have three layers: Background, Compositing Screen, and Blue.

- tool (press V), hold the Shift key, and click and drag the Sample_15_ green.psd image into the Prokudin-Gorskii Composite file. Release the mouse button and then the Shift key. Name the new layer in the Composite image Green.
- 7. Arrange the Prokudin-Gorskii Composite image and the Sample_15_ red.psd image so you can see both on screen, choose the Move tool (press V), hold the Shift key, and click and drag the Sample_15_red. psd image into the Prokudin-Gorskii Composite file. Release the mouse button and then the Shift key. Name the new layer in the Composite image Red. The result of all this clicking and dragging should look like Figure 8.5.

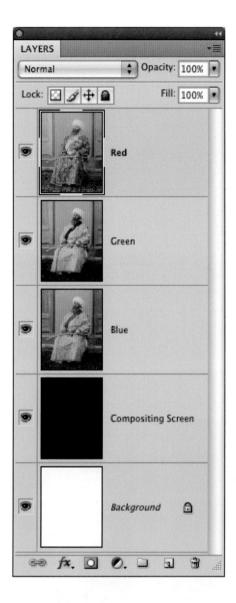

FIG 8.5 The resulting layers from the top down should be Red, Green, Blue, Compositing Screen, and Background.

- Close the Sample_15_red.psd, Sample_15_green.psd, and Sample_ 15_blue.psd images, leaving only the Prokudin-Gorskii Composite image open.
- 9. Shut off the views for the Blue and Green layers so you are viewing only the Red layer. It will still appear in black and white at this point.
- 10. Double-click the thumbnail for the Red layer in the Layers palette. The Layer Style dialog will open.

- 11. Uncheck the Green and Blue checkboxes for Channels under Advanced Blending (see Figure 8.6). The image will turn red, showing a view of how the red light component in the image looks when isolated.
- 12. Shut off the Visibility toggle for the Red layer and toggle the view for the Green layer so it is visible again. The image will appear as a grayscale representation of the Green channel.
- Double-click the thumbnail for the Green layer in the Layers palette for the Prokudin-Gorskii Composite image. The Layer Style dialog will appear.

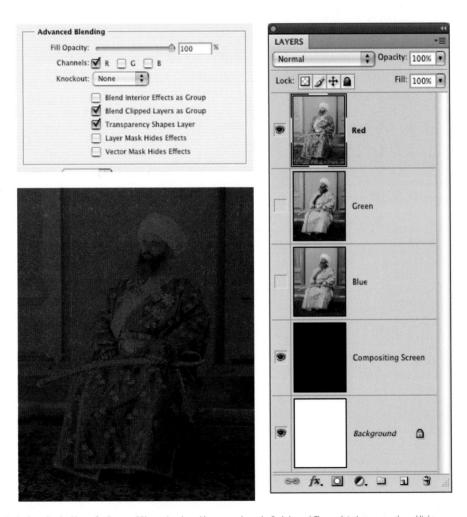

FIG 8.6 Unchecking the checkboxes for Green and Blue makes the red layer act only on the Red channel. The result is that you see the red light component in red.

- 14. Uncheck the Red and Blue checkboxes for Channels under Advanced Blending. The image will show the green component channel in green (see Figure 8.7).
- 15. Shut off the Visibility toggle for the Green layer, and toggle the view for the Blue layer so it is visible again. The image will appear as a grayscale representation of the Blue channel.
- 16. Double-click the thumbnail for the Blue layer in the Layers palette for the Prokudin-Gorskii Composite image. The Layer Style dialog will appear.

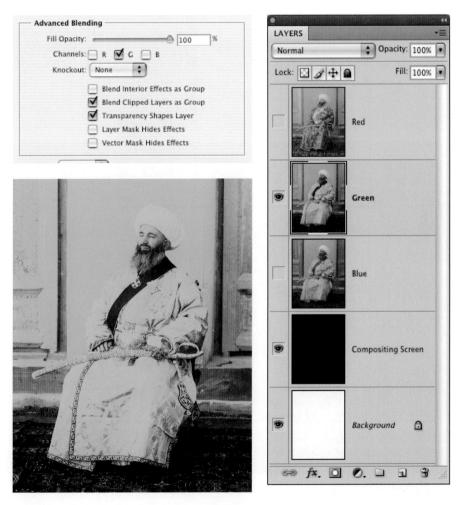

FIG 8.7 Unchecking the checkboxes for Red and Blue makes the green layer act only on the Green channel. The result is that you see the green light component in green.

- 17. Uncheck the Red and Green checkboxes for Channels under Advanced Blending. As you might expect, the image will show the blue component of the image in blue (Figure 8.8).
- 18. Now turn on the Visibility toggles for the Green and Red layers. You will see a full-color composite of the image, though there is no color at all in any of the layers in the Layers palette (see Figure 8.9).

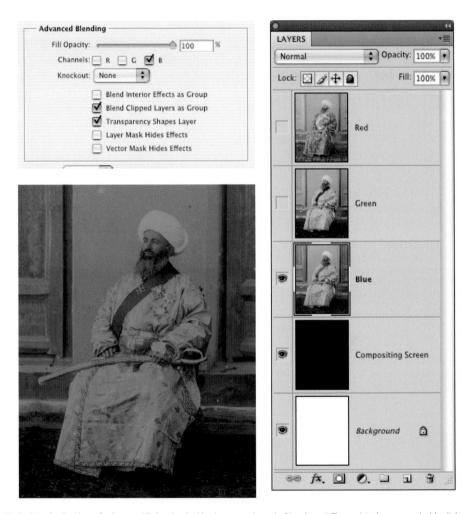

FIG 8.8 Unchecking the checkboxes for Green and Red makes the blue layer act only on the Blue channel. The result is that you see the blue light component in blue.

FIG 8.9 The result has some issues as far as needing color correction, dynamic range enhancement, and some obvious cleanup, but the fact is that you have just created color from images taken about 100 years ago, 20 years before there was color film.

Use of those little checkboxes on the Advanced Blending panel of the Layer Style dialog demonstrates several important light theory concepts. Layer Styles target the content of the layers to make each act like a specific light component, which projects on the dark screen. When all three of the light components are switched on, the red, green, and blue components combine to re-create the full-color image from the three separate black-and-white components. This is what your monitor projects, what your camera captures, and what Photoshop re-creates: red, green, and blue components are assembled to make a color image. The example shows that colored light works when stored as grayscale measurements and is a sort of demonstration of what Prokudin-Gorskii needed to do to re-create the color he captured: project the filtered images onto a screen. Let's look at this same example in a different way to mix in more light and layer theory, continuing on with the same image.

An Alternative: Creating Filtered Color

Prokudin-Gorskii couldn't just click a checkbox to make his glass plates perform and convert to color. He had to make a more rudimentary effort to filter the red, green, and blue light components during projection. Using layer modes, we can mimic filtering the components with color to reproduce color from black and white.

Try It Now

 Double-click the Red layer in the Layers palette in the Prokudin-Gorskii Composite image to open the Layer Style dialog. Check the Green and Blue boxes, and set the Blend Mode to Screen. This mode treats layer content like light: enhancing brightness only (Figure 8.10).

FIG 8.10 The Layers palette looks no different, but the image at this point will look horribly overexposed. We are in the middle of a process that isn't complete, so don't worry about how it looks on screen at this point.

- 2. Double-click the Green layer in the Layers palette in the Prokudin-Gorskii Composite image to open the Layer Style dialog. Check the Red and Blue boxes, and set the Blend Mode to Screen.
- Double-click the Blue layer in the Layers palette in the Prokudin-Gorskii Composite image to open the Layer Style dialog. Check the Red and Green boxes, and set the Blend Mode to Screen. The image will be an overexposed mess at this point.
- 4. Shut off the visibility for the Red and Green layers. Click on the Blue layer to activate it if it is not active already.
- 5. With the Blue layer active, create a new layer (Layer>New>Layer). When the New Layer dialog appears, name the layer Color Blue,

- and change the Mode to Multiply. This mode acts as a multiplier to darken content below, here multiplying by solid blue, which we will fill the layer with in the next step. Check the Group with Previous checkbox. Then click OK.
- 6. Fill the Color Blue layer with pure blue (RGB: 0, 0, 255). You can do this by changing the foreground color to blue and clicking in the image with the Paint Bucket tool or by using the Fill function with the proper foreground or Custom color setting. The result should look like Figure 8.11.
- 7. Shut off the visibility for the Blue layer and turn on the visibility for the Green layer. Click the Green layer in the Layers palette to activate it.

FIG 8.11 The grouped Color Blue layer acts like a filter for blue light as if you were to place a gelatin filter over the Blue content, adding color back to the component.

- The Color Blue layer can remain on. Because it is grouped with the Blue layer, it will not be visible.
- 8. Create a new layer (Layer>New>Layer). When the New Layer dialog appears, name the layer Color Green, change the Mode to Multiply, and check the Group with Previous checkbox. Then click OK.
- 9. Fill the Color Green layer with pure green (RGB: 0, 255, 0) (see Figure 8.12).
- 10. Shut off the visibility for the Green layer and turn on the visibility for the Red layer. Click the Red layer in the Layers palette to activate it.

FIG 8.12 The addition of the Color Green layer will cover the green component content with green color, again as if you had applied a gelatin filter.

- 11. Create a new layer (Layer>New>Layer). When the New Layer dialog appears, name the layer Color Red, change the Mode to Multiply, and check the Group with Previous checkbox. Then click OK.
- 12. Fill the Color Red layer with pure red (RGB: 255, 0, 0). Your layers should look like Figure 8.13.
- 13. Turn on the visibility for the Green and Blue layers. The image will appear in full color again, exactly as before.

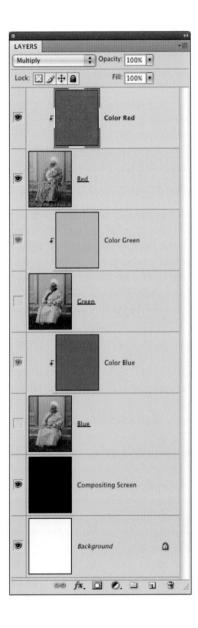

FIG 8.13 Completing the roundup of color additions with the Color Red layer, you are one step away from obtaining full color via filtered layers. When the visibility for all layers is turned on, you'll once again have full color.

In this scenario, the Color layers act like gel filters, adding color to the grayscale representations using the Multiply layer mode. Each of the components themselves is then projected like light on the Composite layer by being set to Screen mode.

This procedure works every time you have grayscale representations of your image ... but it isn't likely that you'll soon be out making a custom camera that will shoot separations on a glass plate. Inside every color image there is light, and because there is light, there are light components: red, green, and blue. Filtering works to put the color into your image, but a lesson learned from Prokudin-Gorskii is that light components can also be filtered *out* and separated from color images.

An interesting option at this point is to work at the Prokudin-Gorskii image and make corrections. You can make a Levels correction for starters and clean up a plethora of spots and dust. You might try sharpening, color balance, contrast enhancements, and any other technique we've looked at thus far. Doing so can help reinforce those techniques and their application.

Separating a Color Image into RGB Components

Just as Prokudin-Gorskii filtered the light in his scenes for red, green, and blue to make his black-and-white "color" plates, you can reverse the process of adding color and create separations in layers. You might say, "Oh, we already have channels for that." But a huge drawback to channels is that they are in a separate palette and you can't work with them nearly as fluidly as you could if you could work them like layers. Let's take a look at the process and then see some of what you can do with separated components.

Try It Now

- Flatten the Prokudin-Gorskii Composite image (Image > Flatten Image). This will commit the changes and merge the image into a Background layer.
- Create a new layer, name it Red Filter, and change the Mode to Multiply.
- 3. Fill the Red Filter layer with pure red (RGB: 255, 0, 0). This will turn the image red and will represent the red light component.
- 4. Create a Hue/Saturation Adjustment layer (above the Red Filter layer in the Layers palette). Choose Reds from the Edit drop-down list and push the Lightness slider all the way to the right. You will be left with a grayscale representation of the red light component. Your layers should look like Figure 8.14.
- 5. Press Command+Option+Shift+E/Ctrl+Alt+Shift+E to copy the visible image to a new layer. Name the new layer Red.

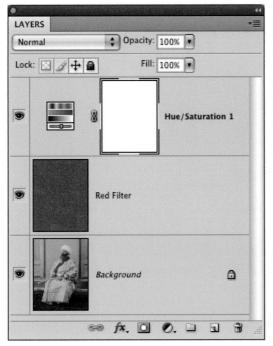

FIG 8.14 Extracting red as the first color component gives you a model for separating the green and blue components as well.

- 6. Delete the Hue/Saturation layer. Shut off the view for the Red and Red Filter layers.
- 7. Create a new layer above the Background layer. Name it Green Filter, and change the Mode to Multiply.
- 8. Fill the Green Filter layer with pure green (RGB: 0, 255, 0). This will turn the image green and will represent the green light component.
- Create a Hue/Saturation Adjustment layer. Choose Greens from the Edit drop-down list and push the Lightness slider all the way to the right. You will be left with a grayscale representation of the green light component.
- 10. Press Command+Option+Shift+E/Ctrl+Alt+Shift+E to copy the visible image to a new layer. Name the new layer Green (see Figure 8.15).
- 11. Delete the Hue/Saturation layer. Shut off the visibility for the Green and Green Filter layers.
- 12. Create a new layer above the Background layer. Name it Blue Filter. Change the Mode to Multiply.
- 13. Fill the Blue Filter layer with pure blue (RGB: 0, 0, 255). This will turn the image blue and will represent the blue light component.

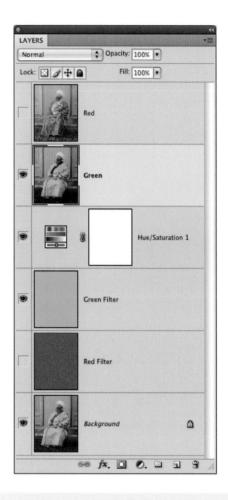

FIG 8.15 After extracting the green component, the layer stack looks like this.

- 14. Create a new Hue/Saturation Adjustment layer. Choose Blues from the Edit drop-down list and push the Lightness slider all the way to the right. You will be left with a grayscale representation of the blue light component.
- 15. Press Command+Option+Shift+E/Ctrl+Alt+Shift+E to copy the visible image to a new layer. Name the new layer Blue (see Figure 8.16).
- 16. Delete the Hue/Saturation layer.

After these steps you should have a Red, a Green, and a Blue layer in your image, all representing grayscale components extracted from the image you were working on. Your next chore is to add the color back to the components to create a color representation while keeping the grayscale components separate. A big hint: look to the earlier part of this chapter in which you added color to the Prokudin-Gorskii image to see how to add color back to grayscale separations. Use the Filter layers as the Color layers (I didn't ask you to delete them so you wouldn't have to re-create them).

Another way to make the separations would be to use the Channel Targeting in the Advanced Blending panel.

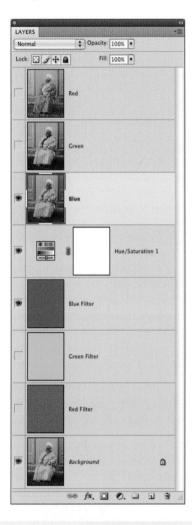

FIG 8.16 The Blue layer gets created with steps almost identical to those for the other components, simply by applying a different color filter.

Try It Now

- Duplicate the Background to a new image. To do this, click the Background layer to activate it, and then choose Layer>Duplicate Layer. When the Duplicate Layer dialog appears, choose New for the Destination, and name your new image Prokudin-Gorskii New (see Figure 8.17).
- 2. Double-click the Background layer in the new image, and when the New Layer dialog appears, rename the layer Source.
- 3. Double-click the Source layer and when the Layer Style dialog appears, uncheck the Green and Blue channels.

FIG 8.17 Settings for the Duplicate Layer dialog should appear as in this sample.

- 4. Create a Hue/Saturation Adjustment layer. Choose Reds from the Edit drop-down list and push the Lightness slider all the way to the right.
- 5. Press Command+Option+Shift+E/Ctrl+Alt+Shift+E to copy the visible image to a new layer. Name the new layer Red.

This will isolate the Red channel. I'll let you figure out the rest for the Green and Blue. If you don't think it through, and just follow what I feed you it will be harder to retain or understand. What either of these methods accomplishes is getting your image components on separate layers. Here we have taken apart and put back together your color images—in a fashion nearly identical to the way your images are separated into components and stored and then reproduced as color from the grayscale channels.

You may think it is a lot of bother to go through to separate out components. That is why I have included some tools on the CD to do it for you. If you load the Separations action set, in it you will find the following tools:

- Complete RGB Separation (duplicates the current image and makes a complete RGB separation following yet another path to separations);
- Blue Component (duplicates the current image and separates out a standalone Blue Component layer);
- Green Component (duplicates the current image and separates out a standalone Green Component layer);
- Red Component (duplicates the current image and separates out a standalone Red Component layer);
- Luminosity and Color (duplicates the current image and separates out Color and Luminosity layers);
- Complete CMYK Separation (duplicates the current image and makes a complete CMYK separation allowing custom UCR/GCR for black generation);
- RGBL Components (duplicates the current image and separates out Red, Green, Blue, and Luminosity layers);
- Richard's Custom Black-and-White (duplicates the current image and creates a black-and-white result that works well with many images);

- Simple Channel Mixer (duplicates the current image and sets up a layerbased channel mixing scenario);
- Target Red (targets the current layer to the Red channel, unchecks boxes in the Advanced Blending for Green and Blue);
- Target Green (targets the current layer to the Green channel, unchecks boxes in the Advanced Blending for Red and Blue);
- Target Blue (targets the current layer to the Blue channel, unchecks boxes in the Advanced Blending for Red and Green);
- Target RGB (resets all Advanced Blending channel checkboxes to checked).

We'll be looking at the RGBL Components and Richard's Custom Black-and-White actions in the following section. Load the actions now so you are ready to go in the next exercise!

Breaking out color components into layers is a very advanced move, and may be something you won't do very often, but it should give you several things, including a good idea of the peripheral power of layers and a good concept of how image information is captured and stored. But what can you do with your knowledge of separations? Follow along into the next section, in which we look at using your separations.

Using Separations

Grayscale channels can be used for a variety of highly specialized purposes. First, you can target changes directly to any one of the RGB components using Adjustment layers in Clipping groups with specific layer color components (red, green, or blue; not the Filter layers). Components can be used for masking, selection, and a plethora of alterations, with a freedom in layers that is not accessible to you with channels and channel functions.

Probably one of the most useful and practical applications of separated components is making custom black-and-white conversions. Many people will suggest turning to Channel Mixer, the Black & White function, or perhaps Calculations. The thing each of these functions has in common is that they use separated components to create the image results. However, because these features are predefined, there are inherent limitations to the ways they can be combined. You can't, for example, use any of these functions to create a calculation with three components of your choosing in different modes simultaneously. Layer-based calculations and channel mixing allow you complete freedom to use the power of layers however you'd like. Let's test it out now.

Try It Now

1. Open the Sample_16.psd image on the CD (see Figure 8.18).

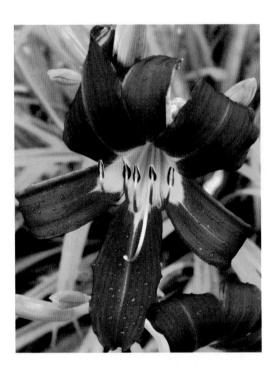

FIG 8.18 A colorful combination leaves some interesting and stark differences between image components after this separation.

- Run the RGBL Components action in the Separations action set. This
 action will run through a series of steps similar to those we have been
 following and will create red, green, blue, and luminosity components
 for the image in separate layers (Figure 8.19).
- 3. Shut off the view for the Luminosity, Red Component, and Blue Component layers in the Layers palette. This leaves the view for the Green Component layer. The flower petals are dark, but they can easily be lightened using the Red Component layer, as we will do in the next step.
- 4. Move the Red Component layer above the Green Component layer in the layer stack. If you view the Red Component layer by itself (turn off the Visibility toggle for the Green Component layer, turn the Visibility toggle for the Red Component layer on), you will see that it is light in the petal areas but dark in the surrounding greenery. Turn on the Visibility toggle for the Green Component layer, change the mode of the Red Component layer to Lighten, and lower the opacity to 60 percent. This will lighten the flower petal area without a significant impact on the area surrounding the flower, which is much lighter in the Green Component layer.

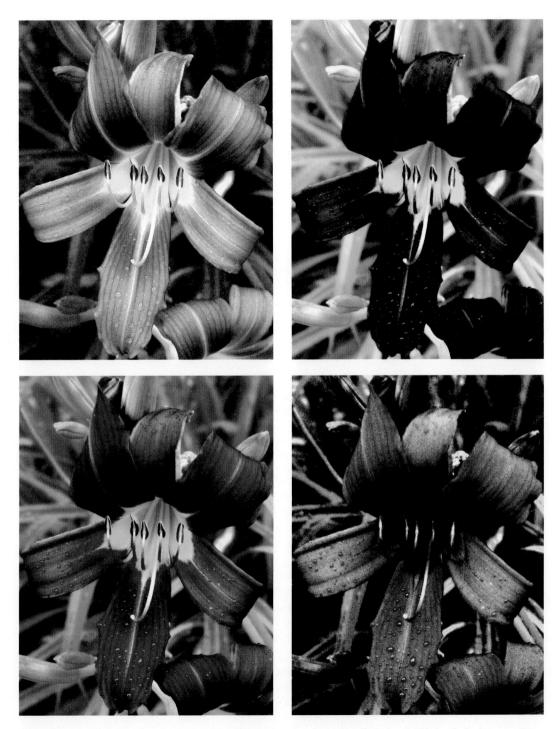

FIG 8.19 The range of looks in this separation shows a marked difference that will need to be changed to make a good black-and-white conversion. Here we have red, green, luminosity, and blue components.

- To add back some of the unique dynamics of the Blue Component and enhance the contrast of the result, turn on the Visibility toggle for the Blue Component layer, change the Mode of the Blue Component layer to Overlay, and reduce the opacity to 16 percent.
- Duplicate the Green Component layer, name the resulting layer
 Green Component Screen, change the opacity to 70 percent, and be
 sure the Mode is Screen. This will lighten the area around the petals
 to create greater contrast.
- 7. Turn on the Luminosity layer, and change the opacity to 33 percent. This will moderate some of the extremes that may have been caused by other calculations (see the result in Figure 8.20).

Steps 6 and 7 add some calculations that experience has shown will render a better general conversion for almost any image from RGB to grayscale. You can repeat this whole series of steps by using Richard's Custom Black-and-White action from the Separations action set.

You may want to play around with the opacity and modes of the component layers both to explore what is going on and to see if you can come to a "better" result. This particular adjustment is one developed after fooling with various possibilities and considering light and color theory. As a conversion, it works fairly consistently over a wide variety of images to produce a pretty good black-and-white image. Give it a try on any color RGB image. Though I often start with this as a base, it is only one of the infinite possibilities for combining tone. You can fine-tune or completely change the result using layer opacity, additional component layers, and different layer-blending modes.

The previous example was a result derived from experimentation with the Green Component layer as a starting point. I chose to start with the Green Component layer because it is similar to how we perceive brightness. If you start with a component other than the Green Component layer, your goals and results for changing the image and the calculations you make may be very different from those we used above. For example, if you make the separations and start with the Red Component layer, you could go in an entirely different direction and attempt to make the petals lighter than the background. Let's try it out.

Try It Now

- 1. Open the Sample_16.psd image on the CD.
- 2. Run the RGBL Components action.
- Shut off the view for the Luminosity, Green Component, and Blue Component layers. This leaves the view for the Red Component layer. The flower petals are dark but brighter and more contrasty than the

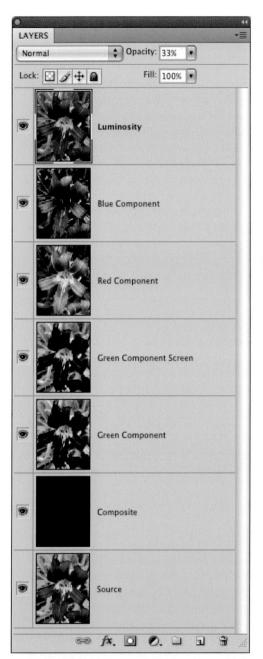

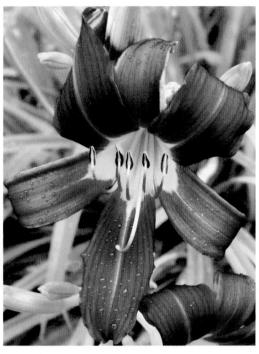

FIG 8.20 This combination of layers, components, and modes cannot be achieved with Photoshop's native functions, and yet it generally renders a favorable black-and-white result with any image. You need the power of Layers to achieve this.

- background. The background can be darkened, the petals lightened, and the contrast enhanced using the following steps.
- 4. Activate the Green Component layer, and toggle the view on. Invert the layer content (Command+I/CtrI+I), change the Mode to Overlay, and reduce the opacity to 24 percent. Inverting the layer changes the content to a negative of the original, in this case making the petals light and the background dark in the Green Component layer. Applying the layer in Overlay should use the inverted content to darken the background and lighten the petals. The great part about this type of masking is that it is prefit to the image as it comes directly from the source.
- 5. Activate the Blue Component layer, and toggle the view on. Apply a Gaussian Blur of 10 pixels, change the Mode to Soft Light, and change the opacity to 60 percent. This will serve to smooth out the roughness of the Blue Component and allow it to be applied to enhance the contrast and soften the image, both at the same time (see the result in Figure 8.21).

This calculation will actually not be likely to produce a good black-and-white conversion on many images, even though it produces interesting results here. The point is that depending on where you start, how you see an image, and how you use the content to make calculations, you can come to very different ends. If you are up to it, try an experiment: start with the Blue Component layer, and see where that leads. See if you can envision the result you want to get and attain it using what you know about layers. It takes vision and practice to be able to use the components creatively and effectively. Practicing your visual evaluations will benefit you even if the conversions to black and white are not entirely successful.

Summary

Separations are the core of another powerful element of Photoshop: Channels. Channels are a powerful tool in their own right; however, when layers are used correctly to their capability, they can make Channels and channel functions virtually unnecessary and superfluous. Using separated components as described in this chapter gives you tremendous flexibility with the application of components in a more straightforward model than using Channels or channel functions. Layering components can help you break away not only from the limitations of Channels, but also of other tools such as Channel Mixer and Calculations.

There is a lot to explore in standard separations of RGB, CMYK, luminosity, and color and perhaps even more to explore with custom separations. That doesn't mean merely that you have an opportunity to explore separations of CMYK

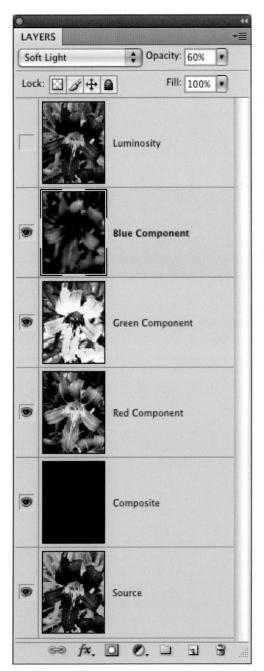

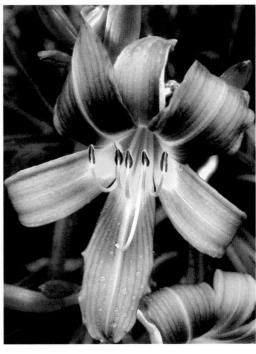

FIG 8.21 Using the same components as from the original procedure with different mode and opacity settings creates a much different result. You are not obligated to use all the layers generated by the Separation action set.

in which you fiddle with the GCR settings, but that you can create completely custom separations for unique colors. Clever use of custom separations may help you define selections and masks or create unique black-and-white results. Creating black-and-white images via separations and calculations is not necessarily an endpoint. Black-and-white images offer opportunity for hand-colored effects and redefining the color that makes the image.

At this point we have looked at most of the more powerful layer functions and a variety of brief exercises that allowed us to apply the tools to achieve specific goals. We've taken a tour of the process of image editing and defined an outline for an editing approach. As we turn the corner into the final two chapters, we will refocus to combine process with a variety of techniques by taking images through corrective steps from beginning to end with layers as our guide to the result.

For more helpful actions for image adjustments in Photoshop, conversions to black and white, and separations and for questions about the techniques and procedures, visit the web site for this book at http://www.photoshopcs.com. I am hoping reader interest and questions on the forum will lead to creating new actions for reader use, which I'll make available, and that discussion will open doors to broader understanding of working with separations for masking, selection, and conversion.

Taking an Image through the Process

Throughout this book we've looked at multiple facets of image correction and adjustment using layer functionality. As we were still busy exploring Layers, there has not been an opportunity to put everything together. The goal of this chapter is to bring together layer techniques that we have learned, to see how the procedures apply to real-world images and real-world editing situations. Seeing the whole process in action should help you to use the concepts and techniques to correct your own images. Using a sample image supplied on the CD, we will step through the process of correction and adjustment from start to finish to show how the process works in practice.

The base process used for the image will follow procedures suggested earlier in this book, and it may go a step farther than you would expect to embellish the image. You don't have to agree with or even like the embellishments, but you should understand the procedures and how they fit into the process of getting to the image result. We will take a critical look at the photo before stepping through the procedures so that we can outline the goals for the

image. This chapter is meant to reflect the way you will approach any image as you continue working with layers in your image editing work flow and the concepts from this book.

The Image

The image in Figure 9.1 was taken by a long-time friend, Luke Delalio, who does a lot of head-shot photography in New York City (lukedelalio.com). He gets outstanding shots of his clients, with a handheld camera, no flash, in natural light—revealing more personality than the standard studio head shots. The image is available on the CD as Sample_17.psd.

FIG 9.1 We'll use this image from the CD to run through the correction process.

Luke had other usable shots from this session of his stunning model Carly, but he had passed this one on to me to see if I could do something with it. I could see what he liked in the image: in addition to the pretty model, there was some interesting lighting, an insolating depth of field, and a flattering pose. Although it is an interesting image, like any image there are quite a few ways that it can be improved. Shot at a wide aperture at 1/30 of a second, it is almost extraordinary that it is as sharp as it is. Whereas this might never be manipulated to be a terrifically sharp image, it might be a terrific image with a softer quality.

The key to working with digital images day to day is usually not to envision them being something they are not already, but working with what you have to enhance what is there. Enhancement in the form of heroic measures and wild antics is a secondary concern.

Let's review our image-processing checklist (from Chapter 2) before getting together a specific outline of changes to perform.

General Image Editing Steps: A Review

Way back at the beginning of this book we looked at an overview of the whole image editing process. By this point in the book, we are concerned more specifically with images than with setup issues. The following list of steps is extracted, and somewhat modified, from the list of steps suggested in Chapter 2 to target the process. We'll follow this editing checklist in processing the Sample_17.psd image.

- Be sure that your computer system is ready for image editing. Your system should be up to speed, your monitor calibrated; you have set up your preferences and tested your output.
- 2. Store the original image file safely and work with a copy to do all of your image editing.
- 3. Have in mind a target range for the resolution and a color mode for the final image.
- 4. Evaluate the image.
- 5. Make general color and tonal corrections.
- 6. Make damage, dust, and other spot corrections.
- 7. Make compositional changes, including cropping, compositing, and replacing image parts.
- 8. Make targeted color and tonal corrections to selected parts of the image.
- 9. Save the layered version of the image. You may want to do some simplifying and optimization at this point.

Note specifically that this list condenses the setup and computer-oriented issues, as well as the concerns for saving. We will assume at this point that you have taken the initiative to calibrate your monitor, build the ICC profile you need for properly viewing your images on screen, and set up your color management (checklist step 1). The concerns for image storage (checklist step 2) are taken care of by providing the file on the CD. The image on the CD cannot be overwritten, so it is safely archived. We will be processing the image using the full size of the provided sample (downsized from the original), which is 9.2×7 inches at 200 ppi (checklist step 3). Now we are ready to evaluate the image (checklist step 4).

EXIF Metadata

I didn't take the shot, but I was able to find out some things about it without asking the photographer. All I did was look into the EXIF data that came with the image. As long as you are using a modern digital camera, the camera captures EXIF data (exchangeable image file), storing information about the exposures you make at the time of capture. You can access and use these data to refer to exposure information.

To find the EXIF data for your images, open Photoshop, and choose File Info from the File menu (File>File Info). The following data were listed for the sample image under the Camera Data 1 category.

Camera make/model: Canon EOS 20D Date and time: 11/28/06, 3:28 PM Shutter speed: 1/30 second Aperture: 2.8 ISO: 800

This information can track what you did to capture the image, give hints as to the quality of the capture, and provide an opportunity for learning. Because this image was taken with a slow shutter, a wide aperture, and a high ISO, it would almost necessarily have a soft quality to it.

Applying the Image Editing Checklist

Working through the process of editing will always *really* start with evaluating the image. No matter what you see in an image preview or in Bridge or other viewers, there is no substitute for actually opening the image in Photoshop. So open Sample_17.psd and have a good look at the image.

Working with RAW Images

Whereas this image is already converted from RAW and does not require dealing with Camera RAW conversions, it is worth mentioning what to do with RAW images and why you might want to consider RAW processing if it is an option.

RAW images are images in their natural capture state—direct off the camera's sensor without any automated in-camera processing. JPEG files, on the other hand, which are often the default means of storage for images on camera, are images that have been processed in-camera, converted from the RAW state into a more globally recognized image file format. One advantage of working with RAW images is that you get to control the image conversion from raw data rather than allowing the camera to use some generic processing that works optimally only in run-of-the-mill situations. When it comes to images that are exposure extremes (over- and underexposure), in-camera processing is not an advantage. Another advantage is that RAW images are high-bit images, taking advantage of the native capacity of a sensor to register many times the information allowed in the JPEG file format. JPEG files are limited to 8 bits (a mere 16.7 million colors per pixel); RAW images can be up to 16 bits per channel (35.2 trillion colors). RAW images offer both more control in the conversion from the RAW information and a higher bit count than a standard JPEG, which is especially beneficial in processing exposure extremes.

If you shoot in RAW format as a deliberate choice, you add a step to your processing, but you also add some extraordinary leeway with shots that are not exposed optimally because of the higher bit count. When opening RAW images, you are led to the intermediate Adobe Camera RAW dialog automatically, where you can make a conversion for the image. There are a lot of controls, and with that goes many opportunities for positive change—as well as negative change. Some users see this as an opportunity, and some as an obligation. My suggestion is not to feel too tempted to make changes in the RAW dialog unless you are positive you can make an advantageous change. If the image is a normal exposure and doesn't have a decided skew or you are not compelled to attempt to rescue highlights or shadows, accept the defaults and go to work in Photoshop, in which you have the full range of tools and Layers to lean on. Just be sure to import 16-bit images. Keep in mind that you do not have to do a thing when you pass through the RAW dialog and are best off considering making changes only when you know the image has exposure issues.

When you decide to make changes and corrections in the RAW dialog, consider the histogram display and use it to help keep you from creating bad adjustments. Although you may trust your screen to a great extent, the graph

helps you see if you are making corrections that are too extreme and actually doing some damage to your image by losing image information. If you see the graph bunching up and spiking at the right or left in the graph display in the RAW dialog histogram, chances are the image is taking a hit and you are ruining image details, perhaps unwittingly. Likewise, if the graph is pulling away from the right or left or forming distinct tails, you may not be making the most of the information you captured. Use these histogram dynamics to help you make intelligent imaging choices.

At the other extreme, don't simply adopt a hands-off attitude when it come to RAW conversions. Automated adjustments selected by Photoshop's Camera RAW dialog don't always make the best choices—they can't see the image. So don't just trust the RAW plug-in to make the choice for you, especially if the preview on screen seems wanting. Play with the possibilities and be careful not to blow out details by being conscious of the histograms provided on the preview. When in doubt, leave the image a little under- or overexposed to save detail so that you can work with it later rather than trying to optimize it all at once in the RAW dialog. You can still fiddle with making changes later. There are actually better tools in Photoshop to use when making corrections. Think of the dialog as a helper rather than an all-in-one correction tool—just like anything else.

To examine the image, you might want to do a few simple things, like zoom in to take a look at details (sharpness, graininess, noise) or even take a look at the RGB channels. You also want to consider the purpose of the correction. Head shots used for advertising (cosmetics, etc.) might be distorted to achieve a look, but head shots used for actors will need to be a reliable semblance of the subject. Sometimes you will find some interesting qualities or the views may suggest specific changes or alterations. For example, you may have a noisy blue channel that suggests a little blurring of the blue might help overall, or there might be tonal qualities you'd like to borrow. Although you can certainly examine the channels by opening the Channels palette and reviewing the channels, doing it the layers way by running the RGBL Components action from the Separations action set (from Chapter 8) may tell you a few things about the image. After running the action, view the channels by toggling the visibility off for the layers from the top of the Layers palette down (see Figure 9.2).

Something about the contrast in the blue channel seems interesting, so later in the corrections we'll look at using the Blue channel to enhance the contrast (checklist step 8). Of course we'll want to do an initial Levels correction (checklist step 5). The initial color is fine, but might be a tinge warm, and it could use some color balance adjustment (checklist step 5). Contrast is good, but might even be stronger, playing on the quality of the light in the image. Consider ideas for cropping (checklist step 7). Do you want to get in tighter to the subject? Are there areas around the subject that might be better if removed? What will the image be used for? In this case we have a head shot. It seems the cropping can come in a bit to make the model's head the obvious focus. We've already mentioned that the image is a bit soft, so we'll work with

FIG 9.2 The RGBL separations show you the tone components that make up your image. Here we see the blue, green, red, and luminosity components taken from the original source.

that by playing up the quality of softness to make it more like a soft-focus glamour shot (checklist step 8).

Getting more specific, the midtone to shadow areas may be slightly oversaturated (checklist step 8). The model has virtually no obvious flaws (birthmarks, scars, wrinkles); however, underlighting seems to be enhancing a ridge along the upper lip, which can easily be smoothed (checklist step 6). The lighting differs in color between the chest and the face, and that will become more pronounced as the correction progresses. One or the other may need some selective adjustment (checklist step 8). As the face is the focus of the shot, it may help to outline the chin. Muscle structure in the neck and cleavage can be enhanced as well to give the subject more depth (checklist step 8). The eyes and teeth are already white, and a Levels correction and color balance will make them whiter still, but you'll need to use care in correction not to blow out detail to make them look fake. We'll look at selective adjustment to these areas to be sure they are optimized and color balanced (checklist step 8).

The final list of corrections per this evaluation is the following, attempting to work from most general to most specific:

- · Levels correction
- · Color Balance
- crop
- · enhance contrast
- add soft-focus effect(s)
- be mindful of saturation, and adjust
- enhance jawline and muscle structure
- · selective balance of lighting between face and chest
- smooth upper lip
- · hold detail and color in eyes and teeth

This may seem like quite a lot to do in an image that is already good, and with all those changes we will want to keep the model recognizable. Running through the steps using techniques we have already learned or that have been hinted at will make short work of the list—even if we do end up with a lot of layers. Be aware that as you go you may create additional issues that will require some attention, and at points the image may actually begin to look worse before it begins to get better. These are all concepts and techniques we have touched on throughout the book and in other corrections. Now let's put them into play.

Try It Now

 Open the Sample_17.psd image in Photoshop if it is not already, and make a Levels correction to the image for each channel in the Channels drop-down list using a Levels Adjustment layer. Name the layer 1 General Levels. See Chapter 3 for a review of Levels correction. See Figure 9.3 for the Levels settings used for the sample.

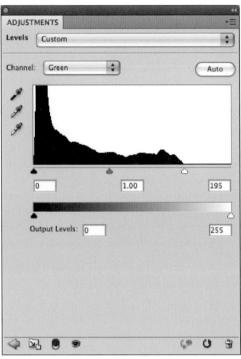

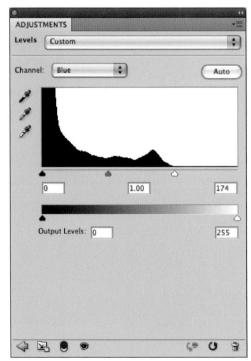

FIG 9.3 For this image there are tails to clip in highlights for each of the channels: Red, Green, and Blue. Although there are different possible strategies, clip the whole tail as shown.

 Adjust Color Balance using a Color Balance Adjustment layer. Name the layer 2 Color Balance. See Chapter 3 for a review of making Color Balance corrections. See Figure 9.4 for the Color Balance settings used.

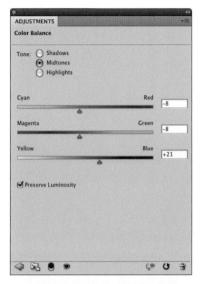

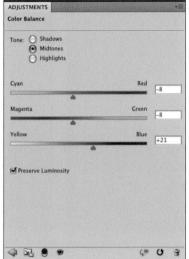

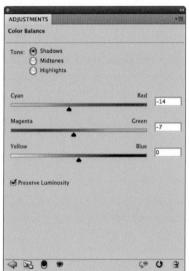

FIG 9.4 There are several different light sources to correct for here; you have to achieve the best balance. Depending on how you start the correction and the settings you begin with, your Color Balance settings may be very different, but the result should be similar—balancing the color.

With the general color and tone corrections complete it is fairly safe to crop the image. Use the Crop tool to trim down the image and change the composition (see Figure 9.5).

FIG 9.5 You could wait until later in the process to crop, as changes in the image may influence your decisions. I set the crop to 5 × 7, to reflect the same crop as the original size, and cropped with the head a little to the side so the shot was not too centered, in a bastardized version of the rule of thirds.

The first corrections have roughened the skin and brightened it a lot. We'll want to darken it up a bit and smooth it out over the next series of steps. We need to work at it somewhat gradually to avoid creating additional issues. To do this we can borrow from the original to get back some of the color and skin tone there and then work with some techniques of masking and blending to enhance what exists in the image.

4. To borrow back from the original skin tone from the image, we need to make a selection and copy out the old skin tone. To do this, open the Channels palette, hold down the Command/Ctrl key (Mac/PC) on your keyboard, and click the Red channel to load it as a selection, which makes a good rough selection of the skin. Click on the Background layer in the Layers palette to activate the Background, then Copy and Paste to create a new layer. Name the layer 3 Red Channel Selection. Press Command+Shift+]/Ctrl+Shift+] to move the layer to the top of the layer stack. Blur 15 pixels, change the mode to Multiply, and reduce the opacity to 50 percent (see Figure 9.6).

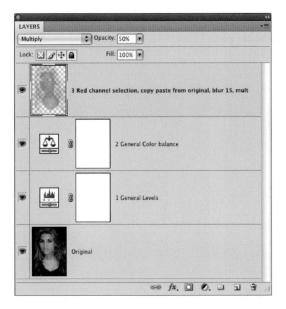

FIG 9.6 The Red channel will correspond to highlights and skin in this image. Copying the background will allow you to replace original skin color based on that selection.

- 5. Duplicate layer 3 Red Channel Selection, and name the new layer 4 Dupe 3 Overlay 50%. This will begin to add back contrast and soften and smooth the skin simultaneously, but saturates too much in the shadows—which we'll work on in the saturation reduction in the next step.
- 6. Create a new layer, call it 5 Desaturate Shadows and fill with 50 percent gray. Using the Blend If actions you loaded from the book, play Target Shadows, Full Range. This will set the Blend If sliders to blend only to the shadows. Set the layer mode to Color and the opacity to 70 percent. This will help desaturate the darker parts of the image (see Figure 9.7).
- 7. The Blue channel is often strongly contoured and can be good for softening without losing too much natural shape. To isolate the Blue channel to work with it over the next few steps, we'll need to start with a snapshot, as what you see on screen after layer 5 is created does not exist in the image proper. Create a Composite layer, and name it 6 Snapshot. To make the composite, press Command+Option+Shift+E/Ctrl+Alt+Shift+E.

As we work through here the goal will be to balance a little sharpening with a little softening so that we retain the detail and sharpness while creating the softening effect.

FIG 9.7 Step 6 cuts the saturation that has built up in the previous corrections significantly.

- 8. With the 6 Snapshot layer active, click the Blue channel in the Channels palette, select all (Command+A/Ctrl+A), copy (Command+C/Ctrl+C), create a new layer (Shift+Command+N/Shift+Ctrl+N), name the layer 7 Blue Component, and paste (Command+V/Ctrl+V). This will take you through making a new layer that isolates the Blue channel. There are, of course, several other ways to accomplish that. Shut off the view for the 6 Snapshot and 7 Blue Component layers as you want to keep track of what you did, but will not be using these directly.
- 9. Duplicate the 7 Blue Component layer and name it 8 Blue Blurred 25. Blur the layer 25 pixels using Gaussian Blur. Set it to Luminosity mode and 15 percent opacity. The Gaussian Blur will take some of the edge off the channel, and Luminosity mode will impart some of its tone without affecting the current color.
- 10. Duplicate the 8 Blue Blurred 25 layer and name it 9 Dupe 8. Set the mode to Overlay and the opacity to 30 percent. Overlay will enhance the contrast according to the content, darkening the darks and lightening the lights. Because the content was previously blurred, it will also add another hint of softening (see Figure 9.8).

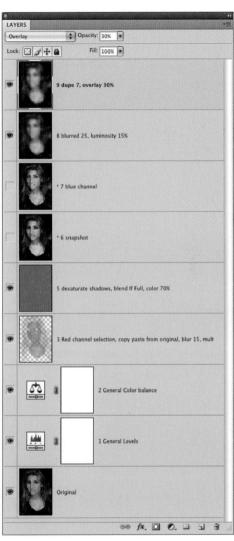

FIG 9.8 Steps 7 to 10 introduce some softening and contrast enhancement.

Before the image gets too soft, let's do some sharpening. First apply manual sharpening as per the technique described earlier in the book (which will reduce some contrast, but have other benefits, as you will see). Then apply some selective sharpening to be sure we are not losing focus on the subject. In between we'll restore some of the original hair color because it has faded.

- 11. Make a snapshot layer by pressing Command+Option+Shift+E/Ctrl+Alt+Shift+E. This will create a new layer above the 9 Dupe 8 layer. Rename it 10 Color Lock and set it to Color mode.
- 12. Click on the 9 Dupe 8 layer to activate it and press

 Command+Option+Shift+E/Ctrl+Alt+Shift+E again to create another snapshot. Change the layer name to 11 Manual Unsharp. Invert the image (press Command+I/Ctrl+I), set the mode to Overlay, and set the opacity to 50 percent. You will see that this correction brings her hair out from the shadows.
- 13. Duplicate the Original layer and bring the new layer to the top of the stack. Change the layer mode to Color. Add a layer mask by clicking the Add Layer Mask button at the bottom of the Layers palette, and then, using black (press D, for default colors) and a large, soft Paintbrush, paint over the subject's face in the mask to mute the color from the layer over the subject's face.
- 14. Keeping tabs on the image sharpness we should snap up her eyes and mouth a little. Create another Composite layer (Command + Option + Shift + E/Ctrl + Alt + Shift + E) and name it 13 Sharpen (or Selective Sharpen). Apply sharpening with Unsharp Mask at 140 percent, with a Radius of 4 and Threshold of 0, then change the opacity to 50 percent. Add a layer mask and fill the mask with black, and then paint with white over the eyes and mouth to unmask those areas and bring back the sharpening detail there. Figure 9.9 shows the current layers and before/after results.

At this point the layer stack is starting to get a bit long and wild. We can trim it up neatly by adding a few layer groups.

- 15. Click the Original layer at the bottom of the layer stack and then click the Create a New Group button at the bottom of the Layers palette. Rename the group General Color Corrections and drag layers 1 and 2 into the group. Then close the toggle for the group to hide the layers.
- 16. Click the General Color Corrections group and then click the Create a New Group button. Name the new group General Toning and Smoothing. Click layer 3, hold Shift, and click layer 13 to highlight all of those layers, then drag them into the General Toning and Smoothing group. Click the toggle to close the group. This will

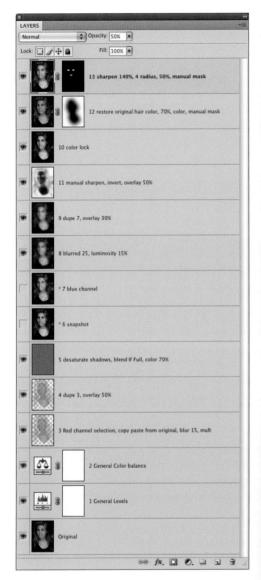

FIG 9.9 Just a touch of sharpening over the whole of the image goes a long way. The eyes are sharp, yet the skin stays smooth.

- neaten the layers significantly and should provide some guidance for finding specific changes. But let's add the next group as well in the next step.
- 17. Click the General Tone and Smoothing group and then click the Create a New Group button. Name the new group Chest Adjustments. Leave this group toggled open so we can add layers and see what we are doing. Your layers should now look like Figure 9.10.

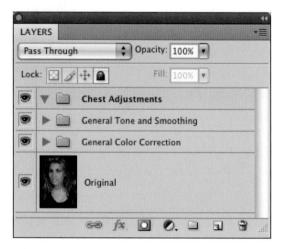

FIG 9.10 The roving layer stack of a few moments ago is now pretty tame. Working forward we'll use the layer groups to target activities and corrections.

To this point we have done little that requires much freehand tool skill. Many corrections have been based on knowledge from previous chapters, modes, opacity, blending, and the advantages offered by light components for quick selection, masking, and calculations. We have also taken care of much of the preliminary part of the hit list, including Levels correction, Color Balance, cropping, contrast enhancement, adding soft-focus effect(s), and being mindful of saturation as it wavered. From here to the end of these corrections, many more of these changes will require some dexterity and individual choice in making more selective corrections.

18. Isolate the chest area for adjustment to match better with the tone of the face. To do this, create a new blank layer, name it 14 Mask Chest, and make a composite (Command+Option+Shift+E/Ctrl+Alt+Shift+E). Make a rough selection around the area to be

- adjusted, then click the Add Layer Mask button. This will create a mask with the selected area. Blur 30 pixels to soften the mask, then run the Target Highlights, Full Range action. This will apply the Blend If targeting to the highlights within the masked area only, compounding the masking.
- 19. Apply a color adjustment to the 14 Mask Chest layer. To do this, choose Layer > New Adjustment Layer > Hue/Saturation, and check the Use Previous Layer to Create Clipping Mask checkbox on the New Layer dialog. Adjust the sliders to better match the area to other skin tone in the image. Name the layer 15 Color Adjust 14. See the Adjustments settings used in Figure 9.11.

FIG 9.11 There are many other ways to make this adjustment. Hue/ Saturation changes shown here reduce saturation, shift the color, and slightly darken the result.

20. Retrieve the necklace from the Original image to restore it. To do this, duplicate the Background layer, name the duplicate 16 Retrieve Necklace from Original, and move the layer to the top of the layer stack within the Chest Adjustments group. Click the Add Layer Mask button, and fill the mask with black. Using small hard brushes

(95 percent hard, 25 pixels round for the pendant and about 10 pixels for the chain), change the foreground swatch color to white and paint on the mask to reveal the necklace. Change the layer mode to Luminosity and reduce the opacity as desired. Painting effectively unmasks the old layer's luminosity, darkening the necklace, which had faded owing to the earlier steps. Your layers should look like Figure 9.12.

FIG 9.12 These changes shift the color and tone of the chest to match the face better.

- 21. Create a new group called Neck and Jawline. Then close the view for the Chest Adjustments group.
- 22. Burn in the jawline. To do this, create a new layer, and name it 17 Burn in Jawline. Choose the Lasso tool and draw a selection around the jawline, then invert the selection so the active area is off the face—targeted to the area outside the original selection. In this case we are most interested in the neck, so the final selection will be of the area below the jawline (see Figure 9.13).
- 23. Choose the Brush tool and a large, soft brush (200 pixels, 25 percent spacing, 100 percent opacity, Normal mode, all Fade and other brush dynamics off), then sample a color from a shadow area of the neck. To sample the color, press Option/Alt and click on the image. Paint in under the jawline by dragging the brush along the selection line (see Figure 9.14).

FIG 9.13 Make the selection broad to cover most of the face so that changes painted in have no chance of bleeding over the wrong side of the selection. You could actually select the whole face if you wanted just to be safe.

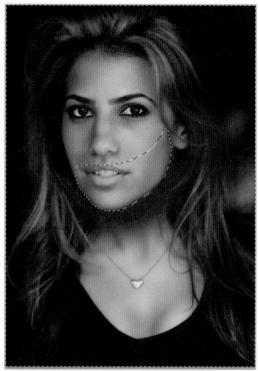

FIG 9.14 The selection will mask the painting so it falls just under the jaw. The painting under the jawline should be dark, flat, and obvious, but we will adjust it.

- 24. Deselect the selection (press Command+D/Ctrl+D), then change the layer mode to Multiply, and drop the opacity to 35 percent or so (you may have a different preference). Apply a Gaussian Blur of 10 pixels. Toggle the view for layer 17 to see before and after; the area under the jawline should darken.
- 25. Create a new layer and name it 18 Burn in Brightspot. Choose a soft, 30-pixel brush and paint in over the bright areas on the viewer's right at the side of the neck, still using the sampled color. Blur the result 20 pixels, change the layer mode to Multiply and set the opacity to 35 percent or so. This will burn in and darken the lighter area at the side of the neck.
- 26. Burn in contours on the neck and chest. To do this, create a new layer and name it 19 Burn in Contours and paint in accents similar to what you've done in the previous steps. For this area, try using a brush with a Fade dynamic (brush size 50, hardness 0 percent; check Shape Dynamics on the Brushes palette; set the Size Jitter control to Fade

and 150). Use Paintbrush strokes on the neck to accentuate contours. After all the accents are in place, blur using a Gaussian Blur of 20 pixels to soften, and set the layer Mode to Multiply and opacity to about 35 percent (or to your preference) to blend. See the Fade setting and brush application in Figure 9.15. Figure 9.16 shows the layers at this point.

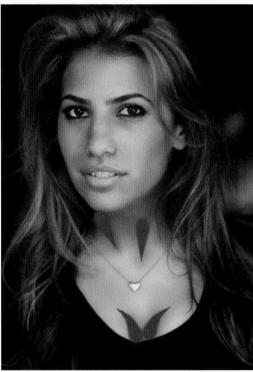

FIG 9.15 Change the brush size and fade length as appropriate to get better matching on contours. Blurring mode and opacity will help you blend in the changes effectively.

- 27. Close up the Neck and Jawline group, and create a new group at the top of the layer stack called Eyes and Mouth.
- 28. Repair the upper lip. To do this, make a new layer and name it 20 Upper Lip Repair. Choose the Healing tool and a small, hard brush (10 pixels). Sample from the cheek on the viewer's right to repair the area above the right side of the lip; sample from the cheek on the viewer's left to repair the left side of the lip. The final result should be a simple smoothing of the shadowed area above the lip. Remember to use the Sample All Layers setting for the Healing tool.

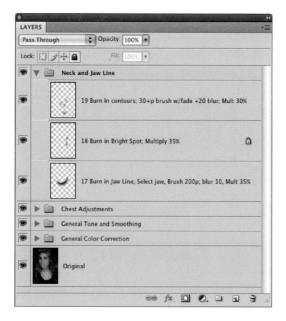

FIG 9.16 The detailing in these few layers helps set off the face.

- 29. Correct the brightness and color balance of the teeth (which have changed partially owing to corrections). Isolate the teeth on their own layer by creating a new Composite layer and renaming it 21 Isolate Teeth. Make a rough selection of the teeth, and click the Add Layer Mask button, then blur slightly to feather the mask. Add a Levels layer as a Clipping group, and make a Levels correction (see Figure 9.17). Rename the Levels layer 22 Levels Teeth Compensation. Adjust the opacity of the 21 Isolate Teeth layer (not the Levels layer) to adjust the result (full opacity may seem too bright/white).
- 30. Correct the brightness and color balance of the eyes. Isolate the eyes by making a new Composite layer, making a selection of the eyes, and adding a mask as in the previous step. Name the layer 23 Isolate Eyes, then add a Levels layer as a Clipping group and make a Levels correction (see Figure 9.18). Rename the Levels layer 24 Eyes Brighten and Balance. Reduce the opacity of the 23 Isolate Eyes layer to adjust the result to a pleasing look.
- 31. Correct the color and intensity of the lips. Isolate the lips just as you did the eyes and teeth, and name the masking layer 25 Isolate Lips. Use a Hue/Saturation Adjustment layer as a Clipping group to make a correction. I pushed the Saturation to 130 and adjusted the Hue to −4. See Figure 9.19 for the current layer stack.
- 32. Close up the Eyes and Mouth group, and create a new group at the top of the layer stack called Lighten Hair and Soften. We'll use this

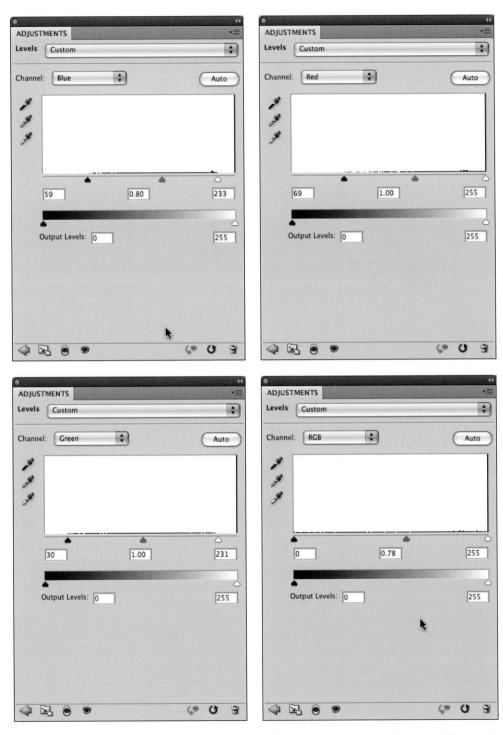

FIG 9.17 In a smaller segmented correction like this, you will be far less likely to cut off tails. Here you want to retain everything or you will blow out details.

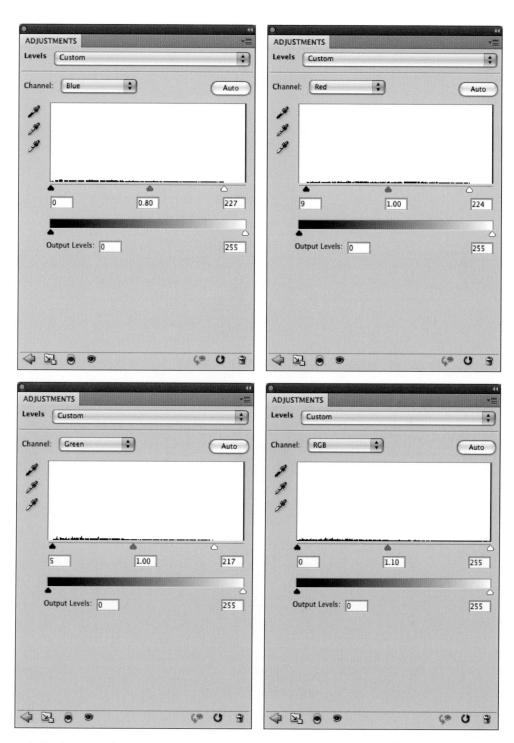

FIG 9.18 Brighten the eyes using the center RGB slider.

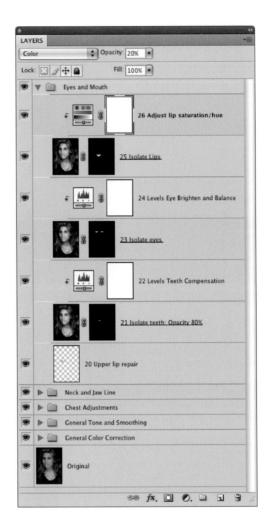

FIG 9.19 Fine-tuning of the whites of the eyes, the teeth, and the lips separately add some polish to the corrections.

- group to adjust the final tone and color of the hair as well as to add some softening and glow.
- 33. Take a snapshot layer to gather all the corrections to this point in one place. Name the layer something clever like 27 Snapshot.
- 34. Isolate the skin tones by loading the Red channel as a selection and then copy/paste to a new layer. Name the new layer 28 Isolate Skin via Red. We'll use this for just a bit more softening of the skin tone.
- 35. Blur the content of layer 28 by 25 pixels using Gaussian Blur, and set the layer mode to Overlay.
- 36. Take a Snapshot layer again, and name the new layer 29 Masked Snapshot. Shut off the view for layers 27 and 28 as they were temporary, used just to get this content. Add a layer mask to layer

- 29, and invert the mask (press Command+I/Ctrl+I). Choose a large, soft brush and paint with white in the mask to reveal the content of the layer only over the face, then reduce the opacity of the layer until pleasing ... I lowered the setting to 50 percent.
- 37. Take a final snapshot of the image (by this time you must have that shortcut memorized!), which we'll use to brighten the hair. Name the layer 30 Snapshot Masked to Hair. Add a layer mask, invert the layer mask (as in the last step), set the layer mode to Screen, and paint over the hair using the same soft brush as in the previous step.
- 38. Finally, soften the hair. Duplicate layer 30, name the new layer 31 Soften Normal. Use Gaussian Blur to blur 35 pixels, and reduce the opacity to 30 percent. This will act to soften the hair. To bring back the contrast we lost there, duplicate layer 31, name it 32 Soften Soft Light, and change the mode to Soft Light, leaving the opacity at 30 percent. See Figure 9.20 for the layer stack at this point.

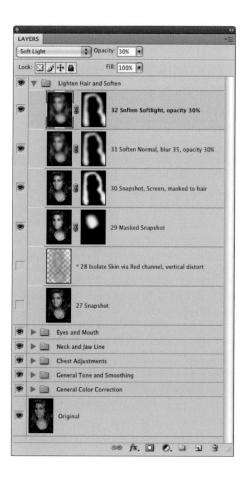

FIG 9.20 I use asterisks in the names of layers I am keeping but that are not visible in the image. If something gets inadvertently turned on or off as I work, I know which layers to shut off the view for.

Cropping in Layers

This image is already cropped from the original, but it may not always be convenient or desirable to crop early in the process. Though you can't really crop in layers, you can create a Crop layer and use it to view the image as if it were cropped. Doing this helps you stay on a path of nondestructive editing.

- 1. Create a new layer at the top of the layer stack and call it Crop. Fill it with black and set the opacity to 0 percent.
- Choose the Rectangular Marquee tool, and set it to 0 Feather. Choose Fixed Ratio and set the ratio according to a standard image size if you want a specific ratio.
- 3. Make a selection of the area that you would want to crop to. Use the space bar to reposition the selection as you create it.
- 4. Invert the selection (Command+Shift+I/Ctrl+Shift+I).
- 5. Click the Add Layer Mask button at the bottom of the Layers palette.

At this point you have your Crop layer. You can turn the opacity up to 100 percent and shut off the layer view. As you work, keep the Crop layer at the top of the layer stack. You can view the crop by turning on the layer view. You can crop the image by Command+clicking/Ctrl+clicking the mask for the Crop layer, inverting the selection, and choosing Crop from the Image menu (Image>Crop). This way the crop can also actually be stored with the image as a layer.

At this point we have run the gamut of corrections on this image, and—for the purpose of this exercise and the original hit list—we have completed the image correction. We should consider the before and after comparison in Figure 9.21 as the result. You can note the progress in the image by opening the Sample_17_complete.tif on the CD, shutting off all the groups, and then turning on the groups one at a time from the bottom of the stack. Note that for the most part you can shut off lower groups out of order and still see the results change because of the way the image was put together (the exception is the lip correction, which may have been made later than necessary).

There may be additional corrections you might like to make or items that you might like to adjust at this point. Of course, you can do more with this image, and experimentation is encouraged.

Summary

In this image exercise we have used virtually every trick in this book, applying almost every layer capability for practical purposes on an image that reflects the type of day-to-day changes you may make to any image. We've had the opportunity to look at evaluating images, how to apply your evaluation to a plan for corrections, and how to apply layers for organizing your path to a result.

FIG 9.21 Again you may not approve of every change you see here, but the concepts of enhancement and targeting allow you to explore techniques in context and, I hope, ultimately lead to a better result.

If you look at the completed sample image provided on the CD, you can turn off the spot-correction layers individually to see how they play into the result. In fact, every layer from the bottom up can be toggled on and off to view its effect in the final result because they are masked and cumulative changes.

As far as working with these techniques in the future, the ideas we have explored here in layering corrections, sharpening, soft focus, and selective correction are applicable whenever you edit images. You are best off, as in this example, working from the general corrections to the more specific and leaving as many layers intact as you need to accomplish the job. You can always go back later and clean them up, organize them, group them into categories, and *learn* from them.

You will note in the sample image that I have noted brush sizes in the layer names, blur radius, and any number of other things that will not be apparent in looking at the content of a layer. In fact, even Photoshop's editing log will not record these details. Make smart use of layers and they can provide a wealth of information, convenience, and flexibility that can be had in no other way.

In the next chapter we look briefly at an extension of correction in what it means to make collage and composite images.

If you have any questions about the techniques and procedures in this chapter, please visit the web site (http://photoshopcs.com) and make your questions known on the forum!

We have looked at quite a lot of things that Layers can do, and the important thing now is to continue to follow through using the techniques you have learned. We looked at the entire process of evaluating and correcting an image in Chapter 9. One step beyond just working out the issues with a single image is combining images for a finished result.

In this chapter, the emphasis is on considering the ideas of collage and compositing and how to be creative in implementing changes and additions to images using the power of layers.

We have touched on using layers for image correction, adjustment, isolation, and masking and how to use layers to manage and group corrections. In reality, collage and compositing are just extensions of that. First we'll look at the ideas of compositing and collage and how you go about collecting images for each. This speaks to the difference in what collage and composite images are.

What Is a Collage?

Collage is supposedly derived from the French word *coller*, which means "to paste"—fitting to the idea of isolation that we looked at early on in this book via copy and paste. We started with the simple idea of pasting, and here we come full circle, returning to the earliest techniques to produce the most complex results. A collage is simply a collection of images, used in part or in whole or cropped out to specific areas, combined or pasted together to create a collective visual. In other words, in making a collage you gather source materials from two or more images and paste them together. It's that simple. Simple in idea, but complex, often very complex, in execution.

A collage can be anything from the old grade-school exercise of taking out a bunch of old magazines and cutting out images and then pasting them to a larger sheet of paper to far more elaborate adventures in imaging. The photographic equivalent is taking a group of pictures, extracting the interesting parts, and combining them to achieve a result. It can be a simple collection of images (say a grouping of family photos) or several organized themes, cleverly composited or completely haphazard. It can be humorous, serious, realistic, surreal, artistic, and more. When you are bored or have a moment to exercise some creative muscles, it can be great fun.

Guidelines for Collage

Because collage can follow many forms and none are right or wrong, guidelines for making a collage can only be general. You have to supply the image choices and creative direction. Below, find my 5 C's of collage:

- Collect your images. You can do this in a variety of ways, from going out and shooting new images to rummaging through old files. At the very least you should be using at least two images ... there is not really an upper limit except for what time allows.
- 2. Create your canvas. Create a new image about two times the size of the finished project. This will give you some layout space to work with and elbow room for placement of the images. You can crop the image down later (or use a Cropping layer as described in Chapter 9) or you may find you just end up filling the space! At the very least this should be two times the width and height of the largest image you plan to use.
- 3. Correct your images. Never neglect to make changes in individual images just because you are going to composite them. The advantages of layer corrections especially will be lost if you wait until later.
- 4. Clip out and composite. Like scissors to a magazine, you have the layer tools to start snipping up your images. Make selections and masks to isolate image areas that you will be using in the final collage, and move those components to the canvas created in step 2.

Compose. With all the images in the new canvas you can spend some time
adjusting positions, compositing, blending, correcting, and meshing.
There is no limit to what you can attempt, and this step can take many
hours depending on the complexity of what you are attempting.

Things to keep in mind:

- Collage doesn't have to appear flat and can include effects (e.g., drop shadows) and patterns (like scrapbooking) instead of just images.
- Some image parts, objects, or components may have to be built to make any composited part of an image work within the new context.
- Color needs to work together. Color can change! When you isolate image
 components, you are giving yourself the opportunity to orchestrate the
 whole scene. Take that opportunity to control the colors and how they fit
 together, as well as the components.
- Be cognizant of light and direction. If you are putting together a wholly new object, and attempting photorealism, you need to ensure that the lighting and light direction on objects in the scene don't conflict with each other. The lighting on all elements of your scene should match or it will appear unnatural.

An Example Collage

Making a collage is a great way to find purpose for those images you would possibly otherwise think belong in the digital trash. In a way it can be like cloud gazing, by which you stare at images until something pops into your head; or you can come at it with a purpose from the outset and fulfill your vision. The images may not need to be superior, or even on a common theme, but should be shots that can be somehow managed and merged. For example, take a look at the grouping of shots in Figure 10.1.

Although there is no central theme to the images selected here, each has something that is central and singular. In this case it is possible to set to work just snipping out the objects and let imagination take over. For example, this might be the source for a somewhat other-worldly scene in which the vacuum is given life, adorned with wings from the butterfly, making its rounds to a bright flower with a strangely twisted stem. To create the scene you might start by creating a new image and then grouping image elements for the butterfly vacuum, and then make the strange flower (see Figure 10.2).

Once the major components are created, they can be fit together in a cohesive whole in the strange terrain (see Figure 10.3). Every one of the techniques required to complete the result was covered in this book. You can probably tell what most or all of the techniques used were by examining the sample processed image on the CD (Sample_18_Processed.psd). You can also attempt to replicate the result or make your own/different collage with the

FIG 10.1 There is nothing particularly connected about these shots, some are common, and some not so good at all

same photos (Sample_18_a.tif, Sample_18_b.tif, Sample_18_c.tif, Sample_18_ d.tif, Sample_18_e.tif).

I would be glad to see creative collages made either with these sample images or from other groupings. See the web site and forums (http://photoshopcs.com) for information about collage contests!

FIG 10.2 Components can be assembled from separate parts before combining them into the whole.

FIG 10.3 This surrealistic scene was built from the five images in Figure 10.1.

Shooting Multiple Source Images

In times of image trouble one of the greatest options to have is the availability of more than one source image to work with. If you take several shots of the same scene, you are really safeguarding yourself for any corrections you might have to make. For example, if you are taking a posed family shot, taking several images of the same exact setup can give you the source to replaced blinking eyes, turned heads, cliché gestures, and the like.

This same philosophy works to help you fix any number of other problems. If you are on a trip to a scenic spot and you think you got the shot, take the same one again. Chances are you won't be coming back all too soon and if you find your hand was a little shaky in the first frame, you'll have possibly saved the shot by squeezing off one more. Other images can be used for patching, copy/pasting, and otherwise fixing a variety of things that go wrong.

Working with collage and compositing can really stretch your layer muscles. The fun part is that the results don't always have to be realistic, and you can practice with aimless ease. Know that all the time you are practicing you are enhancing your editing skills.

Collage can be constructive and fun. But shooting images with the intent of creating a larger scene from a series of shots can expand your canvas. Panoramas are really a natural extension of the concept of collage, and we'll look at that in the next section.

Creating a Panorama

Similar to the ideas of collage and compositing is creating a panorama. You can do this in situations in which you don't have a wide angle to tackle the image you want or to give you greater resolution in the result by stitching together consecutive shots taken in a horizontal or vertical plain. Images shot for a panorama are taken in a series—usually in quick succession—and the series of images is connected to create a continuous landscape. The photos are usually taken in a vertical or horizontal pan to capture a broader or taller area than you would normally get in a single frame with whatever lens you are using. Because you take several overlapping images shot in succession—perhaps using a tilt (vertical movement) or pan (horizontal movement) of a tripod—your resulting image will have more image information once stitched together than any single frame and can be enlarged more as a result (Figure 10.4).

Good panoramas are a little tricky to shoot and often tricky to stitch together seamlessly. Lighting conditions change as you pivot the camera, and cameras in any type of autoexposure mode will try to compensate for that between shots. This leaves you with a lot of tone and color changes to correct in postprocessing. The obvious solution is to shut off autoexposure modes and shoot with manual exposure. Taking some care while shooting the source images for the panorama will help simplify processing. Instead of looking forward to corrections, avoid at least a few by switching the camera to a manual mode first—before shooting any of the images. This will keep the exposure setting the same for each frame in your panorama and will make matching the exposure of the individual frames easier, and your work at the computer a lot quicker later. Setting your camera up on a tripod for the movement can also help by keeping the frames mostly aligned. When you shoot the frames, you will want 30–50 percent overlap to give yourself plenty of room to blend one image into the next as you stitch them together.

During editing to make these images stitch together smoothly, you will probably have to pull out all the stops and use almost all we've done so far to get a good result. If you open the source images (Sample_19_a.psd, Sample_19_b.psd, Sample_19_c.psd, Sample_19_d.psd), you will notice some noise in the images and that the color may need a little correction ... though it is possible to forgo most of these corrections until after the images are stitched together.

FIG 10.4 A series of images can be stitched together to make a complete panorama.

The basic steps for completing a panorama are as follows:

- 1. Collect your images. Purposely shoot a series of images that overlap by 30 percent or more for the purpose of creating your panorama. Often you will want to use a tripod and keep your exposure settings from changing when shooting the series.
- 2. Create your canvas. Create a new image about two times the height of your images and wide enough to fit all the images in the series. As with collage, you leave some layout space to work with and elbow room for placement of the images.
- 3. Compile and collate your images. Get all the images into the new canvas and order them in series. If the series was shot horizontally, start stacking

Using Automated Panoramic Tools

Photoshop provides an automated Panorama tool. To open the tool, choose File>Automate> Photomerge. The Photomerge dialog will open; it allows selection of the images you want to merge and a plethora of options for controlling the result. Just browse for the images you want to merge, and click OK. Generally the results of a merge will be pretty good with a properly shot series of images, and Photoshop will leave the images on separate layers with masks that can be adjusted. It's a fun and easy tool for creating even complex photomerges.

- the images in layers with the rightmost image on the bottom of the layer stack, and work left in the panorama as you add layers so they remain organized in the layer stack. If the series was shot vertically, stack from bottom to top (in the order of shooting). Ordering in layers will help organize your plan.
- 4. *Blend*. The seam between images can be blended in a variety of different ways. The easiest technique (the panorama plug-in is based on this) is simply making a gradient blend at the seam from black to white. Layer masks are recommended. Varying opacity during the blending process can help you see better where edges match.
- 5. Correct. Once you have the panorama stitched together you need to treat it like a single image. You'll want to go through all the steps of correction from Levels and cropping to spot corrections to be sure you are making the best image.

You can try stitching together the sample images provided on the CD for this panorama, and you can see the corrections I made in the completed file Sample_19_processed.psd. The most telling part of the sample will be the masking used for blending the edges of the consecutive shots. Masking helps make some otherwise tricky transitions simple. Waves—like lines in a topographical map—might not want to fit together easily from shot to shot. But overlaps, masking, blending, and the power of layers can help you create a seamless result.

You will probably want to start out simple with panoramas by just pivoting vertically or horizontally to capture your subject(s). You'll really need only two successive shots to see how it works. But once you get to shooting panoramas, horizontal and vertical movements become just the tip of the iceberg. Also consider that you can make "dolly" movements, or change the position of the camera to capture the scene. You do not have to strictly adhere to making pan or tilt movements: you can make a panorama with several rows of shots, or even with random camera movements that change angles. But the first step is to give it a try by shooting your own series of images and stitching them together. Use the Panorama tool in Photoshop for quick results, then try your hand at working the scene manually. Again it can be great practice and can force you to use tools and techniques you might otherwise avoid!

One step even beyond expanding your canvas is expanding the depth of the color and tone you capture in your images. We'll look at that in the next section.

Working with HDR Images

HDR stands for high dynamic range. Images that are HDR have greater dynamic range than standard images. Specifically it refers to images that are 32-bit, twice the number of bits in a 16-bit image and at least 35 trillion times the color possibilities of even 16-bit images. Really there are more color possibilities than that, because of floating point notation, which extends what

the bits can represent. Because there is so much potential image information, HDR images offer a huge potential gain in the image information that can be stored for your images. At the same time they come with huge limitations. Your monitor can't display the detail of HDR images properly all at once, you cannot print them, and, in fact, HDR images do not support layers.

As exciting as the potential of HDR images is, the real interest in the photographic community in HDR recently has less to do with HDR images themselves than with what those HDR images end up getting turned into after processing. Images processed from HDR originals have to be altered to be displayed, and the results are often artistic renderings of a scene made using various techniques to postprocess an assembled HDR image. The images can be surreal, or grungy; they can affect characteristics of watercolor and other artistic effects, though some can affect a reality more like the way the human eye perceives a scene. In reality, to call the images that result from processing "HDR images" is to use a misnomer, as they are images converted from HDR. It doesn't make them bad, or undesirable, just different from HDR. All I want to keep in your mind here is that HDR images and the effects you see attributed to them are two different things. We'll look at both creating HDR images and processing them to attain a result here.

Making an HDR Image

The potential dynamic range of a standard image that comes off your camera is determined by the bit count. The limitations the bit count puts on your range of exposure can be very frustrating: when you expose for midtones, detail in both the highlights and the shadows can suffer. When you expose for either highlight or shadow, the opposite end clearly suffers the most. What if you could combine the benefits of exposing for more than one range to get the most out of highlights, midtones, and shadows? That could potentially mean getting better images with more detail (as long as that detail can be reproduced). Because our eyes are generally more forgiving and have greater dynamic range than a camera and lens, we often perceive more than we can grab in a capture. HDR images, which allow a greater dynamic range, would be images closer to how we see (or what we think we see).

Making an HDR image technically takes no more than two exposures. That is, you can make an exposure that favors the highlights in a scene and then a second exposure that favors the shadows, combine them in a higher bit-count image, and make a more robust exposure of the same scene. You also would need a way to combine the images in a logical fashion so as to make the best use of their respective ranges of exposure. That is, find a way to mix in the exposure ranges without driving yourself quite nuts doing so. Often HDR images are taken with at least three exposures, and sometimes many more. Each exposure needs to give you information the other exposures would not be able to in order to be an effective component of an HDR image. If the range of light that you could capture in a scene is already within the range that you can get in your camera in a single 16-bit image, HDR is a waste of

time. The real interest of HDR is in capturing details in a scene that you would otherwise miss in a single exposure. HDR is interesting and yet becomes the realm of "extreme" images, in which lighting conditions exceed the limitations of the hardware (your camera and sensor).

If you want to take a true HDR image, you need to take shots in scenes in which there are special needs. These scenes should have content for which the exposure ranges extend beyond the range your camera can see in a single exposure.

So, with that in mind, here is the basic procedure for capturing and creating a true HDR image:

- Define a scene that cannot be captured in a single exposure. These are
 usually images that have very distinct exposure zones: exposing for the
 highlights would mean leaving the shadows underexposed; exposing for
 the shadows would leave the highlights overexposed. Examples might be
 taking pictures of stained glass windows inside a dim church or shooting
 a sunrise or sunset where the foreground is silhouetted.
- 2. Take exposures that will cover the exposure zone(s) you have identified in the scene. This can vary widely depending on what you hope to accomplish. I have images, Sample_20_a.X3F, Sample_20_b.X3F, Sample_20_c.X3F, and Sample_20_d.X3F, on the CD that can be used for this exercise. The exposures cover a range of about five stops. If doing your own image series, you'll want to take at least three shots with some exposure difference between each shot.
- 3. Combine the images into an HDR (32-bit-plus) image. This can be done in Photoshop or with other applications and plug-ins. We'll look at making the HDR images in Photoshop and an example of working with them manually to obtain an HDR result below.

Create an HDR Image in Photoshop

Creating an HDR image in Photoshop can be very simple, though the results may not immediately be what you had hoped or expected. Combining the images into an HDR image will not be the last step, as the conversion to 16 or 8 bits will be necessary to make the image truly useful.

Exposure for HDR

Exposures for HDR can be differentiated in a variety of ways. Most common would be to shoot a series of images varying the shutter speed to favor different color ranges in the scene. As an alternative, you could adjust the aperture; however, the response in the captures may be less predictable as the change in aperture will vary the depth of field. Finally you might keep the aperture and shutter speed constant and allow the lighting in the scene to change. The last of these may prove most challenging and time consuming.

☐ Try It Now

- 1. Open Photoshop.
- 2. Choose Merge to HDR from the File>Automate menu. The Merge to HDR dialog will appear.
- 3. Click the Browse button to locate the files you shot for the HDR image. For a test case use the images shot for this purpose on the CD (Sample_20_a.X3F, Sample_20_b.X3F, Sample_20_c.X3F, and Sample_20_d.X3F). Leave the checkbox for Attempt to Automatically Align Source Images unchecked if you have used a tripod as with these sample images.

- 4. Click OK to start the merge. The merge can take a while depending on the size of the images and the computer you are working on. The Merge to HDR dialog will appear after the images are incorporated, allowing you to make a few adjustments at this time. See Figure 10.5.
- 5. Click OK to open the HDR image in Photoshop in 32 bits.

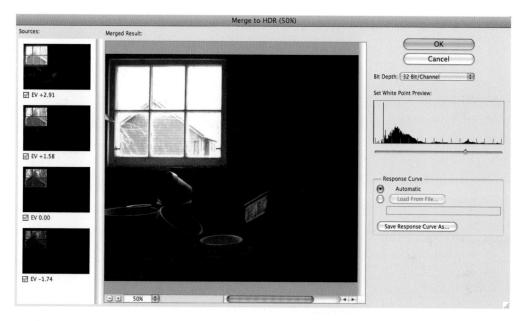

FIG 10.5 The Merge to HDR dialog allows you to preview the HDR images you merge with different source images, different white points, and different response curves.

That is really all there is to creating an HDR image. Although it may not look very exciting, the result you see has to do with the fact that there is far more in the image than your monitor can display. In actuality, the full range of tones for the images that you merged is now housed in the single image, and you can peruse that in step 4 by changing the position of the white point slider on the right of the screen. With the image information successfully stored in one place, you may want to archive your HDR image, as once you convert it the information will be lost, unless you re-create the file (in a similar way, resolution is lost when you downsize an image).

Save this image to a temporary spot on your hard drive. Now that you have the HDR image ... what do you do with it? For most people the next step is what really makes for interest in the concept of HDR. We'll look at conversions in the next sections.

Automated HDR Conversions

Converting the image to something usable from the 32-bit image can again be done with third-party products or right within Photoshop. There is really no right or wrong way, and some of the tools/plug-ins touted for making HDR conversions are revered more for artistic license than for realistic conversions. Let's take a look at how to do it in Photoshop with your hands at the controls.

Try It Now

Choose 16-bit from the Image Mode menu (Image>Mode>16-bit).
 The HDR Conversion dialog will appear. See Figure 10.6.

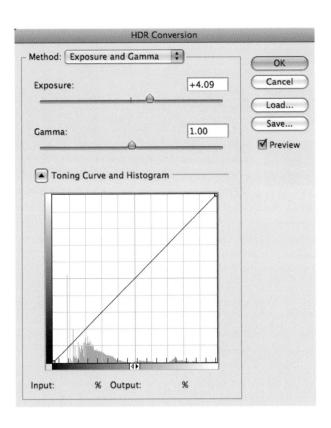

FIG 10.6 As of this writing, the HDR conversion dialog is a little buggy, showing users controls they cannot use for certain conversion types. For example, Curve is useful only with the Local Adaptation choice.

✓ Exposure and Gamma Highlight Compression Equalize Histogram Local Adaptation

FIG 10.7

Choose a conversion method from the drop-down list (see Figure 10.7).Depending on the conversion method you choose, you will have more or less control over the results. See the descriptions below.

TABLE 10.1 Conversion methods.

Conversion Method	What It Does
Exposure and Gamma	Lets you manually adjust the brightness and contrast of the HDR image using sliders.
Highlight Compression	Compresses the highlight values in the HDR image automatically so they fall within values compatible with 8- or 16-bit image files. This method is automatic.
Equalize Histogram	Compresses the dynamic range of the HDR image while trying to preserve contrast. This method is automatic.
Local Adaptation	Adjusts the tonality in the HDR image by calculating the amount of correction necessary for local brightness regions throughout the image. Allows users to apply Radius, Threshold, and Curve adjustments.

3. Click OK to complete the conversion.

That is really all there is to it. Your decisions on the conversion dialog will make the difference in the result. Those who are familiar with what are touted as HDR images will be most interested in the Local Adaptation option, using a wide radius and threshold. Third-party plug-ins will have more variation along these lines. But whatever choice you have made, there is your HDR conversion, and you can go about using the image like you would any 16-bit image. You will probably get more out of it with local contrast enhancement (using the Unsharp Mask filter), but your changes and path from here should come from evaluation of the image. The conversion itself should really not be considered an endpoint, and you may want to convert more than once for different purposes from the same original ... you may see how this can then turn into a bona fide layers project!

Let's have a look at how you might manually handle the entire process to get a better idea of what you are accomplishing in the result. Whereas the following never really creates a 32-bit HDR image, the result is made from multiple exposures and can easily mimic HDR-converted images.

Manual HDR Conversions

Automated conversions may not be terribly intuitive nor may they result in the final image you expect—at least not without a lot of alteration. Being suspicious of automated adjustments, I tend to prefer working images manually, as ultimately I have more control over the result. Like nearly any other change in Photoshop, a hands-on approach may yield a better result that any automated one, as you can see differences and react, whereas an automated solution just performs a calculation. The following works through a simplified process of compiling an HDR result (not the same as an HDR image) from the sample images, starting with the four sample exposures.

My goal for the image is to see all parts of the exposure ranges I intended to expose for: a soft version of the pots, revealing more of the shape of the rims than the pots themselves; details in the sash; and a strong, contrasty rendition of the scene in the window.

Try It Now

- Open all of the HDR sample images on the CD (Sample_20_a.X3F, Sample_20_b.X3F, Sample_20_c.X3F, and Sample_20_d.X3F). When the Camera RAW dialog appears, do not change the settings and accept the defaults.
- 2. Assemble the four images into one layered image. Using the Sample_20_a.x3f image as a base, press Shift, and then click and drag the Sample_20_b into the Sample_20_a image. Do the same click and drag with Sample_20_c, and then Sample_20_d, so they stack in order (a at the bottom, d at the top of the layer stack, brightest at the bottom). Name the layers a, b, c, and d, according to their Sample names. See Figure 10.8 for what your Layers palette should look like.

FIG 10.8 Stack the sample images from the bottom to the top of the layer stack in order.

3. Shut off the Visibility toggles for the b, c, and d layers. Then load the luminosity as a selection. To do this, open the Channels palette and Command+click/Ctrl+click (Mac/PC) on the RGB thumbnail.

- 4. Activate the b layer, turn on the Visibility toggle, and with the selection still active from the previous step, create a layer mask. The mask will automatically fill to allow highlights to pass.
- 5. Load the luminosity as a selection again (it will be slightly different based on the currently visible layers and blending). Then activate the c layer, turn on its Visibility toggle, and create a layer mask, which will automatically fill based on the selection.
- 6. Load the luminosity as a selection a third time (again the selection will have changed and narrowed as the highlights become darker). Then activate the d layer, turn on its View toggle, and create a layer mask. The result in the layer stack at this point should look like Figure 10.9.

FIG 10.9 Stacking layers in consistently darker steps masked to the highlights will serve to darken/burn in the highlights for each successive exposure.

- 7. Make a Levels correction for the image using an Adjustment layer.
- 8. Make a Color Balance correction for the image using an Adjustment layer.
- Make a Snapshot layer in the layer stack to collect the changes to this point. Load the highlights as a selection again and create a layer mask. Paint over the barn with white. Set the layer mode to Overlay (to enhance the contrast and color in the highlight area).
- Add other Hue/Saturation adjustments as desired. The finished sample on the CD shows two such adjustments: one to the base layer to tone

FIG 10.10 Figures a, b, c, and d show the original exposures. The Layers palette shows what these steps result in, and the additional image shows the result.

- down the reds (and essentially desaturate the pots) and another to target and desaturate hotspots where reds were too strong in the pot rims after the various versions of the exposure were merged.
- 11. Blur the masks for the b, c, and d layers. This will blend the changes from one layer to the next and enhance contrast. The blur can greatly affect the result and here it has some dramatic effects. I used 35 pixels. See the Using the Masks Palette for Mask Adjustments sidebar. The results at this point should be like Figure 10.10.

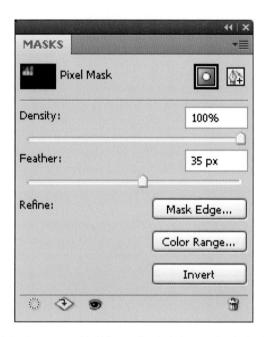

FIG 10.11 The Masks palette is a powerful tool for controlling the deployment of masks, thereby affecting considerations you may want to make in applying masks and masked content.

The result of the HDR composite allows me to show details in the pots, the sash, the barn, and the sky so they can all be visible in a single image, as I want them to appear. This is opposed to what I could get from any one of the single exposures, which would have compromised details in various areas. Though it is more involved, the results of manual assembly also leave more control. In the end, you still have to use layer processing techniques to get the best results and composite image from the HDR source images ... and your choices may be different from mine.

Summary

This chapter lacked specifics in the step-by-step directions at points, quite by design. We covered some of the basic concepts of composite, collage,

Using the Masks Palette for Mask Adjustments

A new feature in Photoshop CS4 is the Masks palette (see Figure 10.11). The palette lets you make adjustments to masks that are nondestructive! That is, instead of applying a blur directly to the mask content as I did in the example, you can apply virtual blur using the Feather option. The great benefit of the Masks palette is that it will store information on mask transparency and blurring separate from that of layers. In this image you would be able to preview different amounts of feathering and blur for each channel without having to undo-redo and compare with Histories or via other more complicated methods. Just make the change to the feathering and see the result in real time, then switch to another mask. Feathering will be approximately the same range as the radius in a blur. Other adjustments implemented via the Mask Edge and Color Range dialogs (opened via buttons at the lower portion of the Masks palette) open many doors for experimentation and merging your layered content.

and HDR as a way to think beyond the boundaries of the confines of single images as an endpoint to your image creations. The techniques you will need to accomplish the merging and creation of these image results were covered earlier in the book. You have been supplied with the images you need and the outline of what to do, and the intent was to leave the details in your hands. If you get stuck, samples on the CD showing my completed images will hold clues to the answers you are looking for. Trying to complete the collage and composites is an opportunity to explore techniques discussed throughout the book before you have to go at it more completely on your own with your own images. The core of this chapter lies in taking a broader view of images, in depth, breadth, and possibility. Objects and images can be combined not just within their own spatial area, but with other images, to expand the borders of what is possible well beyond the scope of the viewfinder and the ability to capture digital information in a single frame.

So you see that with panoramas and blending edges we have truly come full circle. Panorama stitching is quite like trying to put together the pieces of a puzzle, or like blending the edges of a map to stitch together a series of scans—as I told of all the way back in the introduction to this book. I hope that now that you have seen what layers have to offer and how they can enable you to do things with images that would otherwise be far more difficult without layers, you have a map for your future of working with images in Photoshop and expanding on what you can do with your images.

I like to think that the ends of my books are always just the beginning. As you have time to work with Layers, using this book as a starting place and reference, you should grow well beyond what we've looked at to expand your horizons. As you continue to explore Photoshop Layers, please visit the book's web site (http://www.photoshopcs.com) and visit the Layer forums online to ask questions, get answers about layers and other Photoshop issues, and chat with other people who are interested in Photoshop, images, photography, and layers. This author is bound to be there fairly often, and I look forward to seeing you there.

PHOTOSHOP'S ESSENTIAL TOOLS LIST

When an electrician has to climb a telephone pole to fix a problem, he or she doesn't bring every tool in the toolbox. The practical, handy tools go in the belt, and up the pole they go, ready to handle any problem. Photoshop can be looked at in a similar way. The real trick is knowing what tools will handle any job, so you can put those in your belt, and cutting down to the essentials so you can focus on the task. A master tool list of functions that you should be familiar with is included here. This appendix includes a list of tools that you want to be not just aware of, but competent using to get the most out of your corrections with layers and Photoshop in general.

With a core set of tools you'll be able to focus on learning just those tools rather than trying to grasp the function, use, and nuances of each and every tool on every menu—some of which are redundant and essentially unnecessary. When you have less to remember, you have far less to get lost in by randomly exploring tools and functions that you hope will do the job. Exploration and experimentation can be left until you have more expertise, time, or interest (though you should always give exploration a time limit, or you'll get lost). With a lighter tool belt you'll have everything you need when you climb the pole, and you'll be sure to get the job done without coming down to waste time foraging around in the van for more tools.

The Mythical "Read My Mind" and "Do It For Me" Tools

In talking with people about Photoshop, one tool that they always seem to have thought they read about in a tutorial, or saw at a conference, or read about in a book is the Read My Mind tool (also known as the Do It For Me tool, or even the Read My Mind and Do It For Me tool). It seems the eternal hope is that Photoshop will be able to do the thinking. It is terribly frustrating when you get an idea of how a result will look in your head and you use the buttons and functions you thought you should and then don't end up with the result you expected. If you are able to imagine how you want something to look, it means you have a good imagination and eventually Photoshop will work out well for you. However, the tools never do the thinking for you, and they never know what you see in your mind's eye, even when their names suggest they know what you are thinking.

Really, you almost never want the computer to do the thinking for you. The reality of using Photoshop is that automated tools for correction make approximations. Computers also never see an image to make an aesthetic

judgment, they just perform calculations. You are never hardwired to Photoshop, and the program itself isn't much of an artist—regardless of what you pay for it or what version you own. You may think you can depend on it to make images better, but really all it does is enable *you* to make images better. Most of the unpredictable tools are exactly the ones we steer away from if you use the tool list supplied here. To be sure rumors are dispelled: there are no tools that think for you. No matter how elegantly they work, tools will not "read your mind" or "do it for you" and certainly none will do both—whatever the task. That is as it should be (Figure A.1).

FIG A.1 The only tools that attempt to automate corrections are those that you probably shouldn't use.

The following list is categorized into External Applications, Commands, Functions, Freehand Tools, and Filters. Each is explained more fully by section. You can use other tools or additional applications as you explore Photoshop, consult tutorials, or develop your own work flow, but this list will be comprehensive as a base in reflecting what you absolutely need.

Exploring New Tools

One of the reasons users find Photoshop daunting is that they try to learn too much—or even all of it—at once. A better approach for most people will be to learn a tool at a time. If there are tools in the list here with which you are not familiar, note them down, and give yourself the opportunity to explore them one a day, for as many days as it takes, 15 minutes a day on each one, until you get through the list. Make your 15-minute sessions productive by looking up the tool in Photoshop Help (in Photoshop, press Command+/ or Ctrl+/ [Mac/PC]), read the description, and apply the tool/function to a sample image to actually see how it behaves. Don't look so much for expert results as the opportunity to learn how the tool behaves. That experience will go a long way toward incorporating it into your work flow. In this way you can build your

repertoire of the necessary tools in a short period of time. Fifteen or twenty minutes a day for a month would cover this entire list, but chances are you are familiar with many of them already if you are reading this book. If there is a tool or two that you don't get the hang of right away, put them on a new list that allows 30 minutes to explore.

External Applications

External applications are the additional software items that you add to your system to enhance processing. There are a plethora of add-ons you can install for Photoshop, some free and some for a cost, that claim to add on to what Photoshop already does. These may come in the form of plug-ins, actions, scripts, custom shapes and brushes, etc. Some of these additions may be valuable additions (like those included with this book). Some will be good for users who are already very familiar with the tools in Photoshop, know what they want to accomplish with the program, and are looking for a specific enhancement. Generally, the wealth of available add-ons and plug-ins may seem tempting, but many plug-ins and add-ons just duplicate or repackage functionality already in Photoshop, sucking in users with claims that they are the Do It For Me tool. For the most part they promise a lot, deliver a little, and add to the bulk of things you already have to learn. Yes, that's right, you have even more to understand with every tempting addition, not less! For this reason I always suggest keeping add-ons to a bare minimum.

There are really very few external software applications that you *need* to work with Photoshop. Those that you do need are mostly a given. You will need a computer that has operating system software capable of running Photoshop. You will also sometimes need drivers that are provided by the vendor of the additional equipment you purchase (for your printer, camera, backup systems/drives, etc.) or other manufacturer software to run hardware and devices. A few things you will need that are less obvious are software utilities to calibrate your monitor and build an ICC profile (recommended). Some things you may *want*, such as additional editing software, HDR plug-ins, image management, etc., are not necessary, and they shouldn't be allowed to cloud the picture. Hold off on them if you are still working on the basics.

The best overall plan in managing peripheral applications is similar to limiting your tool list: keep it simple so complexity and potential variables stay at a minimum. More software means more to learn, so put all the nonessential software aside. If you have trouble with your computer system, the first place to start troubleshooting is by eliminating extra software and peripherals—or simply not adding them as variables in the first place. See Table A.1.

TABLE A.1 External applications.

Monitor calibration	As time rolls on, I am less enamored of software solutions to calibration. With some great calibration options available for little money (ColorVision SpyderExpress: http://aps8.com/spyder.html), it really doesn't make sense to trust your calibration to your eyes. Software calibration might be used fo precalibration to get you in the ballpark before you even bother calibrating with a hardware device (on a PC that would be Adobe Gamma, found in the Control Panel; on a Mac, Display Calibrator Assistant found in the Displays System Preferences by clicking the Color and then Calibrate buttons). These software utilities do easy monitor calibration and ICC profile generation in one process, but all you really need them for is the base settings. Hardware calibration is simply more reliable than software-only solutions. Monitor calibration and creating profiles can help you stabilize your work flow and get better color matching between your monitor and your output. If you have problems with output color, the solution will likely start with good monitor calibration.
Device software	Scanner, digital camera, printer, card reader, backup/DVD/CD/RAID drivers, and software that enables you to access additional hardware that you will be connecting to your system to access or store images. See user manuals and installation instruction materials for each device you add to the system for more information.
Photoshop Help	Help>Photoshop Help, or press F1. The Photoshop Help system is a reliable resource for basic information on using Photoshop features and functions and is a great place to begin exploration of any Photoshop tool, and the price is right (free). Depending on your choices during the installation of Photoshop, this feature may require additional installation. It is worth the install.

Commands

Commands are simple functions—essentially a single step—used to achieve a result. I say "essentially" because you may have to address a dialog to get the result accomplished. For example, if you open an image, you will need to use the Open command. In the Open dialog, you will have to browse to find the image you want to open.

Most commands will be found on the program menus and can be invoked by shortcuts. See Table A.2.

Functions

Functions are more complex than simple commands that have a definitive, one-step goal. Using functions you will have to determine how to apply settings to achieve results, usually using multiple controls and function features to determine the final outcome. Adjustment of more than one control is usually necessary, and nothing can be achieved using the defaults. See Table A.3.

TABLE A.2 Commands.

New	File>New, or press Command+N/Crtl+N. Opens a new image. In the New dialog, set the color, size, and resolution to use for a new blank image. Creates a new image. You might use New to create a canvas on which you would add other images to make a composite or collage.
Open	File>Open, or press Command+O/Crtl+O. Opens an existing image. You will use this command often to open images you have downloaded from your camera.
Save As	File>Save As, or press Command+Shift+S/Ctrl+Shift+S. Opens the Save As dialog. Save your image with a new name, file type, or location. It is suggested you use Save As most or even all of the time to avoid file conflicts and potential for overwriting original files.
Save for Web	File>Save for Web, or press Command+Shift+Option+S/Ctrl+Shift+Alt+S. Save images for the web using JPEG or GIF file types, limited color, and transparency. Using Save for Web results in a smaller file than just saving as a JPEG even with the same compression ratio. There are additional preview benefits as well.
Undo	Edit>Undo, or press Command+Z/Ctrl+Z. Reverses the previous action you took in editing an image. This is useful for all sorts of things, but mostly for stepping back in the process when you don't like what a change achieved. To step back multiple steps, look to the History palette (Window>History).
Сору	Edit>Copy, or press Command+C/Ctrl+C. With a selection active in your image, you can copy the selected image area to the clipboard. Think of this like you might use copy/paste to move a URL to a browser or to edit text in an email. Copy can be used to duplicate custom selected image areas or move image content to a new image.
Paste	Edit>Paste, or press Command+V/Ctrl+V. Paste the content of the clipboard that was stored using the Copy command into the current image. Copy and Paste are almost always used together to duplicate selected image areas to the same image or other images.
New Layer	Layer>New>Layer, or Command+Shift+N/Ctrl+Shift+N. New layers can also be created with the Create a New Layer button at the bottom of the Layers palette and the New Layer command on the Layers palette menu. This will create a new layer with no content.
Duplicate Layer	Layer > Duplicate Layer, or duplicate a layer in the Layers palette by dragging an existing layer to the Create a New Layer button at the bottom of the Layers palette. The Duplicate Layer command is also available on the Layers palette menu. This will create a new layer that is exactly like the one being duplicated but with the word "Copy" appended to the layer name.
Create Adjustment Layer	Layer>New Adjustment Layer and choose a selection from the New Adjustment Layer submenu. You can also create these with the Create New Fill or Adjustment Layer buttons at the bottom of the Layers palette. These help you keep adjustments distinct from layer content.

(Continued)

TABLE A.2	(Continued)
INDLL M.Z	Continuca

Merge Layers	Layers>Merge Layers (Command+E/Ctrl+E), Layers>Merge Visible (Shift+Command+E/Shift+Ctrl+E). Merge layers in one of several ways to cut down on the number of layers in your image and be sure the file isn't unnecessarily large. Merging content should be done only where you don't expect to have to reverse the changes later; you can use Undo immediately following a merge, but you can't undo the changes in a later editing session (after saving and reopening the image).
Flatten	Layers>Flatten Image (no shortcut). Very much like Merge Layers, but this function specifically combines all layers and image content and flattens the image into a Background layer only.
lmage Size	Image>Resize>Image Size, or press Command+Option+I/CtrI+Alt+I. Allows the user to change the size and resolution of an open image. Usually this will be a step that you will take in preparing an image for output to a printer. Upsampling an image (making it bigger) by more than 10 or 20 percent is not recommended as you cannot re-create detail that you did not originally capture. Downsampling is less problematic. Use Bicubic resampling in most cases to get the best resizing result and Constrain Proportions so the image does not distort horizontally or vertically.
Transform	Edit>Transform, or press Command+T/Ctrl+T. Allows you to reshape an object you have isolated with selection or by Copy/Paste so that it is in its own layer. This can come in handy when you have to patch an image area that is missing or damaged, or when you want to remove objects/people from a scene.
Inverse	Select>Inverse, or press Shift+Command+I/Shift+Ctrl+I. This will take a selection you have made and invert it; instead of the area inside the selection being selected, the selected area will change so that everything outside the original selection is selected. This is great for using a flatly colored background to make a selection of an object or in other instances in which it is easier to make a selection outside an object than of the object itself.
Fill	Edit>Fill, or press Shift+F5. Will fill a whole layer in your image with a single color (foreground, background, black, gray, or white). This is useful for color and tone adjustments, converting to grayscale, etc., but also for creating masks from selections.
Layer Opacity	Opacity slider on Layers palette (no shortcut). Adjust transparency/visibility of individual layers in an image to blend and combine layer content and effects. A variety of uses in blending layer content and for color and tone adjustments. Use up and down arrow keys for fine adjustments.
Layer Mode	The Mode drop-down list on the Layers palette. In keeping with the common theme that everything isn't a necessary tool, of the 23 layer modes, only about six have everyday uses. These modes apply image content selectively. Normal mode is the default, Multiply is used for darkening or creating shadows, Screen is used for lightening, Overlay has several enhancement properties for working with contrast, Color applies layer color only, and Luminosity applies tone sans color.

TABLE A.3 Functions.

Levels	Layer>New Adjustment Layer>Levels or Command+L/Ctrl+L. Opens a Levels dialog, but creates no Adjustment layer. View image histograms as par of the Levels dialog box display. Use simple sliders to adjust tonal dynamic range and balance image color. Helps image contrast and color.
Color Balance	Layer>New Adjustment Layer>Color Balance or Command+B/Ctrl+B. Opens a Color Balance dialog, but creates no Adjustment layer. Adjust color by balancing the influence of color opposites for highlights, midtones, and shadows. Helps remove color casts and stubborn flatness in some images.
Hue/Saturation Layer	Layer>New Adjustment Layer>Hue Saturation or Command+U/Ctrl+U. Opens a Hue/Saturation dialog, but does not create a Hue/Saturation Adjustment layer. Adjust color by using slider controls to alter hue, increase/decrease saturation, and affect general lightness and darkness. Most effective when used to enhance color saturation.
Layer Mask	Layer>Layer Mask>Reveal All (no shortcut). Customize visible image areas without permanently erasing content. Very useful for blending in pasted image areas and molding/fitting parts of a collage or composite. Often used in conjunction with Selection (Polygon Lasso, Magic Wand), Fill, and/or the Paintbrush tool.
Blending Options	Layer>Layer Style>Blending Options, or double-click a content layer. Either action will open the Layer Style dialog. From this screen you can control many options, like General Blending (Mode and Opacity), Advanced Blending (Fill Opacity, Channel Targeting), Blend If (conditional blending based on layer content), and Layer Styles (effects/styles assigned to the layer). This is a very powerful command center for controlling layers and how they interact. Can be used for a wide variety of content blending and effects.

Freehand Tools

The toolbar has many freehand tools on it that you will use infrequently or not at all. By freehand, I mean that the application is controlled by your input device and the position of the cursor.

For all of these tools, be aware that options on the Options bar will affect the way the tools are applied. For basics about options for each of these tools, look them up by searching Help for "[tool name] options." See Table A.4.

Filters

Filters are an area of the program menus that get explored extensively by newer users, who often flock there to try out special effects and put some pizzazz into their images. The foray into filters is usually one that is hit or miss, and although you can spend innumerable hours applying various filters and settings, in reality, you get less pizzazz from filters than you get from shooting better images.

TABLE A.4 Freehand tools.

Crop tool	Press C on the keyboard. Used to change image size by permanently removing (cropping out) image edges. Use this to correct framing for your image, flatten horizons, remove objects at the edge of the image that shouldn't be in the
	frame, and adjust perspective (make images 4×6 , for example).
Polygonal Lasso tool	Press L on the keyboard and Shift+L to scroll the Lasso tools. Create selections of regular and irregularly shaped image objects by clicking at intervals around an object edge. Use short segments to select curved edges. Easier to control than the standard Lasso tool.
Magic Wand tool	Press W on the keyboard. Create selections of areas of same/similar color quickly by clicking in the area. Great for making selections of large, similarly colored areas (sky) or selecting objects with a single-color background (select the background and invert the selection). I use this less and less as I use masking, calculations, and Blend If more and more. Helpful for quick selections but not always very accurate.
Move tool	Press V on the keyboard. Use to reposition objects on layers within your images, such as you might have when pasting replacement areas or when working with collages or composite parts.
Clone Stamp tool	Press S on the keyboard. Make brush-style corrections by sampling image areas to clone to another part of the image. Great for straight duplication of one image area to another. Excellent for all manner of spot correction such as dust or other simple debris.
Healing tool	Press J on the keyboard. Make brush-style corrections by sampling image areas to clone to another part of the image. Healing is similar to Clone Stamp, but this tool makes "smart" corrections to your images by comparing the sampled area to the target and attempting to blend the correction with the surroundings. Perfect for making isolated corrections, like removing a stray eyelash from a cheek.
Paintbrush tool	Press B on the keyboard and Shift $+$ B to scroll the Brush tools. Used for freehand painting. Good for colorizing, adding manual shadows and highlights, and adding dodge and burn effects. An excellent tool for use with layer masks to create custom masking effects.
Eyedropper tool	Press I on the keyboard. Sample to check color and tone values in specific image areas or to set the foreground/background colors that can be used with Fill or Paintbrush. Also used in conjunction with the Info palette to display sampled color information.
Foreground/ Background Swatches	No shortcuts to open the Color Picker. Press D for default colors and X to exchange foreground and background. These color swatches store colors selected from the Color Picker or sampled from the screen using the Eyedropper tool. To change the foreground color, use the Eyedropper tool and click anywhere on your image. To change the background color, press Option/Alt and click on your image.

Filters listed here are few, because it is often difficult to predict exactly how some filters will behave and what benefit you will get from the result of applying it. These filters are the practical ones that you will use for image correction, to fix damage, and to create simple effects. They are not "wow" filters that will create instantly interesting effects. Before you do anything to make fantastic effects you want to have complete control of your image. These filters provide you with a means of control. See Table A.5.

TABLE A.5 Filters.

Add Noise filter	Filter>Noise>Add Noise. Adds digital noise to an image. Useful for roughening up tones that are unnaturally smooth, such as areas painted with a Fill or Paintbrush tool. Sometimes used in conjunction with Gaussian Blur.
Gaussian Blur	Filter>Blur>Gaussian Blur. Blends adjacent pixels to create a blurring effect. Blur filter useful for smoothing out tones that are unnaturally rough or oversharpened or for creating focus effects (e.g., soft focus, depth of field).
Unsharp Masking	Filter>Sharpen>Unsharp Mask. Allows user to adjust both local and fine contrast in the image to affect the appearance of sharpness, improve edge definition, and enhance contrast in color and tone.

Looking over these lists of tools and depending on how you count, there are just about 30 tools to keep in mind for editing your images. That may sound like a lot, but it is a fraction of the total number of tools, yet a complete tool belt that will help you get through any image-editing situation. Be sure to become familiar with these if you are not already.

INDEX

A	clipping text/background, 52–54
ActionFx-CS4_Set_01.asl, 129	compared to normal layers, 14
Actions	Layer from Background method, 17
Black-and-White actions, Richard's Custom,	New Background layer method, 17
220–221	Background/foreground swatches, 282
Blend If actions (on CD), 198-199	Bevel and Emboss, 123
CD. See CD (included with book)	Black-and-White action, Richard's Custon
Color Mask action, 198	220-221, 224
Drop Shadow/Glow action, 136	Black-and-white images
loading, 132–133	creating color from, 202-210
palette, 132–133	creating filtered color, 211–216
RGBL Components action, 220, 222, 224, 233	creating from color images, 221-226
set, 133	custom conversions to, 221–226
Activating layers, 51–52	Blank layers, creating, 16
Add a Layer Mask button, 11	Blend If, 169-199
Add Layer Style button, 11	actions (on CD), 198-199
Add Noise filter, 95, 100, 282	basic use of, 170–174
Add to Sample (Hue/Saturation dialog), 103, 193	compositing, 179-190
Adding layers	creating color-based mask, 191–199
for change, 81	Knockouts, 177–179
nondestructive editing, 4	as mask, 190-191
soft focus, 105–108	vs. masking, 177
Adjustment layers	overview, 169–170
applying Levels for color correction, 70–73	splitting sliders, 176–177, 183–184
basics, 13	This Layer slider, 172–174
correction for flowers example, 102–105	Threshold function, 182–183
correction in, 66	Underlying Layers slider, 174–175
creating, 17, 279	using This Layer slider, 172–174
Levels corrections. See Levels corrections	using Underlying Layers, 174–175
New Adjustment Layer button, 11	Blend_If.atn, 198–199
Adjustments palette	Blending
basics, 13, 17	Mode button, 9
CS4 feature, 26	modes. See Layer modes
Anti-alias, 78	Options, 281
Archiving system, 32	Blog, xxiv
Author, contacting, xxv	Blur filters
	Gaussian blur, 24-25, 96, 283
В	radius, 24
Background layers	Brush tool
basics, 13	creating your signature, 5–6

D. 1. 1/6	T
Brush tool (Continued)	Targeting, 219, 281
for neck/jawline corrections, 247–248	Character palette, 52–53
outlining for masking template, 97–99	Cleaning up images, 93–94
painting areas for sharpening, 114	Clipping group. See Clipping layers
Buttons. See Layer Palette buttons	Clipping layers
6	basics, 14
C	Create Clipping Mask, 14, 24
Calculations	exercise, 52–54
basics, 144	identifying clipping mask layers, 25
separating color/tone, 156–162	Use Previous Layer to Create Clipping Mask
sharpening, 162–165	checkbox, 26, 27, 56, 245
Calibration (monitor), 31, 278	Clipping masks. See Clipping layers
Camera settings/controls, 32, 33	Clone Stamp
Canvas Size dialog, 21	basics, 282
Capture of images, 30, 33	manual sharpening, 115–118
CD (included with book), xxii–xxiii	simple layer repair, 82–84
ActionFx-CS4_Set_01.asl, 129	Close Palette button, 9
Blend_lf.atn, 198–199	CMYK separation, 220
Layer_Effects.atn, 132	Collage
MAC/PC compatibility, xxiii–xxiv	basics, 258
Preset Manager for Styles, 129	creating panoramas, 262–264
Sample_1 files, 5	example, 259–262
Sample_2 files, 20	guidelines for, 258–259
Sample_3 files, 54	HDR images. See HDR images
Sample_4 files, 70, 83	panoramic images. See Panoramas
Sample_5 files, 94, 118	shooting multiple source images, 262
Sample_6 files, 124, 125, 130, 132, 134, 139	summary, 273–274
Sample_7 files, 139	Collage contest, 260
Sample_8 files, 144, 145	Color
Sample_9 files, 144, 145	adding enhancements, 110–111
Sample_10 files, 156	Balance. See Color Balance
Sample_11 files, 163	calculations, 211–216
Sample_12 files, 180, 181, 182, 186	clipping layers, 52–54
Sample_13 files, 180, 181, 182	correction, 70–73
Sample_14 files, 192	effects, 123
Sample_15 files, 202	enhancing natural color/tone, 102-105
Sample_16 files, 222, 224	evaluating images, 34, 231, 233
Sample_17 files, 230, 231, 232, 235, 254	filtering, 211–216
Sample_18 files, 259, 260	images from black and white, 202-210
Sample_19 files, 262, 264	RGB components, 202–204
Sample_20 files, 266, 270	separations. See Separations
Separations.atn, 220-221, 222, 224	Color Balance
Channels	basics, 86–87, 281
layers as, 201, 226	in head shots, example, 237
as masks, 120	in ship's mast, example, 185
RGB, 202-221	for ship's mast example, 188

sliders, 88, 188, 237	Croate Adjustment Layer 17, 270
Color Burn mode, 147	Create Adjustment Layer, 17, 279 Create Clipping Mask, 14, 24
Color Correction	Creating layers. See Layers, creating
Color Balance, 86–87, 185, 188, 237, 281	Crop layer, 254
Levels corrections, 70–73	Crop tool, 237, 282. See also Cropping images
Color Dodge mode, 149	Cropping images, 34, 231, 233, 237–238, 254
Color Mask action, 198	CS4 new features
Color modes, 154, 156–162	Adjustments palette, 13, 17, 26
Color Picker, 52, 125, 135, 282	Masks palette, 273
Color-based mask, 191–199	Custom black-and-white conversions, 221–226
Commands, essential (Photoshop), 278–280	Custom ISS profile, 31
Components	Custom 155 prome, 51
channels as, 201, 226	D
collage example, 259–262	
creating color from black and white, 202–210	Damage corrections basics, 34, 35, 81
creating color from black and writte, 202–210 creating filtered color, 211–216	using Clone Stamp/Healing Tool, 82–85,
creating linered color, 211–210	115–118
separating color image into RGB, 216–221	Darken mode, 146
Composite layers, 100–101	Darker Color mode, 148
Compositing	Deep knockouts, 179
Blend If, 179–190	Delalio, Luke, 230
HDR images. See HDR images	Delete Layer button, 12
panoramas. See Panoramas	Device software, 278
Prokudin-Gorskii image, 179–190	Difference mode, 153
Compositional changes, 34–35, 74–76, 231	Digitized image libraries, 202
Contest, collage, 260	Disk space requirements, 31–32
Context-sensitive menus, 12	Dissolve mode, 146
Contrast. See also Sharpening	Drop Shadow, 122
for head shot example, 239–240	Drop Shadow, 122 Drop Shadow/Glow action, 136
sharpen and enhance, 111–115	Diop shadow/Glow action, 130 Duplicate Layer
Conversions	methods, 12, 16–17, 279
to black-and-white images, 221–226	using, example, 38–41
Convert to Shape, 127	using, example, 36–41
HDR images, 268–273	E
to Smart Objects, 61–62	Edge burning (flower image), 54–55
Copying layers (Layer Via Copy), 16, 17, 74	Editing images, 232–254. See also Head-shot
Copy/Paste, 74, 279	editing
Copyright	applying editing checklist to head shot, 232–254
adding ©, 22	capture, 30, 33
converting copyright layer to Smart Object,	compositional changes, 34–35, 74–76, 231
61–62	editing and correction, 31, 35
creating Type layers, 22, 50	1 (V) (A) (T) (V)
symbol, 22	editing checklist, 231 enhancements, 35
Corrections. See Editing images	ennancements, 35 evaluation, 30, 34–35, 230, 233–235
Corrections, see Editing images Create a New Group button, 12, 44–46	noise reduction, 94–35, 230, 233–235
Create a New Group button, 12, 44–46 Create a New Layer button, 12, 16, 279	nondestructive, 4
CICALC AINCAN EASCI DALLOIL, IZ, IU, Z/J	ווטוועכטוועכוועכ, ד

editing (Continued) outline for, 30–36 process, 92 purposing and output, 31, 35–36 RAW images, 232–233 setup for, 30, 31–33 sharpening. See Sharpening Soft Focus, 105–109, 151, 239–241, 252–253 Effects basics of Styles and, 122–127 Bevel and Emboss, 123 Color, 123 combining manual effects and styles, 134–140 Drop Shadow, 122 Gradient, 123 Inner Glow, 122 Inner Glow, 125 Satin, 123 Shadows, 124 Stroke, 123 Satin, 123 Shadows, 125 Stroke, 123 Summary, 140–141 Visibility toggle, 125–126 Enhancements. See Editing images Enhancing color, 110–111 color/tone, example, 102–104 Equalize Histogram (HDR conversion method), 269 Evaluation of images, 30, 34–35, 230, 233–235 Exposure and Gamma (HDR conversion method), 269 Exposure for HDR images, 266 Eyedropper tool, 102, 282 Feathering, 78, 273 Files on CD. See CD (included with book) creating new, 170, 205, 279 File Info, 231 Fill command (Edit menu), 94–95, 280 layers, 13, 17 vs. Opacity, 140 Filters Add Noise, 95, 100, 282 Filters Add Noise, 95, 100, 282 Baiscs, 281, 283 blur radius, 24 Gaussian blur, 24–25, 96, 283 Ursadius, 24 Gaussian blur, 24–25, 96, 283 Fingerprint of light, 66–67 Flatten Image command, 20, 280 Focus, soft. See Soft Focus Foreground/background swatches, 282 Freehand tools, 281, 282 Functions, essential (Photoshop), 278 Gaussian blur basics, 283 obliterating noise with, 96 radius for, 24–25 Gradient, 123 Gradient Editor, 171 Grayed out menu options, 12 Grayscale images. See Black-and-white images Grayscale layers, 15–7-159 Grouping layers Foreign and object and styles, 134–140 Filters Add Noise, 95, 100, 282 Filters Add Noise, 95, 100, 282 Flaters Gaussian blur, 24–25, 96, 283 Ursardius, 24 Gaussian blur, 24–25, 96, 283 Filters Ocus, soft See Soft Focus Focus, soft See Soft Focus Focus, soft See Soft Focus Flatten Image Command, 20, 280 Flatten Images Gaussian blur, 24–25,	Editing images, 232–254. See also Head-shot	supported file formats, 36
process, 92 purposing and output, 31, 35–36 RAW images, 232–233 setup for, 30, 31–33 sharpening. See Sharpening Soft Focus, 105–109, 151, 239–241, 252–253 Effects basics of Styles and, 122–127 Bevel and Emboss, 123 Color, 123 combining manual effects and styles, 134–140 Drop Shadow, 122 Gradient, 123 Inner Glow, 122 Inner Shadow, 120 Inner Glow, 120 Inner Glow, 121 Inner Glow, 120 Inner Glow, 120 Inner Glow, 121 Inner Glow, 120 Inner	_	
purposing and output, 31, 35–36 RAW images, 232–233 setup for, 30, 31–33 sharpening. See Sharpening Soft Focus, 105–109, 151, 239–241, 252–253 Effects basics of Styles and, 122–127 Bevel and Emboss, 123 Color, 123 Color, 123 Combining manual effects and styles, 134–140 Drop Shadow, 122 Gradient, 123 Inner Glow, 122 Inner Shadow, 122 manual, 130–132 Outer Glow, 122 Pattern Overlay, 123 Satin, 123 Shadows, 122 Stroke, 123 Shadows, 122 Stroke, 123 Shancing color, 110–111 color/tone, example, 102–104 Equalize Histogram (HDR conversion method), 269 Evaluation of images, 30, 34–35, 230, 233–235 EX/IF metadata, 231 Expanding/collapsing view of groups, 42–45 Exposure for HDR images, 266 Eyedropper tool, 102, 282 Freeland miles Freeland tools, 281, 282 Gradient, 123 Gaussian blur basics, 281 Gaussian blur basics, 283 obliterating noise with, 96 radius for, 24–25 Gradient, 123 Gradient Editor, 171 Grayed out menu options, 12 Grayscale layers, 157–159 Grouping layers basics, 14, 42–47 Create a New Group button, 12, 44–46 expanding/collapsing view, 42–45 for head shot example, 242–244 Layer Groups, 14 Hard Light mode, 151 Hard Mix mode, 153 Hardware monitor calibration, 31, 278 setting up, 31–33 HDR conversion methods		
setup for, 30, 31–33 setup for, 30, 31–33 sharpening. See Sharpening Soft Focus, 105–109, 151, 239–241, 252–253 Effects basics of Styles and, 122–127 Bevel and Emboss, 123 Color, 123 combining manual effects and styles, 134–140 Drop Shadow, 122 Inner Glow, 122 Inner Glow, 122 Inner Shadow, 122 Inner Glow, 120 Inner Shadow, 120 Inner Glow, 120 Inner Shadow, 120 Inner Glow, 120 Inner Shadow, 120 Inner Shadow, 120 Inner Glow, 120 Inner Glow, 120 Inner Shadow, 120 Inner Glow, 120 Inner Glow		
setup for, 30, 31–33 sharpening. See Sharpening Soft Focus, 105–109, 151, 239–241, 252–253 Effects basics of Styles and, 122–127 Bevel and Emboss, 123 Color, 123 combining manual effects and styles, 134–140 Drop Shadow, 122 Gradient, 123 Inner Glow, 122 Inner Shadow, 122 Inner Shadow, 122 Inner Glow, 122 Inner Glow, 122 Inner Glow, 122 Inner Glow, 122 Satin, 123 Shadows, 122 Satin, 123 Shadows, 122 Stroke, 123 Summary, 140–141 Visibility toggle, 125–126 Enhancements. See Editing images Enhancing Color, 110–111 Color/tone, example, 102–104 Equalize Histogram (HDR conversion method), 269 Evaluation of images, 30, 34–35, 230, 233–235 Exclusion mode, 153 EXIF metadata, 231 Expanding/collapsing view of groups, 42–45 Exposure for HDR images, 266 Eyedropper tool, 102, 282 Filters Add Noise, 95, 100, 282 Add Noise, 95, 100, 282 basics, 281, 283 blur radius, 24 Gaussian blur, 24–25, 96, 283 Unsharp Mask, 113, 164–165, 283 Fingerprint of light, 66–67 Flatten Image command, 20, 280 Focus, soft. See Soft Focus Foreground/background swatches, 282 Freehand tools, 281, 282 Freehand tools, 281 Filters Add Noise, 95, 100, 282 Focusion Mack, 113, 164–165, 283 Fingerprint of light, 66–67 Flatten Image command, 20, 280 Focus, soft Focus Focus, soft Foc		***
sharpening. See Sharpening Soft Focus, 105–109, 151, 239–241, 252–253 Effects basics of Styles and, 122–127 Bevel and Emboss, 123 Color, 123 Combining manual effects and styles, 134–140 Drop Shadow, 122 Gradient, 123 Inner Glow, 122 Inner Shadow, 128 Inner Info Mix, 6–67 Index Info Mix, 6–67 Ind	-	
Soft Focus, 105–109, 151, 239–241, 252–253 Effects basics of Styles and, 122–127 Bevel and Emboss, 123 Color, 123 combining manual effects and styles, 134–140 Drop Shadow, 122 Gradient, 123 Inner Glow, 122 Inner Shadow, 122 Inner Shadow, 122 Inner Shadow, 122 Inner Glow, 122 Inner Shadow, 122 Inner Shadow, 122 Inner Shadow, 122 Inner Glow, 120 Inner Shadow, 120 Inner Glow, 120 Inner Shadow, 120 Inner Glow, 120 Inner Glow, 120 Inner Shadow, 120 Inner Shad		
basics of Styles and, 122–127 Bevel and Emboss, 123 Color, 123 combining manual effects and styles, 134–140 Drop Shadow, 122 Gradient, 123 Inner Glow, 122 Inner Shadow, 122 Inner Glow, 122 Inner Shadow, 120 Inner Glow, 121 Inner Glow, 120 Inner Glow, 120 Inner Glow, 121 Inner Glow, 122 Inner Shadow, 120 Inner Glow, 120 Instructions, 5ee Soft Focus Inner Glow, 120 Inner Glow, 120 Instructions, 5ee Soft Focus Inner Glow, 120 Inner Glow, 120 Instructions, 5ee Soft Focus Inter Inner Glow, 120 Inter Inter Inner Glow, 120 Inter In		
basics of Styles and, 122–127 Bevel and Emboss, 123 Color, 123 Color, 123 Combining manual effects and styles, 134–140 Drop Shadow, 122 Gradient, 123 Inner Glow, 122 Inner Shadow, 122 Inner Shadow, 122 Inner Shadow, 122 Feehand tools, 281, 282 Outer Glow, 122 Pattern Overlay, 123 Satin, 123 Shadows, 122 Stroke, 123 summary, 140–141 Visibility toggle, 125–126 Enhancements. See Editing images Enhancing color, 110–111 color/tone, example, 102–104 Equalize Histogram (HDR conversion method), 269 Evaluation of images, 30, 34–35, 230, 233–235 Exposure and Gamma (HDR conversion method), 269 Exposure for HDR images, 266 Eyedropper tool, 102, 282 Box on CD. See CD (included with book) creating new, 170, 205, 279 blur radius, 24 Gaussian blur, 24–25, 96, 283 Unsharp Mask, 113, 164–165, 283 Inner Also, 166–67 Flatten Image command, 20, 280 Focus, soft. See Soft Focus Foreground/background swatches, 282 Freehand tools, 281, 282 Freehand tools,		
Bevel and Émboss, 123 Color, 123 Color, 123 Color, 123 Combining manual effects and styles, 134–140 Drop Shadow, 122 Gradient, 123 Inner Glow, 122 Inner Shadow, 122 Inner Shadow, 122 Inner Shadow, 122 Inner Shadow, 122 Inner Glow, 120 Outer Glow, 122 Freehand tools, 281, 282 Freehand		
Color, 123 combining manual effects and styles, 134–140 Drop Shadow, 122 Gradient, 123 Inner Glow, 122 Inner Shadow, 122 Inner Shadow, 122 Inner Shadow, 122 Inner Shadow, 122 Inner Glow, 120 Outer Glow, 122 Pattern Overlay, 123 Satin, 123 Shadows, 122 Stroke, 123 summary, 140–141 Visibility toggle, 125–126 Enhancements. See Editing images Enhancing color, 110–111 color/tone, example, 102–104 Equalize Histogram (HDR conversion method), 269 Evaluation of images, 30, 34–35, 230, 233–235 Exclusion mode, 153 EXIF metadata, 231 Expanding/collapsing view of groups, 42–45 Exposure for HDR images, 266 Eyedropper tool, 102, 282 H Hard Light mode, 151 Hard Mix mode, 153 Hardware monitor calibration, 31, 278 setting up, 31–33 HDR conversion methods		
combining manual effects and styles, 134–140 Drop Shadow, 122 Gradient, 123 Inner Glow, 122 Inner Shadow, 122 manual, 130–132 Outer Glow, 122 Pattern Overlay, 123 Satin, 123 Shadows, 122 Stroke, 123 summary, 140–141 Visibility toggle, 125–126 Enhancements. See Editing images Enhancing color, 110–111 color/tone, example, 102–104 Equalize Histogram (HDR conversion method), 269 Evaluation of images, 30, 34–35, 230, 233–235 Exclusion mode, 153 EXF metadata, 231 Exposure for HDR images, 266 Eyedropper tool, 102, 282 Financing Foreground/background swatches, 282 Focus, 5oft. See Soft Focus Focus of Saturdons, 20, 24–25 Focus of Sat		
Drop Shadow, 122 Gradient, 123 Inner Glow, 122 Inner Shadow, 128 Inner Shadow, 129 Inner Shadow, 128 Inner Shadow, 129 Inner Shadow, 128 I	Color, 123	
Gradient, 123 Inner Glow, 122 Inner Shadow, 122 manual, 130–132 Outer Glow, 122 Pattern Overlay, 123 Satin, 123 Shadows, 122 Stroke, 123 summary, 140–141 Visibility toggle, 125–126 Enhancements. See Editing images Enhancing color, 110–111 color/tone, example, 102–104 Equalize Histogram (HDR conversion method), 269 Evaluation of images, 30, 34–35, 230, 233–235 Exclusion mode, 153 EXIF metadata, 231 Exposure for HDR images, 266 Eyedropper tool, 102, 282 Focus, soft. See Soft Focus Foreground/background swatches, 282 Freehand tools, 281, 282 Functions (Photoshop), 281 Functions, essential (Photoshop), 278 Gaussian blur basics, 283 obliterating noise with, 96 radius for, 24–25 Gradient Editor, 171 Grayed out menu options, 12 Grayscale images. See Black-and-white images Grayscale layers, 157–159 Grouping layers basics, 14, 42–47 Create a New Group button, 12, 44–46 expanding/collapsing view of groups, 42–45 for head shot example, 242–244 Layer Groups, 14 Ferehand tools, 281, 282 Freehand tools, 281, 282 Functions (Photoshop), 281 Gaussian blur basics, 283 obliterating noise with, 96 radius for, 24–25 Gradient Editor, 171 Grayed out menu options, 12 Grayscale layers, 157–159 Grouping layers basics, 14, 42–47 Create a New Group button, 12, 44–46 expanding/collapsing views, 42–45 for head shot example, 242–244 Layer Groups, 14 Hard Light mode, 151 Hard Mix mode, 153 Hardware monitor calibration, 31, 278 setting up, 31–33 HDR conversion methods	combining manual effects and styles, 134–140	
Inner Glow, 122 Inner Shadow, 122 Inner Shadow, 122 manual, 130–132 Outer Glow, 122 Pattern Overlay, 123 Satin, 123 Shadows, 122 Stroke, 123 summary, 140–141 Visibility toggle, 125–126 Enhancements, See Editing images Enhancing color, 110–111 color/tone, example, 102–104 Equalize Histogram (HDR conversion method), 269 Evaluation of images, 30, 34–35, 230, 233–235 Exclusion mode, 153 EXF Expanding/collapsing view of groups, 42–45 Exposure for HDR images, 266 Eyedropper tool, 102, 282 Foreground/background swatches, 282 Freehand tools, 281, 282 Freehand tools, 281, 282 Functions (Photoshop), 281 Functions, essential (Photoshop), 278 Gaussian blur basics, 283 obliterating noise with, 96 radius for, 24–25 Gradient Editor, 171 Grayed out menu options, 12 Grayscale images. See Black-and-white images Grayscale layers, 157–159 Grouping layers basics, 14, 42–47 Create a New Group button, 12, 44–46 expanding/collapsing view of groups, 42–45 Exposure and Gamma (HDR conversion method), 269 Exposure for HDR images, 266 Eyedropper tool, 102, 282 H Hard Light mode, 151 Hard Mix mode, 151 Hard Mix mode, 153 Hardware monitor calibration, 31, 278 setting up, 31–33 HDR conversion methods	Drop Shadow, 122	Flatten Image command, 20, 280
Inner Shadow, 122 manual, 130–132 Outer Glow, 122 Pattern Overlay, 123 Satin, 123 Shadows, 122 Stroke, 123 summary, 140–141 Visibility toggle, 125–126 Enhancements. See Editing images Enhancing color, 110–111 color/tone, example, 102–104 Equalize Histogram (HDR conversion method), 269 Evaluation of images, 30, 34–35, 230, 233–235 Exclusion mode, 153 EXERDAGING FOR HDR images, 266 Eyedropper tool, 102, 282 Freehand tools, 281, 282 Functions (Photoshop), 281 Functions, essential (Photoshop), 278 Gaussian blur basics, 283 obliterating noise with, 96 radius for, 24–25 Gradient, 123 Gradient Editor, 171 Grayed out menu options, 12 Grayscale layers, 157–159 Grayscale layers, 157–159 Grouping layers basics, 14, 42–47 Create a New Group button, 12, 44–46 expanding/collapsing view of groups, 42–45 Exposure and Gamma (HDR conversion method), 269 Exposure for HDR images, 266 Eyedropper tool, 102, 282 H Hard Light mode, 151 Hard Mix mode, 153 Hardware monitor calibration, 31, 278 setting up, 31–33 HDR conversion methods	Gradient, 123	
manual, 130–132 Outer Glow, 122 Pattern Overlay, 123 Satin, 123 Shadows, 122 Stroke, 123 summary, 140–141 Visibility toggle, 125–126 Enhancements. See Editing images Enhancing color, 110–111 color/tone, example, 102–104 Equalize Histogram (HDR conversion method), 269 Evaluation of images, 30, 34–35, 230, 233–235 Exclusion mode, 153 EXIF metadata, 231 Expanding/collapsing view of groups, 42–45 Exposure and Gamma (HDR conversion method), 269 Exposure for HDR images, 266 Eyedropper tool, 102, 282 H H Hard Light mode, 151 F F Hard Mix mode, 153 Feathering, 78, 273 Files on CD. See CD (included with book) creating new, 170, 205, 279 F F Hunctions, essential (Photoshop), 278 Gunctions, essential (Photoshop), 278 F Gaussian blur Saussian betasien, 96 F Fadius for, 24–25 F Farcuc	Inner Glow, 122	Foreground/background swatches, 282
Outer Glow, 122 Pattern Overlay, 123 Satin, 123 Shadows, 122 Stroke, 123 summary, 140–141 Visibility toggle, 125–126 Enhancements. See Editing images Enhancing color, 110–111 color/tone, example, 102–104 Equalize Histogram (HDR conversion method), 269 Evaluation of images, 30, 34–35, 230, 233–235 Exclusion mode, 153 EXIF metadata, 231 Expanding/collapsing view of groups, 42–45 Exposure and Gamma (HDR conversion method), 269 Exposure for HDR images, 266 Eyedropper tool, 102, 282 H Hard Light mode, 153 Feathering, 78, 273 Files on CD. See CD (included with book) creating new, 170, 205, 279 Files Gaussian blur Gaussian blur basics, 283 obliterating noise with, 96 radiust, 96 Gradient Editor, 171 Grayed out menu options, 12 Grayscale layers, 157–159 Grouping layers basics, 14, 42–47 Create a New Group button, 12, 44–46 expanding/collapsing views, 42–45 for head shot example, 242–244 Layer Groups, 14 Hard Light mode, 151 Hard Mix mode, 153 Hardware monitor calibration, 31, 278 setting up, 31–33 HDR conversion methods	Inner Shadow, 122	Freehand tools, 281, 282
Pattern Overlay, 123 Satin, 123 G Shadows, 122 Stroke, 123 summary, 140–141 Visibility toggle, 125–126 Enhancements. See Editing images Enhancing color, 110–111 color/tone, example, 102–104 Equalize Histogram (HDR conversion method), 269 Evaluation of images, 30, 34–35, 230, 233–235 Exclusion mode, 153 Exposure and Gamma (HDR conversion method), 269 Exposure and Gamma (HDR conversion method), 269 Exposure for HDR images, 266 Eyedropper tool, 102, 282 H Hard Light mode, 153 Feathering, 78, 273 Files on CD. See CD (included with book) creating new, 170, 205, 279 Gaussian blur basics, 283 obliterating noise with, 96 radius for, 24–25 foradient Editor, 171 Grayed out menu options, 12 Grayscale images. See Black-and-white images Gradient Editor, 171 Grayed out menu options, 12 Gradient Editor, 171 Grayed out menu options, 12 Grayed out	manual, 130–132	Functions (Photoshop), 281
Satin, 123 Shadows, 122 Stroke, 123 summary, 140–141 Visibility toggle, 125–126 Enhancements. See Editing images Enhancing color, 110–111 color/tone, example, 102–104 Equalize Histogram (HDR conversion method), 269 Evaluation of images, 30, 34–35, 230, 233–235 Exclusion mode, 153 EXPANSIVE and Gamma (HDR conversion method), 269 Exposure and Gamma (HDR conversion method), 269 Exposure for HDR images, 266 Eyedropper tool, 102, 282 H Hard Light mode, 151 F Hard Mix mode, 153 Feathering, 78, 273 Files on CD. See CD (included with book) creating new, 170, 205, 279 Gaussian blur basics, 283 Gaussian blur basics, 283 Gaussian blur basics, 283 obliterating noise with, 96 radius for, 24–25 Fadius for, 24–25 Gradient Editor, 171 Grayed out menu options, 12 Grayscale layers, 157–159 Grouping layers Grouping layers Frace a New Group button, 12, 44–46 expanding/collapsing views, 42–45 for head shot example, 242–244 Layer Groups, 14 Frace Hard Mix mode, 151 Hard Mix mode, 153 Hardware monitor calibration, 31, 278 setting up, 31–33 HDR conversion methods	Outer Glow, 122	Functions, essential (Photoshop), 278
Shadows, 122 Stroke, 123 summary, 140–141 Visibility toggle, 125–126 Enhancements. See Editing images Enhancing color, 110–111 color/tone, example, 102–104 Equalize Histogram (HDR conversion method), 269 Evaluation of images, 30, 34–35, 230, 233–235 Exclusion mode, 153 EXIF metadata, 231 Expanding/collapsing view of groups, 42–45 Exposure and Gamma (HDR conversion method), 269 Exposure for HDR images, 266 Eyedropper tool, 102, 282 H Hard Light mode, 151 F Hard Mix mode, 153 Feathering, 78, 273 Filles on CD. See CD (included with book) creating new, 170, 205, 279 Gaussian blur basics, 283 obliterating noise with, 96 radius for, 24–25 Gradient Editor, 171 Grayed out menu options, 12 Grayscale layers, 157–159 Grouping layers basics, 14, 42–47 Create a New Group button, 12, 44–46 expanding/collapsing views, 42–45 for head shot example, 242–244 Layer Groups, 14 Hard Light mode, 151 Hard Mix mode, 153 Hardware monitor calibration, 31, 278 setting up, 31–33 HDR conversion methods	Pattern Overlay, 123	
Stroke, 123 summary, 140–141 Visibility toggle, 125–126 Enhancements. See Editing images Enhancing color, 110–111 color/tone, example, 102–104 Equalize Histogram (HDR conversion method), 269 Evaluation of images, 30, 34–35, 230, 233–235 Exclusion mode, 153 EXIF metadata, 231 Expanding/collapsing view of groups, 42–45 Exposure and Gamma (HDR conversion method), 269 Exposure for HDR images, 266 Eyedropper tool, 102, 282 F H Hard Light mode, 151 F Feathering, 78, 273 Files on CD. See CD (included with book) creating new, 170, 205, 279 basics, 283 obliterating noise with, 96 radius for, 24–25 Gradient Editor, 171 Grayed out menu options, 12 Grayscale images. See Black-and-white images Grayscale layers, 157–159 Grouping layers basics, 14, 42–47 Create a New Group button, 12, 44–46 expanding/collapsing views, 42–45 for head shot example, 242–244 Layer Groups, 14 Hard Light mode, 151 Hard Mix mode, 153 Hardware monitor calibration, 31, 278 setting up, 31–33 HDR conversion methods	Satin, 123	G
summary, 140–141 Visibility toggle, 125–126 Enhancements. See Editing images Enhancing color, 110–111 color/tone, example, 102–104 Equalize Histogram (HDR conversion method), 269 Evaluation of images, 30, 34–35, 230, 233–235 Exclusion mode, 153 EXIF metadata, 231 Expanding/collapsing view of groups, 42–45 Exposure and Gamma (HDR conversion method), 269 Exposure for HDR images, 266 Eyedropper tool, 102, 282 Feathering, 78, 273 Files on CD. See CD (included with book) creating noise with, 96 radius for, 24–25 Gradient, 123 Gradient Editor, 171 Grayed out menu options, 12 Grayscale images. See Black-and-white images Grayscale layers, 157–159 Grouping layers basics, 14, 42–47 Create a New Group button, 12, 44–46 expanding/collapsing views, 42–45 for head shot example, 242–244 Layer Groups, 14 Hard Light mode, 151 Hard Mix mode, 153 Hardware monitor calibration, 31, 278 setting up, 31–33 HDR conversion methods	Shadows, 122	Gaussian blur
Visibility toggle, 125–126 Enhancements. See Editing images Enhancing color, 110–111 color/tone, example, 102–104 Equalize Histogram (HDR conversion method), 269 Evaluation of images, 30, 34–35, 230, 233–235 Exclusion mode, 153 EXIF metadata, 231 Expanding/collapsing view of groups, 42–45 Exposure and Gamma (HDR conversion method), 269 Exposure for HDR images, 266 Eyedropper tool, 102, 282 Feathering, 78, 273 Files on CD. See CD (included with book) creating new, 170, 205, 279 Gradient, 123 Gradient Editor, 771 Grayed out menu options, 12 Grayscale layers, 157–159 Grouping layers basics, 14, 42–47 Create a New Group button, 12, 44–46 expanding/collapsing views, 42–45 for head shot example, 242–244 Layer Groups, 14 Hard Light mode, 151 Hard Mix mode, 153 Hardware monitor calibration, 31, 278 setting up, 31–33 HDR conversion methods	Stroke, 123	basics, 283
Visibility toggle, 125–126 Enhancements. See Editing images Enhancing color, 110–111 color/tone, example, 102–104 Equalize Histogram (HDR conversion method), 269 Evaluation of images, 30, 34–35, 230, 233–235 Exclusion mode, 153 EXIF metadata, 231 Expanding/collapsing view of groups, 42–45 Exposure and Gamma (HDR conversion method), 269 Exposure for HDR images, 266 Eyedropper tool, 102, 282 Feathering, 78, 273 Files on CD. See CD (included with book) creating new, 170, 205, 279 Gradient, 123 Gradient Editor, 171 Grayed out menu options, 12 Grayscale images. See Black-and-white images Grayscale layers, 157–159 Grouping layers Foration definition, 12, 44–46 expanding/collapsing views, 42–45 expanding/collapsing views, 42–	summary, 140-141	obliterating noise with, 96
Enhancements. See Editing images Enhancing color, 110–111 color/tone, example, 102–104 Evaluation of images, 30, 34–35, 230, 233–235 Exclusion mode, 153 EXPANSIVE METAGAINE, 269 Expanding/collapsing view of groups, 42–45 Exposure and Gamma (HDR conversion method), 269 Exposure for HDR images, 266 Eyedropper tool, 102, 282 Feathering, 78, 273 Files on CD. See CD (included with book) creating new, 170, 205, 279 Gradient Editor, 171 Gradient Editor, 171 Grayed out menu options, 12 Grayscale layers, 157–159 Grouping layers basics, 14, 42–47 Create a New Group button, 12, 44–46 expanding/collapsing views, 42–45 for head shot example, 242–244 Layer Groups, 14 Hard Light mode, 151 Hard Mix mode, 153 Hardware monitor calibration, 31, 278 setting up, 31–33 HDR conversion methods		radius for, 24–25
Enhancing color, 110–111 Grayed out menu options, 12 color/tone, example, 102–104 Grayscale images. See Black-and-white images Equalize Histogram (HDR conversion method), 269 Evaluation of images, 30, 34–35, 230, 233–235 Exclusion mode, 153 EXIF metadata, 231 Expanding/collapsing view of groups, 42–45 Exposure and Gamma (HDR conversion method), 269 Exposure for HDR images, 266 Eyedropper tool, 102, 282 Feathering, 78, 273 Files on CD. See CD (included with book) creating new, 170, 205, 279 Grayscale layers, 157–159 Grayscale images, 26e Black-and-white images Grayscale layers, 157–159 Grayscale layers, 162 Grayscale layers, 157–159 Grayscale layers, 162 Grayscale layers, 162 Grayscale layers, 162 Grayscale layers For layers		Gradient, 123
color, 110–111 color/tone, example, 102–104 Equalize Histogram (HDR conversion method), 269 Evaluation of images, 30, 34–35, 230, 233–235 Exclusion mode, 153 EXIF metadata, 231 Expanding/collapsing view of groups, 42–45 Exposure and Gamma (HDR conversion method), 269 Exposure for HDR images, 266 Eyedropper tool, 102, 282 H Hard Light mode, 151 F Hard Mix mode, 153 Feathering, 78, 273 Files on CD. See CD (included with book) creating new, 170, 205, 279 Grayscale images. See Black-and-white images Grayscale inages. See Black-and-white images Grayscale inages. See Black-and-white images Grayscale inages. See Black-and-white images Grayscale layers For all and Security For all and Security F F		Gradient Editor, 171
color/tone, example, 102–104 Equalize Histogram (HDR conversion method), 269 Evaluation of images, 30, 34–35, 230, 233–235 Exclusion mode, 153 EXIF metadata, 231 Expanding/collapsing view of groups, 42–45 Exposure and Gamma (HDR conversion method), 269 Exposure for HDR images, 266 Eyedropper tool, 102, 282 H Hard Light mode, 153 Feathering, 78, 273 Files on CD. See CD (included with book) creating new, 170, 205, 279 Grayscale layers, 157–159 Grouping layers basics, 14, 42–47 Create a New Group button, 12, 44–46 expanding/collapsing views, 42–45 for head shot example, 242–244 Layer Groups, 14 Hard Light mode, 151 Hard Mix mode, 153 Hardware monitor calibration, 31, 278 setting up, 31–33 HDR conversion methods		
Equalize Histogram (HDR conversion method), 269 Evaluation of images, 30, 34–35, 230, 233–235 Exclusion mode, 153 EXIF metadata, 231 Expanding/collapsing view of groups, 42–45 Exposure and Gamma (HDR conversion method), 269 Exposure for HDR images, 266 Eyedropper tool, 102, 282 H Hard Light mode, 153 Feathering, 78, 273 Files on CD. See CD (included with book) creating new, 170, 205, 279 Grayscale layers, 157–159 Grouping layers basics, 14, 42–47 Create a New Group button, 12, 44–46 expanding/collapsing views, 42–45 for head shot example, 242–244 Layer Groups, 14 H Hard Light mode, 151 Hard Mix mode, 153 Hardware monitor calibration, 31, 278 setting up, 31–33 HDR conversion methods		
Evaluation of images, 30, 34–35, 230, 233–235 Exclusion mode, 153 EXIF metadata, 231 Expanding/collapsing view of groups, 42–45 Exposure and Gamma (HDR conversion method), 269 Exposure for HDR images, 266 Eyedropper tool, 102, 282 H Hard Light mode, 153 Feathering, 78, 273 Files on CD. See CD (included with book) creating new, 170, 205, 279 Grouping layers basics, 14, 42–47 Create a New Group button, 12, 44–46 expanding/collapsing views, 42–45 for head shot example, 242–244 Layer Groups, 14 H Hard Light mode, 151 Hard Mix mode, 153 Hardware monitor calibration, 31, 278 setting up, 31–33 HDR conversion methods		
Exclusion mode, 153 EXIF metadata, 231 EXIF metadata, 231 Expanding/collapsing view of groups, 42–45 Exposure and Gamma (HDR conversion method), 269 Exposure for HDR images, 266 Eyedropper tool, 102, 282 H F Hard Light mode, 151 F Hard Mix mode, 153 Feathering, 78, 273 Files on CD. See CD (included with book) creating new, 170, 205, 279 basics, 14, 42–47 Create a New Group button, 12, 44–46 expanding/collapsing views, 42–45 for head shot example, 242–244 Layer Groups, 14 F Hard Light mode, 151 Hard Mix mode, 153 Feathering, 78, 273 Hardware monitor calibration, 31, 278 setting up, 31–33 HDR conversion methods		
EXIF metadata, 231 Create a New Group button, 12, 44–46 expanding/collapsing view of groups, 42–45 Exposure and Gamma (HDR conversion method), 269 Exposure for HDR images, 266 Eyedropper tool, 102, 282 Hard Light mode, 151 F Hard Mix mode, 153 Feathering, 78, 273 Files on CD. See CD (included with book) creating new, 170, 205, 279 Create a New Group button, 12, 44–46 expanding/collapsing views, 42–45 for head shot example, 242–244 Layer Groups, 14 For head shot example, 242–244 Layer Groups, 14 For head shot example, 242–244 Layer Groups, 14 Exposure for HDR images, 266 Hard Light mode, 151 Feathering, 78, 273 Hardware monitor calibration, 31, 278 setting up, 31–33 HDR conversion methods		
Expanding/collapsing view of groups, 42–45 Exposure and Gamma (HDR conversion method), 269 Exposure for HDR images, 266 Eyedropper tool, 102, 282 H Hard Light mode, 151 F Hard Mix mode, 153 Feathering, 78, 273 Files on CD. See CD (included with book) creating new, 170, 205, 279 expanding/collapsing views, 42–45 for head shot example, 242–244 Layer Groups, 14 H Hard Light mode, 151 Hard Mix mode, 153 Feathering, 78, 273 Hardware monitor calibration, 31, 278 setting up, 31–33 HDR conversion methods		
Exposure and Gamma (HDR conversion method), 269 Exposure for HDR images, 266 Eyedropper tool, 102, 282 H Hard Light mode, 151 F Hard Mix mode, 153 Feathering, 78, 273 Files on CD. See CD (included with book) creating new, 170, 205, 279 for head shot example, 242–244 Layer Groups, 14 H Hard Light mode, 151 Hard Mix mode, 153 Hardware monitor calibration, 31, 278 setting up, 31–33 HDR conversion methods	*	
Exposure for HDR images, 266 Eyedropper tool, 102, 282 H Hard Light mode, 151 F Hard Mix mode, 153 Feathering, 78, 273 Files on CD. See CD (included with book) creating new, 170, 205, 279 Layer Groups, 14 Layer Groups, 14 H Hard Light mode, 151 Hard Mix mode, 153 Hardware monitor calibration, 31, 278 setting up, 31–33 HDR conversion methods		
Eyedropper tool, 102, 282 H Hard Light mode, 151 F Hard Mix mode, 153 Feathering, 78, 273 Hardware files monitor calibration, 31, 278 setting up, 31–33 creating new, 170, 205, 279 HDR conversion methods		
Eyedropper tool, 102, 282 H Hard Light mode, 151 F Hard Mix mode, 153 Feathering, 78, 273 Hardware files monitor calibration, 31, 278 setting up, 31–33 creating new, 170, 205, 279 HDR conversion methods	Exposure for HDR images, 266	
Hard Light mode, 151 Feathering, 78, 273 Feathering, 78, 273 Files on CD. See CD (included with book) creating new, 170, 205, 279 Hard Mix mode, 153 Hardware monitor calibration, 31, 278 setting up, 31–33 HDR conversion methods		Н
Feathering, 78, 273 Feathering, 78, 273 Files on CD. See CD (included with book) creating new, 170, 205, 279 Hard Mix mode, 153 Hardware monitor calibration, 31, 278 setting up, 31–33 HDR conversion methods		Hard Light mode, 151
Feathering, 78, 273 Files on CD. See CD (included with book) creating new, 170, 205, 279 Hardware monitor calibration, 31, 278 setting up, 31–33 HDR conversion methods	F	
Files monitor calibration, 31, 278 on CD. See CD (included with book) setting up, 31–33 creating new, 170, 205, 279 HDR conversion methods		
on CD. See CD (included with book) setting up, 31–33 creating new, 170, 205, 279 HDR conversion methods		
creating new, 170, 205, 279 HDR conversion methods		
3		

Exposure and Gamma, 269	Add to Sample tool, 103, 193
Highlight Compression, 269	adding color enhancements, 110
Local Adaptation, 269	adjusting, 55
HDR images	commands, 281
automated conversions, 268–269	creating color-based mask, 192–193
basics, 264–265	desaturating shadows, 239, 240
capturing/creating, 265–266	enhancing natural color/tone, 102–
creating in Photoshop, 266–267	104
exposure for, 266	separating color image into RGB, 216–220
manual conversions, 269–273	
Head-shot editing. See also Editing images	1
applying editing checklist, 232–254	Icons
Color Balance, 237	layer types, 18–19
corrections, list of, 235	Layers palette, 9–12
cropping image, 237–238	Image Size command, 280
enhance contrast, 239–240	Images
evaluating image, 230	cleaning up, 93–94
eyes/mouth corrections, 248–249	creating new, 170, 205, 279
general editing steps, 231	editing. See Editing images
Levels corrections, 235–236, 249–251	evaluating. See Evaluation of images
lighten/soften hair, 252–253	isolating components, 74–81
masking, 242, 244–245, 249	separations. See Separations
matching tone of face/chest, 244–246	Inner Glow, 122
neck/jawline corrections, 246–248	Inner Shadow, 122
saturation adjustments, 239–240	
sharpening, 242	Input devices, 31
-	Inverse command, 102, 280
skin tone corrections, 238–239	Isolating Image Objects, 74–81
softening, 239–241	Isolation, enhanced, 91–120
summary, 254–255	Isolation techniques. See also Masking
Healing tool	adding layers for change, 81
basics, 282	Color Balance, 86–87, 88, 185, 188
for head shot example, 248	correction in Adjustment layers, 66
manual sharpening, 115–118	isolating components of image objects, 74–81
simple layer repair, 82–85	Levels corrections, 66–74, 185, 187, 235–236
Help (Photoshop), 2, 278	simple layer repair example, 82–85
Heroics, imaging, 34, 35	summary, 87–89
Highlight Compression (HDR conversion method),	
269	K
Highlighting/selecting layers, 43-44,	Keystrokes, about this book's notation for, 23
48	Knockouts, 177–179
Histogram	
Equalize, 269	L , , , , , , , , , , , , , , , , , , ,
Levels, 67-72, 185, 187, 236	Layer Actions.atn, 132
History palette, 74, 109	Layer-based workflow, 29–63
Hue mode, 154	Layer_Effects.atn, 132
Hue/Saturation	Layer from Background method, 17

Layer icons, 18–19	summary, 166–167, 280
Layer management	useful/commonly used, 155
clipping layers, 52–55	Vivid Light mode, 152
creating layers, 12, 16-20, 23, 37, 279	Layer Opacity, 9
creating layers via copy, 16, 17, 74	Layer Opacity commands, 280
grouping layers, 12, 14, 42–47, 242–244	Layer Palette buttons, 8–12
highlighting/selecting layers, 43-44, 48	Add Layer Mask, 11
introduction, 29-30	Add Layer Style, 11
linked layers, 56-60	Blending Mode, 9
merging layers, 47-50, 280	Close Palette, 9
moving/activating layers, 51-52	Create a New Group, 12
naming layers, 37–41	Create a New Layer, 12
outline for image editing, 30-36	Delete Layer, 12
Smart Objects, 60–63	Layer Visibility Toggle, 10
summary, 63	Layers Palette menu, 10, 16
Layer modes	Link Layers, 10
behavior of, 144	Lock All, 10
Color Burn mode, 147	Lock Image Pixels, 10
Color Dodge mode, 149	Lock Layer Positions, 10
Color mode, 154, 156–162	Lock Transparent Pixels, 10
Darken mode, 146	Minimize Palette, 9
Darker Color mode, 148	New Adjustment Layer, 11
Difference mode, 153	Resize Palette, 12
Dissolve mode, 146	Layer Properties, 23, 40
Exclusion mode, 153	Layer stack. See also Layers palette
Hard Light mode, 151	adding layers, 23
Hard Mix mode, 153	basics, 3–4
Hue mode, 154	Layer Style dialog, 125
Lighten Color mode, 150	Layer types
Lighten mode, 148	Adjustment, 13. See also Adjustment layers
Linear Burn mode, 148	Background, 13, 14, 17, 52–54
Linear Dodge mode, 150	Clipping, 14. See also Clipping layers
Linear Light mode, 152	Fill, 13, 17
Luminosity mode, 155, 156-162	Groups, 14. See also Grouping layers
Multiply mode, 147	Smart Objects, 14, 60–63
Normal mode, 145	Type, 13, 17, 52–54
occasionally used, 155	Video layers, 14
Overlay mode, 150	Layer Via Copy method, 17
Pin Light mode, 152	Layer Viewing preferences, 15–16
rarely used, 155	Layer Visibility Toggle button, 10
Saturation mode, 154	Layers. See also Layer management; Layer modes
Screen mode, 149	activating and moving, 51–52
sections of Mode menu, 166–167	basics, 2–7
separating color/tone, 156-162	copying, 16, 17, 74
sharpening calculations, 162–165	grouping, 42–47
Soft Light mode, 151	linking, 56–60

logic of, 36	M
merging, 47–50	Magic Wand tool, 99, 282
moving/activating layers, 51–52	Managing layer styles, 129–130
naming, 37–41	Masking
palettes and menus, 7–12	Add a Mask button, 11
selecting, 43–44, 48	adding color enhancements, 110–111
Smart Objects, 60–63	adding soft focus, 105–109
types of, 13–15	vs. Blend If, 177
Layers, creating	Blend If as mask, 190–191
basics, 16–18	cleaning up images, 93–94
exercise, 20–27	color-based, 191–199
when to create, 36	correction list for, 92–93
Layers palette	creating color-based mask, 191–199
features found on, 8–12	enhancing natural color/tone, 102–105
icons, 9–12, 18–19	for head shot example, 242, 244–245, 249
opening, 7	Layer Mask commands, 281
Layers Palette menu, 10, 16	Masks palette, 273
Layers Panel Options, 15	options, summary, 118–120
Levels corrections	reducing image noise, 94–102
basics, 66–74, 281	sharpen and enhance contrast, 111–115
for color, 70–73	sharpening calculation using Layer Modes,
for head shot example, 235–236	162–165
for ship's mast example, 185, 187	simplest form of, 91–92
Levels slider changes, 67–74, 185, 187, 235–236,	summary, 118–120
249–251	Unsharp Mask filter, 113, 164–165, 283
Leveraging Photoshop Layers blog, xxiv	Unsharp Mask Layer, 162–165
Libraries	vector masks, 127
digitized images, 202	Wild Type Effectz, 138
Styles, 127, 129–130	Masks palette, 273
Lighten Color mode, 150	Memory requirements, 31–32
Lighten mode, 148	Menus, 8, 12
Light's Fingerprint, 66–67	Merge Layers command, 48, 280
Linear Burn mode, 148	Merging layers, 47–50
Linear Dodge mode, 150	Minimize Palette button, 9
Linear Light mode, 152	Modes. See Layer modes
Link Layers button, 10	Monitor calibration, 31, 278
Linked layers, 56–60	Move tool, 5, 282
Load actions, 132–133	Moving image components, 75–76
Local Adaptation (HDR conversion method),	Moving layers, 51–52
269	Multiply mode, 147
Local contrast, 114	MyName layer, 4–6
Lock All button, 10	,ae.aye., . e
Lock Image Pixels button, 10	N
Lock Layer Positions button, 10	Naming layers, 37–41
Lock Transparent Pixels button, 10	Nested groups, 44–45
Luminosity mode, 155, 156–162	New command/New dialog, 170, 205, 279

New Layer commands, 20, 279 New Layer via Copy command, 74 Noise Add Noise command, 95, 100, 282 reducing, 94–102 Nondestructive editing, 4 Normal layers, compared to background layers, 14 Normal mode, 145	filters (recommended list), 281, 283 freehand tools (recommended list), 281, 282 functions (recommended list), 278, 281 Help, 2, 278 setting up, 31–32 versions, xxiv, 12 Photoshopcs.com, 28 Pin Light mode, 152
Opacity adjusting (for soft focus), 107–108 control (Layers palette), 9, 280 corrections, 73–74 vs. Fill, 140	Polygonal Lasso tool, 78, 80, 196, 246, 282 Preset Manager for Styles, 129 Prokudin-Gorskii images, 202–204 Prokudin-Gorskii, Sergei Mikhailovich, 202 Properties (Layer Properties), 23, 40 Purposing and output of images, 31, 35–36
for translucent type, 138 Open command (File menu), 279 Optimizing images for output, 36 Options bar, 22 Outer Glow, 122 Output and purposing, 31, 35–36 Output Levels slider changes, 67–69, 236, 249–251 Overlay mode, 150	R Radius, blur, 24 RAM, 31 RAW images, 232–233 Rebuild edges, 117–118 Repairing with layers, example, 82–85 Resize Palette button, 12 RGB components
P Packaging images for output, 36 Paintbrush tool, 110, 115, 282 Palettes Actions palette, 132–133 Adjustments palette, 13, 17, 26 Character palette, 52–53 described, 8	creating color from black and white, 202–210 creating filtered color, 211–216 Prokudin-Gorskii images, 202–204 separating color image into, 216–221 RGBL Components action, 220, 222, 224, 233 Richard's Custom Black-and-White actions, 220–221, 224
History palette, 74, 109 Layers palette, 7–12, 18–19 Masks palette, 273 Styles palette, 124, 128–129 Panoramas creating, 262–264 using automated tools, 264	Sample Size option, 102 Satin effect, 123 Saturation. <i>See</i> Hue/Saturation Saturation mode, 154 Saving images via Save As command, 279 Save for Web command, 279
Paste/Copy, 74, 279 Pattern Overlay, 123 Photomerge, 264 Photoshop commands (recommended list), 278–280 expectations for tools, 275–276 exploring new tools, 276–277 external applications (recommended list), 277–278	styles, 127–128 supported file formats, 36 Scanners, 32, 33 Screen mode, 149 Selecting/highlighting layers, 43–44, 48 Selection, complex, 97–99 Separations action set (on CD), 220–221, 222, 224

CMYK, 220	Styles palette, 124, 128–129
of color image into RGB components, 216–221	System requirements, 31
color/tone, using modes, 156-162	_
custom black-and-white conversions, 221–226	T
history of Prokudin-Gorskii images, 202	Text. See Type layers
RGBL Components action, 220, 222, 224, 233	Threshold function, 182–183
summary, 226-228	Thumbnail Size preference, 15–16
Sets. See Grouping layers	Tone
Setup for image editing, 30, 31–33	correction for flowers example, 102–105
Shadows, 122	evaluating images, 34, 231, 233
Shallow knockouts, 178–179	separating color/tone using modes, 156–162
Shapes, Convert to, 127	Tool bar, Background/foreground swatches, 282
Sharpening	Transform command, 280
calculations and modes, 162–165	Translucent type, 134–138
enhancing contrast, 111–115	Type layers
in head shot example, 242	basics, 13
manual, 115–118, 242	clipping text/background, 52–54
oversharpening, 112	creating, 17
rebuild edges, 117–118	Type tool
Unsharp Mask filter, 113, 164–165, 283	copyright layer, 22, 50
Unsharp Mask Layer, 162–165	type and sizing, 52–53
Signature layer, creating, 4–6	3,1
Skin tone corrections, 238–239	U
Smart Objects, 14, 60–63	Underlying Layers and Blend If, 174–175
Snapshots	Undo command (Edit menu), 48, 59, 279. See also
	History palette
History palette, 74	Unsharp Mask filter, 113, 164–165, 283
Snapshot layers. <i>See</i> Composite layers Soft Focus	Unsharp Mask Layer, 162–165
	Use Previous Layer to Create Clipping Mask
in head shot example, 239–241, 252–253	checkbox, 26, 27, 56, 245
soft focus effects, 105–109	
Soft Light mode, 151	V
Softening. See Soft Focus	Vanishing Point files, 86
Software	Vector masks, 127
device, 278	Video layers, 14
external applications, 277–278	Visibility toggle for Layers, 125–126
setting up, 31–33	Vivid Light mode, 152
Stroke effect, 123	3
Styles	W
ActionFx-CS4_Set_01.asl, 129	Ward, Al, 129
adding, 11	Web sites
applying, 124–127	Adobe, 31
combining manual effects and, 134–140	for digitized images, 202
libraries, 130	for this book, 28, 167, 228, 260
managing, 129–130	Wild Type Effectz layer, 124, 131, 134–138
personalized, 127	Workflow, layer-based, 29–63
saving, 127–128	